29.95

THE BODY FANTASTIC

THE BODY FANTASTIC

FRANK GONZALEZ-CRUSSI

The MIT Press
Cambridge, Massachusetts
London, England

© 2021 Massachusetts Institute of Technology

All rights reserved. No part of this book may be reproduced in any form by any electronic or mechanical means (including photocopying, recording, or information storage and retrieval) without permission in writing from the publisher.

This book was set in Adobe Garamond and Berthold Akzidenz Grotesk by Jen Jackowitz. Printed and bound in the United States of America.

Library of Congress Cataloging-in-Publication Data
Names: Gonzalez-Crussi, F., author.
Title: The body fantastic / Frank Gonzalez-Crussi.
Description: Cambridge, Massachusetts : The MIT Press, [2021] | Includes bibliographical references and index.
Identifiers: LCCN 2020037092 | ISBN 9780262045889 (hardcover)
Subjects: LCSH: Human anatomy—History. | Human anatomy in literature. | Human body in literature. | Human body—Mythology. | Human body—Folklore. | Human body (Philosophy) | Medicine—History.
Classification: LCC QM11 .G67 2021 | DDC 611—dc23
LC record available at https://lccn.loc.gov/2020037092

10 9 8 7 6 5 4 3 2 1

Contents

Foreword by John Banville *vii*

INTRODUCTION *1*

1 **VALÉRY'S FOUR BODIES REDUCED TO ONE ORGAN: THE UTERUS** *5*

2 **TO SEIZE THE EXTERNAL WORLD, THE BODY FANTASTIC RELIES ON A STORMTROOPER: THE STOMACH** *45*

3 **THE INVISIBLE CLOUD OF SYMBOLS AND MYTHS AROUND THE BODY CONDENSES INTO RAINDROPS OF CURATIVE POWER** *73*

4 **HAIR: IS IT A DISTILLATE OF HUMAN ESSENCE OR A DISCARDABLE REFUSE?** *121*

5 **OUR AQUATIC PAST: THE BODY FANTASTIC DREAMS OF A RETURN TO ITS WATERY CRADLE** *153*

6 **THE BODY FANTASTIC WALKS ON FEET OF DOUBLE SIGN: PAIN AND PLEASURE** *187*

7 **TO THE BODY FANTASTIC, ORALITY EQUALS INDIVIDUALITY** *215*

Notes *241*
Index *263*

Foreword

by John Banville

There are numerous aspects of his character and thought on which René Descartes may be commended, not least his well-known predilection for cross-eyed women, but his assertions on dualism and the mind–body debate have proved nothing short of catastrophic for humankind. How are we to give this sheath of flesh in which we are encased its proper due if it's nothing more than an automaton, an elaborate wax figure, dead in itself and worked only by the mind's invisible wires, as Descartes in his wisdom taught?

In the Western religio-philosophical tradition, Plato and St. Paul, to name but two influential haters of the flesh, had already done much to make the earthly body seem a trivial, annoying, and even disgusting appendage of the divine soul: God's practical joke upon the creatures whom, so the priests tell us, he fashioned in his own image.

Indeed, given Christianity's reprehension of the merely physical, it is a question as to why at the Second Coming it is necessary that we should be returned to corporeality. Surely the angels will snigger at us behind their hands as, in

our newly reconstituted bodies, we mill about up there in post-Resurrection Paradise, helpless in our trillions, as closely packed as passengers on a rush-hour commuter train, though this one will be infinitely long and will have no destination.

Nietzsche made every effort to restore the body's reputation, insisting always on its equal value in the mind–body equation. His Zarathustra tells us "there is more wisdom in your body than in your deepest philosophy," and, warming to the task, suggests that "once the soul looked contemptuously upon the body, and then that contempt was the supreme thing:—the soul wished the body lean, monstrous, and famished. Thus it thought to escape from the body and the earth. But that soul was itself lean, monstrous and famished . . ."

And recall the Reverend Sydney Smyth, that delightful, irrepressible, ever wise, witty and mischievous clergyman philosopher, who in a sermon enjoined his congregation to keep ever in mind the fact that, since God is omnipresent, he inhabits not only the soul of man but also that part upon which man, and woman, necessarily sit. This, we may say, surely is a fundamental truth.

Frank Gonzalez-Crussi is a champion of the body in all its prosaic as well as its mysterious manifestations. He has spent his adult life studying it, as a pathologist and academic and, starting in mid-career, as a writer. He is also an antiquarian and an omnivorous reader—for evidence of his scholarship, take a glance through his notes and list of sources for *The Body Fantastic*.

His precursors include the Roman physician and philosopher Galen of Pergamon; Sir Francis Bacon, First Viscount St. Albans, one of those who transformed the "natural

philosophy" of the ancients into what we know as science, and who according to John Aubrey died of pneumonia contracted while seeking to deep-freeze a chicken by stuffing it with snow; Sir Thomas Browne, scholar and supreme prose stylist, the author of, among other notable works, the splendidly titled *Pseudodoxia Epidemica*, or "Vulgar Errors"; and Robert Burton, who sought to cure his own sick spirit by writing *The Anatomy of Melancholy*, an enormous work of which he produced no fewer than five revised and expanded editions in his lifetime. We might also cite as a fellow member of the brotherhood of the arcanum Gonzalez-Crussi's Latin American neighbor, Jorge Luis Borges.

It was from a poet, indeed a poet philosopher, that Gonzalez-Crussi had his initial inspiration for this book. Paul Valéry, he tells us, set out in his essay "Réflexions simples sur le corps" the proposition that we inhabit not one but four bodies. First is the one in which we live our quotidian lives, second, the one that others see, third, "the inner, biological body made up of organs," and fourth—although Valéry only glances at this possibility—what might be designated the quantum body, the one that has its flickering, liminal existence within the swirl of particles and probabilities that the quantum scientist will tell us is the "real" world.

The Body Fantastic is a cabinet of curiosities, a *Wunderkammer* fully worthy of the Emperor Rudolf II, that would have been much appreciated by Sir Thomas Browne, in particular, whose *Hydrotaphia*, or *Urne Buriall*—"Life is a pure flame, and we live by an invisible Sun within us"—suffers not at all from the fact that the funerary urns which are the starting point for his magnificent essay were not ancient Roman

artifacts, as he thought, but Anglo-Saxon in origin. . . . As we see, the urge to veer off and ramble happily down side tracks, as our author loves to do, is catching. But what is duller than a straight road?

Valéry's "fourth body," as the poet himself writes, and as Gonzalez-Crussi quotes, is no more or less distinguishable from the subatomic spume in which it has its being "than is a whirlpool from the liquid in which it is formed"; an insubstantial thing, "an ethereal entity," Gonzalez-Crussi suggests, "immersed in an atmosphere made of history, symbolism, myths, legends, tales, mental representations, desires, fears and hopes." However, this patchwork mantle that so neatly wraps us round and so diligently shields us from harsh winds and killing frosts is as integral to us as is the thinking mind.

The dream of flying by the body's nets into the free, clean, and luminous realm of pure, unfettered being is as old as *Gilgamesh*, and is the basis of all religions. But would this really be a desirable state in which to pass our lives? To live is to be in the world, which is the body's home, cluttered, ramshackle, and ever in need of repair though it may be. We persist in living, as Rilke beautifully writes in the *Duino Elegies*,

> because being here is much, and because all this
> that's here, so fleeting, seems to require us and strangely
> concerns us. Us the most fleeting of all.

Gonzalez-Crussi takes a measure of the body from top to toe, calling on a host of witnesses as inquisitive, open-minded, and wide-ranging in their interests as he is himself. And there are some surprises, such as Casanova, "a remarkable individual" of "profound erudition" and, you will be startled

to know, something of a feminist, as Gonzalez-Crussi demonstrates in some judiciously chosen passages from the Venetian savant's writings.

We are introduced also to scores of lesser-known figures, all of them fascinating in their colorful ways. In the first paragraph alone of his chapter on the stomach, the author calls to our attention a miniature gallery of English eccentrics. There is the Cornishman Robert Stephen Hawker, an Anglican priest who excommunicated his cat for catching mice on Sundays; John "Mad Jack" Mytton, who kept two thousand pet dogs and who once arrived for dinner at a friend's house riding on the back of a bear; and the Reverend Dr. William Buckland, theologian, paleontologist, "and 'zoophage' extraordinaire," who styled himself "the man who ate everything," and to whom, it was said, "Noah's Ark looked like a dinner menu."

There are chapters here devoted to the uterus—everyone, even the wisest, used to believe it wandered about inside the body—the stomach, the mouth, and down to the all too often disregarded feet. It is a marvelous tour of a marvelous phenomenon, this tender but tough machine that houses us so diligently for our time on earth, and which Dr. Gonzalez-Crussi does proud. Not only does he celebrate the body fantastic, he sings, with Whitman, the body electric:

> O I say these are not the parts and poems of the Body only, but of the soul,
> O I say now they are the soul!

INTRODUCTION

The French poet and philosopher Paul Valéry (1871–1945) proposed in a brilliant essay that we have not one but several bodies.[1] There is, first of all, the body that we "live in," which we call "our body." This body we perceive incompletely: we catch glimpses of our limbs, but never see it in its entirety, unless we use some reflective device, like a mirror. Our second body is the body that others perceive. We owe to it our social identity; we *are* because others look at us. Thirdly, there is the inner, biological body made up of organs, such as liver, spleen, kidneys, and so on. We are not made to suspect the existence of this third "inner body"; and perhaps this is just as well, because in daily life we have no way to act upon our own body's hidden components.

Almost as an afterthought, at the end of his essay, Valéry introduces the possibility of the existence of a "fourth body," which paradoxically could be called "Real Body" and equally well "Imaginary Body." In his words:

> This one may be considered as indivisible from the unknown and unknowable environment which physicists make us suspect every time they . . . discover phenomena whose origin

they place either above or below the scope of our senses, of our imagination, and ultimately of our intellection itself.

From this inconceivable milieu, my *Fourth Body* is neither more nor less distinguishable than is a whirlpool from the liquid in which it is formed.[2]

Here, Valéry's thought seems more difficult to follow. As I understand it, when he refers to the "unknown and unknowable" environment that physicists present to us, he is alluding to the striking revelations that scientists make about the constitution of the world. For instance, they tell us that solid objects, apparently firm and stable, are made of astoundingly minute atoms, themselves resolved into inconceivably smaller particles charged with electromagnetic energy and moving at incredible speed; that light spreads not uniformly, but is of granular nature, like hail, and the granules are named "photons"; that space and time are not separate entities, but may be thought as one called "spacetime"; and many other astounding things, always far beyond the perceptive ability of our senses. Yet we, our bodies, exist in this wondrous, unimaginable environment. We are *an* integral part of it, and at the same time distinct from it. The poetical image is singularly felicitous. We are *like the whirlwind that forms in a liquid, which is obviously part of it, yet retains its own distinctness.*

The idea of a plurality of bodies, which at first blush might seem the futile conceit of a poet, was the stimulus that prompted me to write the present work. No idea is ever wholly futile or useless, and this one directs the imagination toward new ways of conceiving corporeality. The first body yields only subjective and transient experiences; the second is an object for others to consider; the third one is best left

to biomedical specialists. But the idea of a "fourth body" makes us imagine our body as an ethereal entity immersed in an atmosphere made of history, symbolism, myths, legends, tales, mental representations, desires, fears and hopes. This is the whirlwind in the midst of which we find ourselves. It may be seen as a robe or a mantle that covers us. Only this invisible cover, I would argue, is an integral part of the person. Invisible as it is, it is part of our selves. Cut it out, and the human being is reduced to a mere assemblage of organs and tissues. It would be like cutting a man off from himself.

Myths, legends, allegories, and fables are not simply absurd errors of the past or preposterous beliefs that we would do well to relegate to a modern oblivion. They are representations rooted in the deepest regions of the psyche; they form the symbolic expression of aspirations and emotions that found no other way of bursting forth. Myths and stories sometimes give voice to the unrealized wish that the body should remain forever flourishing and supremely strong ("Would that we could live under water!"; "What if we could eat anything?"); at other times, to the obscure fear of its inevitable withering and destruction.

The old dualist idea of mind and matter ("body and soul," it used to be said) is not dead. Body and consciousness are still seen as two things incommensurable and independent from each other. Neuroscientists have made it difficult of late to maintain this opposition in its traditional form, but the dualistic concept is by no means defunct. The notion still endures that "body" stands in opposition to "spirit," "thought," or "mind." And there is a rich history of misprize, disdain, and condemnation of the body. Philosophers have argued, as

did Socrates in Plato's *Phaedo*,[3] that the clearest truth can be attained only by "staying as far as possible from eyes and ears and, broadly speaking, of the body altogether." When the body is partner of the mind, they say, the result is confusion. Pain and pleasure, like all bodily sensations, are a hindrance to intelligence.

Therefore, a millenarian tradition sees the body as a ballast or impediment against the mind's creative flights. Perhaps this is why something in us, an irrational impetus, makes us wish we could surpass the limitations imposed by the body's material nature. If the stomach can digest food, an obscure, unreasonable yearning imagines it capable of digesting stones and metals. If the lungs sustain our lives inside the atmosphere, we should like to see them enabling our survival in the ocean depths. If our flesh is perishable and impermanent, something deep down in us inclines us to hope—haply to believe—that hidden somewhere in our flesh is the principle of youth and the balm that heals all afflictions. These obscure aspirations find symbolic expression in some of the tales, histories, and bizarre beliefs that I recount in this book.

Many of the anecdotes, legends, and fanciful ideas about the body collected in this book reflect concepts that were once recognized as genuinely "scientific." Time has revealed them to be eccentric or outright laughable. This means that the invisible robe that all of us wear around our bodies is a striking, tessellated garment embroidered with contradictory, multicolored, variegated strands. This is how it should be. For on the stage of the world we often play the fool, and we must dress accordingly. Hazlitt said of the fool in Shakespeare that "motley's his proper wear."

1 VALÉRY'S FOUR BODIES REDUCED TO ONE ORGAN: THE UTERUS

THE WOMB AS ANIMAL

Few organs of the body occupy a larger place in men's minds. Modern science has erased old superstitions, yet many of the ancient symbolic meanings attached to the uterus remain unchanged. It seems that a close acquaintance with anatomy is not necessary in order to form strong opinions about this organ. Among the ancient Greeks, Hippocrates and his followers had never seen a human uterus. Aristotle admits never having seen one, but only some wombs of animals. This did not impede the ancients from vividly describing the structure of this organ, or heatedly discussing its putative functions.

Unacquainted with anatomy as they were, the ancient Greeks knew very well that women have a uterus, and where this organ resides. That they knew its location is obvious, since they named it *hystera*, a term of Sanskrit roots which means "placed behind." The first-century physician Soranus of Ephesus stated that the uterus probably was so named because it is "lying after all the entrails"; and the fifth-century Greek grammarian Hesychius of Alexandria affirmed that the name

of the womb meant "the back part." Indeed, it is an organ that lies in the lowermost reaches of the abdominal cavity. The Hippocratic doctors may never have examined an entire human uterus, but they certainly could palpate it and perceive it by touch.[1]

Hence our puzzlement when considering that the intellectually outstanding men of classical antiquity, and among them the great philosopher Plato, of all people, entertained the bizarre, outlandish notion of a mobile, "wandering" uterus. The fact is, most people in ancient Greece believed that the uterus moved about like an independent animal inside the woman's body—"an animal within an animal"[2] was the traditional simile—and many women wore amulets to protect them against this nefarious uterine movement. The contention was that as the womb moved erratically here and there it would compress other organs, causing havoc in the organism. It would enter the thorax, there compressing the lungs and heart; climb into the throat, giving rise to suffocation; ramble through the abdominal cavity, causing digestive troubles; and everywhere accounting for dreadful spasms and untold suffering, sometimes giving rise to convulsions similar to epilepsy. Later ages would call the symptom complex thus produced "hysteria," a term that, it should be noted, was *never* used by the ancients.

Not only was the uterus credited with mobility, it was also assumed to be sentient, since it was believed to detest disagreeable odors and to be attracted by pleasant fragrances. This is why one of the most celebrated Greek physicians, Aretaeus of Cappadocia (flourished in the second century AD), wrote that "if one approaches a repugnant odor to the nose

of a woman, the uterus descends, and if one presents such an odor to the vulva, the uterus goes up."[3]

A rational therapy followed logically from this. Do we want to stop the distress caused by the wandering womb in the throat or other parts in the upper regions of the body? Then we must force it to go down by applying to the patient's nostrils fetid substances that will drive it back, like burnt hairs, extinguished lamp wicks, castoreum (a yellowish secretion that comes from the anal sacs of the beaver,[4] which this animal uses, together with urine, to mark its territory), or old, stale urine "whose bad odor and strength are such as to bring a dead man back to life, therefore very appropriate to make the womb go down," wrote Aretaeus. Asphalt, sulfur, and pitch are other substances that may be burned, and the smoke used to fumigate a stray womb. The nose and sometimes the ears of the patient were anointed with evil-smelling substances. It is noteworthy that the uterus's sentience was thought to extend to hearing, since loud noises, like clanging bronzes, were used to intimidate a mischievous womb into going back to its normal residence site.

On the other hand, agreeable odoriferous substances were applied to the patient's vulva, on the assumption that this would attract a displaced womb back to its pelvic seat. The woman's genitals would be smeared with the Bacchari of Egypt, a precious unguent prepared with an odoriferous plant, which some think was the *Inula conyza*, called "Baccharis" in honor of the god Bacchus. The English popularly called this plant "the ploughman's spikenard"; it was much appreciated for the aromatic nature of its root, which was the part used in the uterus-luring unguent.[5] Aretaeus recommends

also the cinnamon-like plant called "malabathrum" or "malabathron" (scientific name *Cinnamomum malabatrum*) from India, whose leaves were highly prized throughout the Middle Ages in the preparation of perfumes. If these rare and elaborate preparations were lacking, the patient could be made to sit on a basin containing oils with ground cinnamon or other cheap perfumes. A therapist probably hoped for a uterus that was not overly finicky and would settle with ordinary, undistinguished perfumery.

Mind you, Aretaeus was making these recommendations four or five centuries after the far-fetched Hippocratic asseverations, and long after dissections of human bodies had shown that the uterus is firmly anchored to the surrounding structures and to the pelvic wall by strong ligaments, making movements impossible. Aristotle concluded as much based on comparisons from animal anatomy. It is true that Aretaeus limited the upward motions of the womb to the level of the breastbone, reaching as far as the liver on the right side and the spleen on the left. The uterine ligaments, he thought, could be stretched to that extent "like the sails of a ship"—a considerably more modest claim than that of the Hippocratic authors, who saw no reason why the restless womb could not climb all the way to encroach upon the structures of the head!

Medicine in Hippocratic times has been compared to a medical Renaissance, because the old animistic beliefs were being discarded; disease was no longer attributed to the malfeasance of evil spirits, but to natural causes. It is the glory of the Hellenic world that here, before any other Western region, disease was looked upon as explainable and medicine

transformed from a magical practice into a *techné*, a Greek term that may be translated as both "art" and "science."

However, experience shows that blind beliefs, prejudice, and fanaticism flourish side by side with the progress of science. It has even been argued that the more scientific and technological progress is achieved in a society, the more will people feel the need to turn to irrationalism, sorcery, and "the occult." The classical Greco-Roman era was no exception. Together with the strides of rationalism in medicine, there was a burgeoning of healers, exorcists, and professional magicians who applied nonmedical techniques to stop the depredations of a wandering womb.

The incantations and exorcisms used by magicians to expel demons or evil spirits have been compared to the practices devised to stop the pernicious ramblings of a womb out of control.[6] Both sorcerers and physicians used similar methods, such as fumigations, loud noises, and exposure to repellent or pleasing odors. Physicians did this in the belief that such stimuli would compel a mobile organ to change its site; magicians thought such actions could attract auspicious gods that would expel the evil demons. Commonality of methods in medicine and sorcery suggests that the ancients saw the uterus both as a sentient animal with desires, and as a supernatural, otherworldly being. Starting in about the fourth century, the notion was added that this supernatural creature could act maliciously; not only crowding the organs of the body, but actually biting, chewing, cutting, or poisoning the woman's inner organs.[7] This explains the urgency to carry out expelling incantations and exorcisms.

The vaginal speculum, which allows at least a partial look at the uterus, was not perfected until the nineteenth century, when it was received with exaggerated acclaim. (It was "to diseases of the womb what the printing press is to civilization," and "what the compass is to the mariner," among other equally hyperbolic praises.)[8] But physicians of antiquity had at their disposal rudimentary contraptions that would have allowed them a view, albeit difficult and incomplete, of the uterus. They would have seen the *os uteri*, the mouth of the cervix, i.e., the part of the womb that protrudes into the vagina. They would have known that this part is fixed, not mobile. Therefore, to accept that the uterus moved all over the body required a belief that the body of the uterus disconnected itself from the cervix and went out on its mischievous perambulations, at the end of which it would return to reattach itself to the cervix. The Hippocratic writers never developed a general theory to explain how this could happen.

It seems incongruous that such a mind as Plato's should have accepted a physiology so full of absurdities. At least one scholar has said that the text in which the illustrious philosopher first denounced the womb's Wanderlust (see below) should receive an alternative interpretation.[9] However, Plato, although unquestionably an intellectual giant, was a man of his time, and it is difficult to know to what extent he was influenced by deep-rooted beliefs and received ideas of the society in which he lived.

The notion of uterine mobility is generally traced to a section of Plato's *Timaeus* (91b–e). In this narrative, the gods, intent on infusing human beings with sexual desire for each other, make the male and female genital organs willful animals

in their own right.[10] The uterus is "like a living animal (*zôon*) desirous of childbearing. When, in spite of a favorable season, the womb remains sterile a long time, it becomes dangerously irritated; it is agitated in every direction within the body, obstructs the passages of air, impedes breathing, and puts the body in the worst anguishes, causing all sorts of maladies" (*Timaeus* 91c). Therefore, the reason for the uterus's restlessness is, in essence, its desire to become impregnated. It hankers after the male seed; for Classical Antiquity the main goal of the female body was reproduction. The male body, in contrast, was never considered from this exclusive perspective.[11]

The male sex organ was also created as a self-willed, wanton animal. There is no equivocation. Plato's *Timaeus* is explicit: the penis, too, was a *zôon* "deaf to the voice of reason and carried away by furious appetites." But the phallus promptly disappears from Hippocratic discourse. No more is heard about its beastly nature in Hippocratic pronouncements.

Yet the animal comparison touched a sensitive nerve: endlessly reiterated examples prove that the human male has been dragged into ruin, disgraced, dishonored, and in countless ways irremediably wrecked by the "furious appetite" manifested in his genitals. The image of a self-willed animal is illustrated in the following anecdote recounted by Tallemant des Réaux (1619–1692). An Italian man goes to confession. The priest, alarmed at the confessant's recitation of his overabundant examples of sexual promiscuity, admonishes him severely: tells him, in no ambiguous terms, that his behavior in this life is sure to earn him eternal punishment in the next. At the end of his remonstrance, seeing that his words appeared to have made an impression, the priest asks the sinner if he is

going to mend his ways and embrace a life of moderation, and continence. The man says, with a contrite air: "Yes, Father," and then, pointing to his genital area: "But now, you talk to this beast!" (*Ma parlate a questa bestia!*).

Only the uterus was consistently and enduringly identified with an animal in the ancient world. If recalcitrance, contumacy, and waywardness were the determining criteria for this designation, surely the male organ deserved the animalistic reputation many times more than the womb. But society was organized as a patriarchy and saturated with misogyny. This probably explains the pervasiveness of the idea of the bestial nature of the uterus in the ancient Mediterranean world. But what species of animal was it? A free-roving creature suggests a rodent: a mouse, perhaps? Haply the womb, moving along bodily passageways which the Greek called *phlebes*, was like one of the numerous burrowing mammals that ramble, like the mole, in their neatly crafted underground tunnels? Not so: the metaphor that evolved in the Greco-Roman cultural milieu linked the uterus to a marine animal: the octopus.

This makes perfect sense. For in man's imagination, woman and the sea appear joined from time immemorial. One of the hoariest, most venerable metaphors describes woman as life-giving, like the ocean. She is, like the ocean, eternal, unconstrained, mysterious; creative and destroyer at one and the same time. Woman is yielding and flowing, like water; yet, also like water, strong enough to wear the crags away. Camille Paglia, who had many (and often disturbing) things to say about the identification of women with nature, wrote that "woman's body is a sea acted upon by the lunar wave-motion . . . her fatty tissues are gorged with water,

then suddenly cleansed at hormonal high tide."[12] It is thus not surprising to find that the ancients equated the uterus with a live being from marine life. The octopus evokes the humid nature of the uterus, which, the ancients believed, was always in quest of liquid matter: blood, semen, or the clear, watery amniotic fluid in which we are all harbored before we are born. Its many tentacles suggested the ease with which it displaced itself with undulating motions in every direction, whenever assailed by the desire to wander.

An erudite classicist, Véronique Dasen, has described ancient talismans worn by pregnant women to protect them from harm during childbirth.[13] One of these was an intaglio carved in red jasper that shows on one side the uterus in the form of an octopus, surmounted by a scarab. In Hellenized Egypt, this insect represented the sun. The rising sun was a clear allusion to the process of birth, in which the newborn emerges from the dark maternal enclosure, as does the sun from its nightly confinement at daybreak. In the talisman, the scarab directs its legs toward the octopus, as if to facilitate the emergence of the fetus from its uterine enclosure. Above these images, three kappa letters, KKK, allude, according to Dasen, to a magic invocation supposed to protect the pregnant woman against the pains of childbirth. Leaving no doubt that the talisman refers to parturition, its opposite face shows a naked woman sitting on an obstetrical stool, and firmly holding the grasps with which it is provided. The meaning is clear: this is the moment of delivery (fig. 1.1).

Medical authorities, for their part, reinforced the link between animality and the womb. Herophilus of Chalcedon (335–280 BC) compared the uterine lower part (cervix)

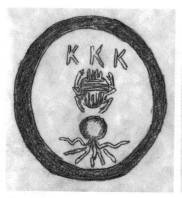 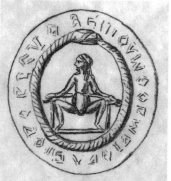

Figure 1.1

Gem-amulet in red jasper, found enchased in a ring. *Left*: the scarab appears to draw its legs toward the octopus, which represents the uterus. The octopus is unrealistic, having only seven tentacles, thought to represent the seven "teeth" of the lock that kept the uterus hermetically closed, except during menses, during conception, and at delivery. *Right*: The opposite face of the amulet shows a woman sitting at the delivery stool, grasping its handles. The Ouroboros, or snake swallowing its tail, encircles the scene, meaning that the parturient woman is now in a "protected" space. Redrawn from Véronique Dasen, "Métamorphoses de l'utérus d'Hippocrate à Ambroise Paré," *Gesnerus* 59, no. 3–4 (2002): note 11. Credit for drawing: Wei Hsueh.

to the head of an octopus. The resemblance was not only in form, but in consistency. The *cervix uteri* of young virgins was said to feel relatively spongy; but, according to Soranus and Herophilus, in women who had given birth it became tougher to the touch, like the head of an octopus. Galen, writing about four centuries later, stated that the uterus, like the tentacles of the octopus, was provided with suckers, or "cotyledons" (the word comes from the Greek *kotyle*, a cup or a hollow vessel) whose role it was to fix securely the placenta

to the inner uterine lining. In support of this asseveration he quoted Hippocrates, who in *Aphorisms* (V, 45) declared that abortion in the first trimester of pregnancy in an otherwise healthy woman is caused by an excess of mucus on the cotyledons. Presumably, this makes them slippery, thus unable to retain firmly the embryo and the placenta, which are easily detached and slide off by their own weight.

Aristotle accepted the presence of sucker-like formations in the interior of the womb, with "their concavity toward the embryo, their convexity toward the womb." He considered these structures as repositories of blood to nourish the fetus.[14] Earlier physicians, like Diocles of Carystus (c. 375–c. 295 BC), had proposed that the inside of the uterus had protrusions shaped like nipples, whose function it was to accustom the fetus, ahead of time, to suckle from the maternal breast. Add to this that the word for "tentacle" was also used to designate the Fallopian tubes or other uterine adnexa; that octopus meat was recommended by physicians as therapy for various gynecological maladies, notably for infertility; and that in the religious ceremony called "amphidromy," celebrated in honor of the newly born (never before the fifth day after the birth), octopus meat was customarily brought to the mother; add all this, and the symbolic link between the uterus and the octopus will appear undeniable.

On the other hand, the human imagination will not be easily contented; it demands a variety of representations, and must ever create new ones: such is its nature. The uterus has also been represented as a winged creature. In the year 1623, the famous painter Peter Paul Rubens received as a gift from an antiquarian friend four engraved gems, among which was

one that had an incised figure of a uterus standing on a base and furnished with butterfly wings. Presumably, this object had come from the ancient Hellenic world, although experts had reasons to doubt its authenticity. Rubens was so delighted with this gem, and with the figure engraved in it, that he sketched it on the margin of his letter of thanks to the friend who offered it to him.[15]

Uterus as butterfly is an uncommon figuration, but a birdlike resemblance presents itself naturally to the mind. The somewhat pear-shaped contour of the uterine body and cervix could pass for the body of the bird; and the structures known by the descriptive name of "broad ligaments"—big membranous folds of peritoneum that serve to anchor the uterus to the walls and floor of the pelvis—arising from the right and left sides of the uterus look strikingly like the extended wings of a fowl (fig. 1.2).

It is perhaps no coincidence that the folklore of many countries made the stork the means of conveyance for the newly born arriving into our world. In the realm of imagination, birds are, like fantastic winged creatures, the most suitable transport medium between the world of reality and the domain of the surreal or preternatural. The shaman who falls into a trance and goes to visit a world that we cannot see chooses a mask and disguise of a bird as most appropriate to undertake the perilous journey. It is therefore fitting that we should come into existence inside a bodily organ whose birdlike shape betokens its ability to transport us from the realm of nonexistence into the world of concrete reality.

Another example of uterine zoomorphism is noteworthy. Odd as it may seem, the uterus has been compared to a toad or

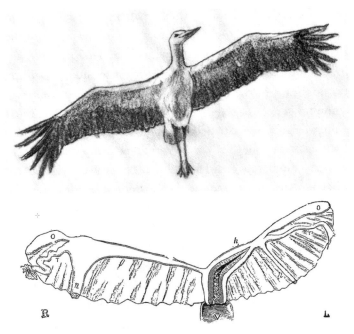

Figure 1.2
Uterus with its broad ligaments attached, reminiscent of a bird with extended wingspan. The specimen shown in the lower figure is anomalous, in that only the right Fallopian tube is patent (*h*) and communicates with the uterine cavity. The left tube is transformed into a solid tissue band and connected with a hypertrophied round ligament (*r*). *O*: ovary; *T*: Fallopian tube; *V*: vagina. From A. Ribemont-Dessaignes and G. Lepage, *Traité d'Obstétrique* (Paris: Masson et Cie., 1914). Bird drawing credit: Wei Hsueh.

a frog. In many countries, churchgoing people used to make gifts to the church, and specifically to the saint of their devotion, in gratitude for deliverance from disease or some form of distress. These votive offerings, or "votives," could be effigies in the likeness of the part of the body that had received the

heavenly-dispensed benefit. Thus, a patient recovered from an ophthalmic disease might bring to the church a figure in the shape of an eye. Such effigies were made of materials ordinary or precious, and crudely or exquisitely executed, according to the means of the offeror. Up to the 1920s they were still common in Bavaria, Germany, where scholars have identified a number of votives shaped like frogs or toads. These objects went back for about 500 years,[16] and reportedly were used for uterine complaints only. Some of these votives were somewhat like tortoises. Some had flattish bodies, four limbs, and a socket or pedestal attached to their hindquarters, presumably because they were supposed to stand upright (fig. 1.3).

To compare the uterus with a toad does not make sense. Morphologically, the resemblance is faint and evoked only after vigorous effort of the imagination. A fanciful scholar proposed that frogs, once skinned and ready for cooking, reminded cooks of the shape of the uterus of the animals they habitually saw, such as deer, sheep, and cattle.[17] This explanation seems a bit forced. The idea of the batrachian nature of the uterus must have been arrived at through the often untraceable, labyrinthine byways followed by human imagination. This is suggested by an old legend in which womb and amphibian are linked. It is told in Jacobus Voragine's famous compilation of lore about the lives of the saints, *The Golden Legend*.

A LEGEND OF THE UTERUS AS BATRACHIAN

According to this legend, the monstrously cruel emperor Nero, after ordering the murder of his own mother, Agrippina,

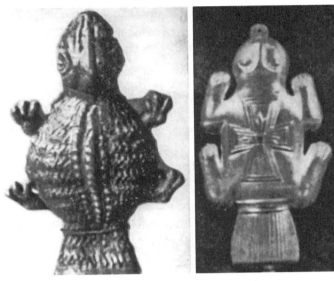

Figure 1.3
Toadlike votives. *Left:* From E. Holländer, *Plastik und Medizin* (Stuttgart: Ferdinand Enke Verlag, 1912). *Right:* Silver votive, with a cross on the back. From R. Kriss, *Das Gebärmuttervotiv* (Augsburg: Benno Filser Verlag, 1929). Both images were reproduced in Alfred Plaut, "Historical and Cultural Aspects of the Uterus," *Annals of the New York Academy of Sciences* 75, no. 2 (January 1958): 389–411.

went to witness her autopsy. A tradition maintains that he was obsessed with the mystery of generation, particularly his own. He commanded to be shown the interior of Agrippina's body because he wanted to know "where he had come from." The court physicians reproached him for his lack of filial sentiments. They told him it was contrary to nature's laws to have ill-used the woman who bore him in her womb for months, then suffered great pains in bringing him forth to the light. His

imperial majesty did not know, they said, how much a woman suffers in bearing a fetus, then delivering it as a child. Nero retorted that he, a divine being, would be no lesser than any human being, be it man or woman, including his mother. He wished to be able to conceive, carry, and deliver a child, just as his mother had done. No one would dare say, afterward, that he did not know what the pain of childbirth was. The physicians replied that this was impossible. But Nero countered with a most persuasive argument: either they would see to it that he, Nero, gave birth, or they, in their turn, would be put to death amid atrocious tortures.

Aware that his imperial majesty was not in the habit of joking when he announced planned brutalities, the medicos quickly devised a plan. They made him drink a potion which contained an embryonic toad, and saw to it that this creature should be maintained alive inside Nero's stomach. That the immature batrachian was not digested by Nero's gastric acid secretion should surprise no one. First, because in the world of legend physiology enjoys little authority; and secondly, because this was the time when physicians were also philosophers, and philosophers were often magicians. It so happened that in Nero's court there were accomplished Chaldean magicians who knew how to feed the amphibian retained in Nero's stomach, and to ensure that it should grow and develop unharmed. So well did they manage to do this that the toad and the imperial gastric sac grew together, simulating pregnancy.

At length, however, severe gastritis supervened. Nero's belly was now inflated to a degree that caused the ruler unbearable pain. He asked the doctors to free him from his intolerable burden. The physicians obliged. They gave him

an emetic, and out came the toad. It was a repugnant sight, indeed: warty, deformed, covered with mucus, and streaked with blood. "Is this how I looked when I was in my mother's womb?" asked Nero, horrified. "Yes," answered the physicians, adding that the unsightly appearance was due to his having interrupted the pregnancy before it reached term. Nero, despite his repugnance, could not discard the feeling that anything concerning his person was sublime, exalted, and divine. The ugly product of conception was, after all, *his* fetus. Therefore, he would not have it destroyed. He ordered that it be locked up in a vaulted room, there to be fed and taken care of. "But these things," reads the *Golden Legend*, "are not recounted in the chronicles, because they are apocryphal." (A candid confession! By implication, everything else in the book of holy miracles was strictly veridical.)

Meantime, the Romans rebelled, having had enough of Nero's diabolical cruelty. Matricide was bad enough. But to set the whole of Rome on fire and to watch the devastation while declaiming verses from the *Iliad*? The Senate declared him an enemy of the people, and sent guards to arrest him. When he found out what kind of punishment the senators had in mind for him, his knees gave way. His head was supposed to be put in a wooden fork, and his stripped body flogged until he died. His fondness for Greek literature did not help him in this difficult pass. He was known to constantly declaim verses of lamentation, and rhetorical perorations lauding suicide as a manly way to exit life when great adversity threatens to take away personal dignity. But it was one thing to recite things his Stoic teacher had taught him in his youth, and another to put them into practice. He just could not summon the

courage to take a short cut out of this lowly world. Suetonius and other historians describe how he urged his secretary and other assistants to kill themselves first, just to set him in the right mood by their example. At last, when the mounted centurions were coming close, and Nero and his men could hear the noise of the horses' hooves, the emperor prevailed on a servant to plunge a dagger into his throat. The *Golden Legend* differs from this version in stating that Nero killed himself with a cane whose tip he sharpened with his own teeth! The soldiers broke in when Nero was about to breathe his last. One of them tried to staunch the bleeding with his cloak. Nero muttered: "Too late, too late. . . . Ah, but what fidelity!" These were his last words.

The rebels found the toad in the vaulted room where it had been kept. The legend says that they chased it out of the city, although it is hard to picture a toad leaping for dear life ahead of a raging mob. In the end, they caught it and burned it. The legendary narrative closes by informing us that the place where the toad or frog had been kept has since been known as "Lateran," and that this name memorializes the imprisonment of the innocent amphibian, because it comes from *latens rana*, Latin for a "latent frog."[18]

THE GRADUAL DEMONIZATION OF THE WOMB

With the advent of modernity, the uterus stopped moving. We no longer hear about its fluttering like a butterfly, soaring like a bird, undulating like an octopus, or leaping like a frog. The progress of rationalism and the ever more frequent practice of anatomical dissections did away with the absurd notion of

the womb as self-willed animal. But this organ lost none of its mystery and fascination. The generation of a human being is an amazing biological phenomenon, which none but the unreflective could look upon without marveling. The uterus, as the place of the new being's conception and early development, has been called the cause of all the happiness, but also of all the misfortunes, of humankind. In medicine, it was traditionally associated with countless ills. Physicians of the past quoted Hippocrates as saying: "the uterus is the cause of all the maladies of women" (*uteri omnium morborum causae sunt*).

Historically, a profound ambivalence has pervaded the medical mentality with respect to this organ. In the seventeenth century, a Spanish physician, Gaspar Bravo de Sobremonte (1603–1683), court physician, Knight of the Order of Calatrava, and professor at the University of Valladolid, rhapsodized about the uterus in the most exalted tones. His extremely prolific writings (mostly in Latin) contain more than one laudatory mention of this organ. He defended the biological and ontological parity of woman against the Aristotelian idea—still viable in his time, albeit weakened—that woman is a "frustrated," incomplete, or imperfect form of man. In his *Opera medicinalia* (1671), in one of his *Disputationes* (1679), and other works, he discusses hermaphroditism and declares he is convinced of the impossibility of one sex transforming into another. Such a phenomenon he calls "poets' figments" (*poetarum figmenta*). In the course of his dissertations he alludes to the womb as the noblest part of woman, an almost divine spark from which are drawn the most recondite treasures of nature. It is like a feracious field that receives the seed of man and of woman (the idea that the

female's *testiculi*, as the ovaries were then called, elaborate a "female seed" or female sperm, was generally accepted), all this expressed amid laudatory rhetorical flourishes.[19]

In striking contrast, one of Sobremonte's contemporaries, the erudite Dutch physician Isbrand van Diemerbroeck (1609–1674), wrote in his work *Opera omnia antomica et medica* that the female genital organs involve the women in a thousand miseries, and destroy men in a thousand ways. For these organs

> sank into ruin emperors most powerful and august; turned the sage and the learned into ignoramuses; seduced the most prudent; threw the hale into the misery of pitiful maladies; consumed plenteous patrimonies; debased the strongest heroes; robbed the most holy prophet David of his reason; pushed the most wise King Solomon into idolatry. Because of these organs, the cities of Sichem [written *Shechem* in the Hebrew Bible] and Troy were destroyed, and many kingdoms were devastated. . . . On the other hand, [the genitalia] of woman are sometimes considered beautiful, whereas there are none more revolting in her whole body; for these are parts naturally infect and filthy, full of rottenness, continuously dirtied with abundant urine, whence putrid and mephitic odors exhale. So unworthy to be seen are they, that nature buried them in the most recondite and despicable site, very close to the anus and the feces, thus constituting, in a word, the cloaca of all colluvies,[20] where every species of foulness drain.[21]

After this fierce, baroque invective, our author waxes philosophical and tells us the wherefore of this unfortunate disposition of the female genital system. It was appointed that here, in this contemptible place, should be "formed, shaped, and ripened that most superb animal that shortly shall rise to

heaven—man—so that he should remember his most abject, sordid, and stinking first domicile." This way, man should never inflate his pride to the point of raising his head against the Creator, but instead "admire, humble and abased, with due veneration, the divine grandeur and majesty." For only by addressing his supplications to the incommensurable divine clemency might he hope to obtain a blessed place of rest for his soul in heaven. Plenty of writers of homilies and philosophical works have used this same trope: the "bad" anatomical position of the uterus, between the organs that store urine and feces, is the way Divine Providence reminds us of our lowly, paltry origin, and admonishes us against becoming too proud.

About a hundred years after Sobremonte's and Diemerbroeck's effusive dissertations, Europe was well into the historical period justly called the Enlightenment. Obscurantism receded before the resolute advance of science, and superstition kept losing ground to reason's headway. All of which did not impede misogyny and ignorance from continuing to spin absurd notions about the uterus, as shown by a curious controversy that took place in the illustrious University of Bologna, the oldest institution of learning in continuous operation in Europe. This academic dispute came to be known as the debate of "the thinking uterus."

THE UTERUS AS "THINKING ORGAN," OR DO WOMEN THINK WITH THE UTERUS?

Toward the end of the year 1771, a Doctor Petronio Zecchini (1739–1793), who taught anatomy at the University of Bologna, anonymously published a little book with a pompous

title that may be translated as "Genial Days Dedicated to the Dialectic of Women Reduced to Its True Principle" (*Dì geniali della dialettica delle donne ridotta al suo vero principio*). The book caused a scandal in the little world of Bologna's university faculty, as its main thesis was that the "true principle" of feminine "dialectic" is the uterus. What does this mean? "Dialectic" is a term in philosophy rich in meanings, but in general it denotes "a form of reasoning" (traditionally, by weighing and trying to reconcile opposing arguments). In the past, it was often used with the simple meaning of "logic." Philosophers have since annexed various different connotations to this word, but it retained its primary meaning of thinking and exerting discernment. Therefore, the title of the book could be written as "The thinking (or reasoning) of women reduced to its true principle," and this "principle" turns out to be the womb. The sense of the main thesis developed in the book was inescapably clear, namely: *women think with the uterus*. The author explains that, to be precise, he meant that the troubles originating in the uterus had ample repercussions in the intellectual capacities of women, and that here resides the fundamental difference between the thinking processes of men and women.[22]

Zecchini's book is brief; it consists of an introduction, eight chapters, and a conclusion. The style is affected, pompous, and saccharine; the tone, condescending toward women; and, although the author is presumably setting forth a theory of physiology, no major physiological or medical works are cited: the chief references are to poets and philosophers.

The difference in the way of thinking of men and women, we are told, has to proceed from a principle that contains in

itself "the sufficient reason of all the phenomena of the feminine mind." If such a principle exists, continues the pedantic professor, it must have been put in women by nature. Therefore, it must be present in all women, without exception. "I am not saying that you think badly because you think in your own way," he is quick to add, always blarneying his female readers; "of course not; for we do not blame the things that are made in accordance with their end. Those things are perfect in their kind, precisely because they are not different from what they ought to be."

Next, the author strives to demonstrate that the difference between the "natural dialectics" (i.e., logical thinking process) in men and women does not reside entirely in the mind. The mind is the same in both: in both equally able to distinguish right from wrong, or truth from falseness. But there is something in every body that imposes limits. In women, this is "a motor sufficiently strong to agitate their imagination and confuse their ideas." This something, this "motor," is purely corporeal, that is, alien to the mind. And to those who think the mind is always the leader to which the body pays obeisance, our author addresses the trite metaphor of horse and rider. Take two riders of equal deftness, but put one on a tame and docile trotter, and the other on a frisky and bizarre bronco. The former will advance at a sure pace, unfailingly obeying the commands of reins and spurs; the latter, in contrast, will jump erratically, and try to shake off the weight that it bears on its back. If the two riders are of the same horse-riding ability, why is it that one rider arrives punctually at his destination, while the other finds himself thrown to the ground in the middle of the road? The difference resides entirely on the steed.

The conclusion was predictable: the rider is the mind; the horse is the body. Our author thus pontificates: "man is the first rider, woman the second." The feminine body dominates the mind, whereas man's mind dominates the body. This leads the author to a discussion of the mind-body relationship according to concepts prevalent in the eighteenth century.

Next, the author sets out to demonstrate that one part of the body, more than any other, may dominate the mind. Here, he resorts to clinical examples. One man is grouchy because he digests poorly; another one melancholic on account of liver disease. "Conclude yourselves if in the first one it is the stomach who thinks, and in the second the liver," writes the professor. He goes on to propose that there are individuals whose actions depend on the gall bladder, and others on the spleen. By the same token, there are cardiac thinkers, and intestinal thinkers, and so on. This line of reasoning is capped by a grotesquely satirical proposition: "Those who suffer of hemorrhoids think with their hemorrhoids. They are anal-thinkers, the thinkers of the anus" (*pensatori del podice*,[23] says the Italian text).

The sixth chapter's title is: "That the Predominant Organ in Women Is Not the Brain." Zecchini declares that he is not concerned with the role of this organ in generation: "I only stop to consider the moral force by which it dominates the mind, and I honor it with the sublime title of *thinking uterus*." Finally, in the last chapter, Professor Zecchini explains why the uterus is uniquely apt to discompose the woman's reasoning faculty. This organ is the site of a rich innervation; it is constantly receiving impulses of extraordinary vivacity. Therefore, it is an organ that lives in "a state of constant

irritation." Moreover, the nervous network extends from the uterus to all parts of the organism. The theory was that the wild nervous impulses that reach the uterus are "capable of upsetting the whole animal economy, and reducing hysterical women to spasms, convulsions, deliriums, and deadly anguishes." Is this not like a modern version of the uterus as a disorderly, agitated, mobile organ, a theory in which no one believed anymore?

In summary, Zecchini concludes that women possess a capacity of reasoning equal to that of men, but limited and confused by influences stemming from their predominant bodily organ, the uterus. As a necessary corollary, women would do well to forsake engaging in any endeavor that demands an equilibrated judgment and a constant, sober "dialectic" (by which we are to understand logic and discernment).

The scandal over Zecchini's thesis had barely started when a second book, also written anonymously, saw the light. Its purpose was to refute, one by one, the arguments developed in the first work. The undisclosed second author was Zecchini's colleague at the University of Bologna, Germano Azzoguidi (1740–1814). His book, consisting of only 59 pages, was written in French, the lingua franca of intellectuals at the time. It adopted the epistolary style, under the pretense of being the correspondence that an imaginary "Madame Cunégonde" addressed from Bologna to her friend, an equally nonexistent "Madame Paquette," residing in Paris. It is noteworthy that these two names, Cunégonde and Paquette, correspond to female personages in the famous novel *Candide*, by Voltaire, where both are depicted as women abused by men in a variety of ways, not excluding physical violence. Flattered and

cajoled while young and pretty, they are neglected or despised once their beauty is gone. They must display uncommon astuteness and a truly Machiavellian talent in order to ferret out a decent post in society and some comfort in their late years. At least, this is a point that Voltaire tries to make in his celebrated novel.

The title of Azzoguidi's book, cast in the wearisome prolixity then in vogue, is *Letters of Madame Cunégonde written from B to Madame Paquette at F . . . on the occasion of a book that bears the title of Genial Days Dedicated to the Dialectic of Women Reduced to its True Principle*. There is not much worth recounting in this short opuscule with a long title. The two fictitious letter-writers exchange their impressions on Zecchini's idea of "the thinking uterus." More than a serious refutation of this absurdity, the two ladies use irony and derisive comments against the author's ill-conceived ideas and boring writing style.

A truly surprising development was the appearance soon thereafter, in 1772, of a third book that joined the debate.[24] This new volume was a criticism of the two preceding works. Its author was a fascinating and often misunderstood adventurer, proto-feminist, former church cleric, swindler, prison escapee, seducer, translator, amateur mathematician, legendary memorialist, and unquestionably talented writer (now finally anointed by the academic establishment): Giacomo Casanova (1725–1798).

The idea that many people make themselves of Casanova is a caricature. He is usually portrayed as a reprobate seducer whose erotic memoirs are but a compilation of morbid and lubricious episodes. Even Italians are ambivalent about this

man. For he was born in Venice but wrote in French, lived a good part of his life in Paris, roamed indefatigably through Europe, and went to die in a remote rural part of what is now the Czech Republic. Today, however, he is recognized as a remarkable individual, in many ways representative of the eighteenth-century society in which he lived; and his memoirs are acknowledged as a superb portrait, framed in 3,700 autobiographical pages, of that society.

Casanova visited Bologna during his second forced exile (once again he had escaped from a Venetian prison). He read the books on the "thinking uterus," and felt prompted to participate in the debate. Those unacquainted with Casanova's literary *œuvre* would no doubt be surprised by the profound erudition, often to the point of being tedious, which the famed seducer displays. He mentions past authors who tried to "explain" the different style of reasoning of women. Among these is Valens Acidalius (1567–1595), a physician, who published in 1595 a book which proposed that women are not reasoning animals, although he claimed that the author of this book had been merely the copyist of a work which had previously appeared in Poland. The book became quite popular. Translations and variants continued to be printed for many years; one, as late as 1766, entitled *Paradox of Women, Wherein It Is Attempted to Demonstrate That Women Are Not Part of the Human Species*.[25] Casanova says that this book was intended as a piece of humor, but many scholars took it seriously, and wasted time and effort refuting it. Simon Gediccus, or Gedick (1551–1631), a German theologian, was among those who failed to perceive the humor and undertook the defense of women. As for the Bolognese book causing the "thinking

uterus" debate, Casanova says pungently, nothing in it compels laughter, "unless it be the ineptness of its author."

Casanova's criticism of Zecchini's book is firm. If the uterus is not literally the thinking organ, but "the organ that makes women think," the Bolognese professor could just as well have said that the lungs make the voice, not the larynx or the glottis; and that the bellows make the sound of the organ, not its pipes. But, even if we accept that women's thought processes are different from men's, what compelling reason determined the would-be philosopher to search for the explanation in the entrails, and not in the mind? A woman who adopted his thesis might say:

> If nature formed me, insofar as thinking being, different from man, it follows from this that the sperm shall have the same effects in man, and shall constrain him to think in a certain manner, to let himself be conducted by spermatic thoughts, and to think in an entirely particular way, different from that of woman. . . . The conclusion will thus boil down to saying that man thinks as man, and woman thinks as woman, *Peter dances better than Jack, Jack dances better than Peter, and both dance quite well.*[26]

Considering the repressive patriarchy and widespread misogyny of the eighteenth century, it is surprising to see that the quondam Venetian philanderer put forth statements infused with a remarkable feminist spirit. Thus, the following asseverations are found in various sections of *Lana Caprina*:

> The education and the [social] condition of woman are the two causes that that make her different from us in her system; and

education and the social condition are the two causes that render us different from woman in our reasoning.

Man has everything in his power, and woman possesses only what man gives her: this is why woman is dominated more by avarice than by lasciviousness, and man quite the contrary. It is rather banal to see that a pretty girl ruins an avaricious man, but it is extremely rare to see a woman ruined by a handsome boy. And when this happens, the influence of the uterus is not evident.

If women give themselves to some extravagances, it is because their nature, weaker than ours, is made still weaker by their education. In spite of this, it would be easy to demonstrate that they do in the world a lot more good than men do, and much less evil; and that, when their uterus acts up, they become agitated, irritated, and deserving of our pity.[27] But that it should influence her thinking faculty is no more credible than an influence of sperm upon the nature of the soul.

The condition of women would have been exceedingly painful if, apart from the inconveniences that they suffer in consequence of our despotism, of the weakness of their sex, and of the duties that nature and the family impose upon them as soon as they enter into civil society, God had endowed them with an internal animal, called the uterus, which not content with its many whims of material nature, still wanted to become master of their head.... If things were really like that, it would be good to decide that they are not really of the same nature as men, but that they represent an imperfect production of nature.

Certain forms of mental dysfunction seen in women were popularly known as "vapors," "spleen," "English malady," and,

of course, "hysteria." At the time, an organic base was being searched for these illnesses, and the most progressive medical opinion favored a preeminent role for the uterus as cause of these mental health problems. Thus, Zecchini's thesis was perfectly well aligned with the dominant medical doctrine of the times, except that the Bolognese professor grossly exaggerated it and tried to make it into an "explanation" of the normal function of feminine intelligence. It was Casanova's undisputable merit to have emphasized that the cause of both normal and pathological female mental activity was to be found not in the organic constitution of the female body, but in the way women were educated and in the countless conflicts to which their social situation constantly exposed them.

WOMB AS MODERN AND POSTMODERN ORGAN

The "vapors" was a unique form of pathology that the best medical minds of the Enlightenment could not pin down. That it was a neurosis somehow related to the uterus, most members of the profession would readily admit. Some physicians treated it with charitable solicitude, others with rude bluntness, according to their individual temperament. Then, as now, some doctors were rough or uncaring, others sympathetic and sensitive. Among the former species was the famous Dr. John Radcliffe (1640–1729), whose exalted position he took as permission for incredible breaches of etiquette. One time, having been urgently summoned by special messenger to St. James's Palace to take care of the Princess of Denmark, whom he knew for a sufferer from "vapors," he answered that he would visit her the next day, and added: "Tell Her Royal

Highness that her distemper is nothing but vapors. She's in as good a state of health as any woman breathing, only she can't make up her mind to believe it." In any case, vaporous maidens continued to be pale, and to swoon at the drop of a hat; or rather, at the drop of their suitors' affection, or any of numerous other important life events.

The era of Enlightenment went by, and the world saw the advent of the Industrial Revolution, with its attendant train of jaw-dropping technological innovations. As to medical attitudes, it is fair to say that the uterus was no longer overtly zoomorphic in the minds of medicos, but the idea of the womb's animality persisted somehow, as evidenced by official pronouncements such as this one, found in one of the most influential American textbooks of obstetrics published toward the middle of the nineteenth century:

> Plato said "the womb is a wild beast that obeys no law, but which, when its desires are unsated, wanders about within the body, and excites all sorts of irregular motions." Now, it must be admitted that this picture of the womb is true, not only in outline, but in every particular, physiologically considered. . . . The ancients entertained very significant notions of the controlling influence of the uterus over other organs of the animal economy, and appreciated the truth in the aphorism promulgated by Van Helmont in the 17th century: "*Propter solum uterum est mulier id quod est*" [Because of the uterus only the woman is what she is].[28]

Together with such residues of unabashed misogyny, nineteenth-century medical doctrines undertook an astonishing exaggeration of the physiological importance of the uterus.

A professor of medicine in New Haven could say, addressing the members of a medical society, that "it seemed as if the Almighty, in creating the female sex, had taken the uterus and built up a woman around it."[29] The womb was conceptualized as the center from which nervous impulses radiated to the whole of the organism. A uterine aberration might seem inconsequential—say, a mild retention of menstrual flow—but it could start a chain of reactions that, upon reaching the nervous system, provoked profound derangements throughout the organism, not excepting remote organ systems. Thus, to nineteenth-century medical practitioners, palpitations, tiredness, asthma, and hemoptysis (coughing up blood) could be chest complaints echoing a primary uterine pathology. Especially severe were the nervous system manifestations, which included convulsions, catalepsy, melancholia— "even mania," says a medical author emphatically; and, of course, the epitome of all uterus-generated illnesses, the affliction named after this very organ: hysteria.

Hysteria, magnificently explored by Professor Jean-Martin Charcot (1825–1893) in that "asylum of misery" (his own words) that was the Salpêtrière, the giant public hospital in Paris, was a disease comprising a number of complex motor and sensory abnormalities, together with the most bizarre neurological symptoms. These could be tics, migraine, epilepsy-like convulsions, catalepsy, contractures, mutism, somnambulism, and a host of other utterly puzzling, often spectacular manifestations. Charcot was elated when he and his followers discovered the so-called "hysterogenic patches," zones on the surface of the body which, when stroked or rubbed, provoked an attack (fig. 1.4). These investigators came to believe that

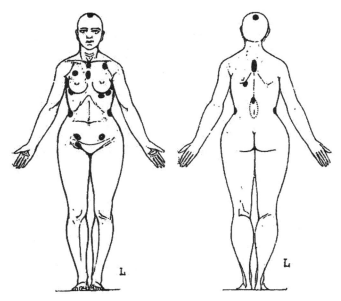

Figure 1.4

Hysterogenic zones. Areas of the body that, when stimulated by touching, pressing, or rubbing, could cause hysteric symptoms or reactions. Once developed, the attack could be halted by vigorous pressure exerted at the same points. According to Charcot, these areas could become erotogenic (causing a "voluptuous tickling sensation") in some hysteric patients. From *Iconographie photographique de la Salpêtrière*, vol. 2 (1878).

they were studying a real disease entity, whose neurological basis (and, who knows, its ties to the uterus?) would be made evident by their labors. Alas, their hopes were dashed. It became apparent that the so-called "hysterical" behaviors of their patients were largely the result of suggestion due to the expectations of the physicians, the suggestibility of the "patient-performers," and the highly theatrical environment in which the demonstration took place.

One of the attendees at those demonstrations was Sigmund Freud, whose admirable theoretical constructs of psychoanalysis later came under attack, pretty much for the same reasons as Charcot's idea.

And thus we come to today's wonder medicine. We now have robotic surgery, molecular probing of disease processes, and genetic engineering, a discipline that suffuses human beings with a feeling of omnipotence, and sends them, in arrogant imitation of the Almighty, puttering about Creation, cutting odds and ends of the genetic endowment of plants or animal species, and tinkering away with the very destiny of the human race. Needless to say, in this advanced, "postmodern" era, there is no place for the crass errors of the past. The uterus as autonomous, wanton animal; the uterus as "principle" of reason and discernment (or of "dialectic," as a pedantic Italian professor once said); and the uterus as fundamental organ, cipher and compendium of Woman; all these ideas are now definitively and irreversibly discredited. In their place, the uterus has become *nothing but* the organ for woman's childbearing function. Like the liver, the spleen, or the kidney, it is part of the bodily machinery. And like other cogs and wheels of the machine, it may be repaired, exchanged, transplanted, replaced, or discarded.

Uterine transplant is already a reality. In 2014, the first child born after uterus transplantation was reported by Professor Brannström's team at the University of Gothenburg, Sweden.[30] A thirty-five-year-old woman unable to conceive received the uterus of a live sixty-one-year-old donor, who altruistically donated her womb out of friendship to the recipient. Four more babies were born in 2015, when the Swedish

team repeated this surgical procedure.[31] There are formidable medical, legal, social, and ethical complexities that must be addressed for this kind of procedure to become widespread; but no doubt more cases will follow, since the need exists, and both live and cadaveric donors may be used.

There is also futuristic talk of doing away with the womb altogether; in other words, cultivating the embryo from the beginning (after obtaining it by *in vitro* fertilization) in an artificial housing, without the need for a uterus at any stage of fetal development. This possibility is still hypothetical, but the word to designate this process has already been created: "ectogenesis"; and some steps conducive to its realization have been taken. Indeed, a "partial ectogenesis" is already taking place, since ever more sophisticated artificial environments, such as incubators ("humidicribs"), miniaturized oxygenators, and other technologies are continually being devised to save increasingly premature fetuses. Make no mistake: these advances have been called "steps toward the artificial placenta" by experts. Although ectogenesis research has been officially banned in some countries, these developments adumbrate the advent of the artificial womb in the not too distant future.

We can see why these alternative ways of human gestation entered the medical scene. Uterine transplant addresses the suffering of an important population of infertile women. About 9.5 million women in the United States alone are unable to bear children due to some uterine abnormality.[32] This may be a consequence of disease, accident, or congenital anomaly (including total absence of this organ). Alternative reproductive methods may be inaccessible or undesirable. Gestational surrogacy is formally prohibited in some countries;

and in some American states the law bars same-sex couples from adopting children. A transplanted uterus potentially furnishes the recipient with the opportunity to experience how it feels to carry and deliver a child. For some women, the gestational part of motherhood may be important. Additionally, in contrast with adoption, a genetic relationship with the child is maintained, which to some families is a weighty consideration. Ectogenesis might be perfected to the point at which it would benefit homosexual male couples, who could then reproduce without having to resort to a maternal surrogate or any other alternative.

These medical advances are commonly deemed good. At least they forebode a time when our lives will be healthier and happier. But, in the meantime, it is hard to avoid the feeling that the womb's venerable rank is being degraded; that this peerless organ is made to seem lower in esteem, and, in a word, cheapened. We already see this happening with uterine transplants, where the womb is not the object of the same deference as other organs. As things now stand, uterine transplant is ephemeral. Because the womb is not essential to life, surgeons remove this organ immediately after childbirth. To leave it longer inside the body of the recipient would require prolonged administration of risky immunosuppressive medication to avoid organ rejection. Therefore, once the womb has accomplished its intended function, out it goes! Rejected and discarded, without the least compunction.

Futurist defenders of ectogenesis assert that this reproductive alternative will liberate women from the burdens of gestation, and will provide the fetus with an environment where "nutrition, temperature, and oxygenation will be perfectly

calibrated for ideal growth."[33] They argue that women are being unfairly censured and punished for exposing themselves to prenatal hazards, such as tobacco, alcohol, pharmaceutical and recreational drugs, often *before* they knew they were pregnant, or when exposure was not their fault, as when coming in contact with secondhand smoke or harmful industrial products. Presumably, the artificial womb would eliminate the possibility of such toxic exposures, and thus create greater "equality among fetuses and future children," all of whom would benefit from optimized gestational environment.

Against such logical, solid arguments, we can only raise this timid remark: that the symbolic significance of intrauterine gestation ought to deserve some attention. For millions of years, since placentation was first evolved, we human beings have come into the world after a several-months-long period of dormancy. This is a sketchy, unripe existence during which we are aquatic beings: we float in a lukewarm, clear liquid, now slowly buoying up, now descending, but always moored to the placenta by a white cord, like a boat firmly fastened with a line to its harbor. The state of lethargy is untroubled by thoughts, images, or dreams: of these our inchoate brain is still not capable. However, it is probably not impervious to some form of obscure, elementary, prerational sensation of being part of another being, indistinguishable from the substance of the womb that encloses us—flesh of the flesh of our mother—whose ceaseless heartbeats we keep hearing, and cannot distinguish from our own.

Before birth, we feel we *are* that womb and we *are* that heart. But, in the deepest strata of the imagination, heart and womb are all one. It is not by chance that W. Tyler Smith,

a nineteenth-century English obstetrician, homologized the uterus and the heart, when he proposed that "the uterus is to the Race what the heart is to the individual, the organ of circulation of the species." In his striking medical-poetical metaphor, the ages are the circulatory channels in which living beings circulate; and human beings constantly pass from the maternal womb into the womb of time. "Parturition is the systole of the uterus; the unimpregnated state its diastole." And we, human beings, are like the minuscule red blood cells of this mighty, cosmic circulatory bloodstream. Dragged by the forces of the torrent that we cannot control, we clash against other beings; and the constant collisions and wear-and-tear will very rapidly destroy us; yet our disappearance will scarcely be noted among the myriads of other circulatory elements quickly annihilated and instantly replaced.

Against the reality of this grim prospect of stress and destruction, we raise the obscure remembrance of a prenatal life untroubled by thoughts, desires, memories, or images. Just so the people of former times, pressed by all sorts of harshness and deprivation, used to raise the dream of a mythical Golden Age when everything was harmony, felicity, and abundance. The ultimate sense of security for us in this life is that which we enjoyed inside the maternal womb. This is the perfect refuge, the definitive sanctuary, the utmost safeguard: warm, snug, loving, and magnanimously unconditional. Like everything perfect, we can enjoy it once only; it admits no reuse. Ectogenesis, we are told, will one day suppress the loving womb altogether. If so, the "Evocation of the Uterus" will become a consoling myth, like that of the Golden Age.

In conclusion, within the rich mantle of myths, stories, and legends that constitute the body fantastic, the segment that corresponds to the uterus is singularly multitudinous and variegated. It is the only organ that has been constituted as an independent being, whose wanton disposition had to be stabilized for the sake of the woman's (and society's) wellbeing. But at the same time, it was recognized as a refuge, an asylum, an emblem of self-protection and all-embracing guardianship for which only one name is fitting: *maternal*. And since maternity naturally extends its protection and tutelage over all who need it, the magical and mythical properties of the womb had to be essentially "sympathetic," as a scholar has pointed out.[34] Sympathetic magic rests on the belief that a link of brotherhood joins all things, and that similar things affect each other across time and space. Thus, Pliny wrote (*Natural History* VII, 7) that to produce an abortion, magicians exposed the patient to the smell of a lamp just put out (it is a shame, he says, that the origin of the proudest of animals could be stopped by so trivial a measure!); to bring forth a menstrual flow, the spell was best buried near a stream; and witches could delay a woman's parturition by sitting in front of her with legs crossed.

Modern science may have relegated fanciful ideas of magic and superstition to oblivion, but the image of the womb looms ever great and portentous in human imagination. In the body fantastic, it truly stands as "the mother of all organs."

2 TO SEIZE THE EXTERNAL WORLD, THE BODY FANTASTIC RELIES ON A STORMTROOPER: THE STOMACH

Great Britain has contributed countless cultural, scientific, and technological benefits to the world. But the British contribution includes also a contingent, probably larger than that of any other country, of unconventional, original individuals, the notorious English "eccentrics." Among them was Robert Stephen Hawker, Anglican priest and poet of Cornwall, best known for having composed *The Song of the Western Man*, a patriotic Cornish song which he published anonymously in 1826. A new Diogenes, he spent a long time in a wooden hut he built himself, always wore bright-colored clothes (black only for his socks), and excommunicated his cat in punishment for "mousing" on Sundays. Another eccentric was John "Mad Jack" Mytton, a Regency gentleman who once came to a dinner "in grand style," riding a bear, to the undisguised terror of all those in attendance. His numerous pets included 2,000 dogs; to those he liked best he fed steaks and champagne. However, most germane to the present discussion is another English eccentric, the Reverend Dr. William Buckland (1784–1856), Dean of Christ Church, eminent

geologist, and "zoophage" extraordinaire. It has been said that his cherished ambition was to carve himself a pathway through life with knife and fork, eating every living animal in existence. In a word, he prized himself on being *the man who ate everything*.

William Buckland obtained scientific credentials as genuine as they were well deserved. He excavated one of the oldest human remains ever found, and was the first person to teach geology at Oxford University. As a lecturer he was immensely popular: his diction was clear, his delivery was lively, and he moved around holding specimens, telling jokes (sometimes racy and profane), and imitating the gait of extinct animals. All this in order to gain a large audience of fee-paying students. The following anecdote, told by one of his students, attests to the fact that William Buckland earned a prominent place in geology and paleontology, as well as in gastronomy and the history of the stomach.

> He paced like a Franciscan preacher up and down behind a long showcase. . . . He had in his hand a huge hyena's skull. He suddenly dashed down the steps—rushed skull in hand at the first undergraduate on the front bench and shouted "What rules the world?" The youth, terrified, answered not a word. He rushed then on to me, pointing the hyena full in my face— "What rules the world?"
>
> "Haven't an idea," I said. "The stomach, sir!" he cried "rules the world. The great ones eat the less, the less the lesser still!"[1]

At his soirées, undoubtedly popular, guests were likely to savor such delicacies as boiled hedgehogs, mice on toast, crocodile steaks, roast ostrich, porpoise, panther, or cooked

puppies. Once, our man was visiting a cathedral and was shown some stains on the floor. The priest told him that according to a venerable old tradition, the spots had been caused by the spilled blood of a saint who had been martyred right there. The omnivorous—or perhaps best termed "omniphagous"—paleontologist, not waiting a second, went down on his hands and knees, licked the flagstones, and solemnly declared: "This is not blood. I can tell you with absolute assurance, this is bat's urine!" (Luckily for him, those were not the times of the coronavirus responsible for the 2020 pandemic and probably originating in bats.) Upon the incontrovertible evidence furnished by his tongue's gustatory papillae, Dr. Buckland had definitively disproved (albeit by a method not easily reproducible) an ancient myth.

Another anecdote has our man visiting Lord Harcourt at Nuneham House in Oxfordshire (the villa still exists, currently a property of Oxford University). The aristocratic host told his guests that he had been able to acquire the preserved heart of a French king. Some say it was the heart of no less than the "Sun King," Louis XIV; others that it was that of Louis XVI, guillotined during the French Revolution. However this might be, monarchical loyalists had managed to save the organ from the fury of the fanatical revolutionists who desecrated and pillaged the royal tombs at the church of St. Denis during the time of the Terror. The mummified organ, reduced by time and embalming to the size of a small nut, was enclosed in a silver locket. No sooner had Buckland seen it than he proceeded to eat it. Before anyone could say a word, the royal heart was deliquescing inside the English professor's stomach, thereby lending reality to the scholar's axiom that it

is not kings, but the stomach, who truly rules the world. Presumably, his only comment was: "I have eaten many strange things, but have never eaten the heart of a king before." Not a word about its taste, or whether the morsel had been worth the deglutition.

Dr. Buckland's son, Francis Trevelyan, better known as Frank (1826–1880), inherited his father's voracious and bizarre tendencies. It has been said that to father and son, "Noah's Ark looked like a dinner menu." Frank's mother was a paleontologist and fossil collector, as well as an illustrator. The father, as noted above, was a man of the cloth. The son, therefore, must have been amply exposed to biblical references, and may have literally interpreted the admonition found in Genesis 9:3: "Every moving thing that lives shall be food for you." But this raises the question of whether William Buckland and his family said grace before each meal. If they did, there seems to be a contradiction between their indiscriminate devouring of all animal species and the act of dutiful religious devotion that preceded each assault. It might have looked as if each wolfish attack was ushered in by a pious disclaimer.

This reservation has been made to the custom of saying grace before meals generally. Charles Lamb expressed it most eloquently: "With the ravenous orgasm upon you, it seems impertinent to interpose a religious sentiment. It is a confusion of purpose to mutter out praises from a mouth that waters. The heat of epicurism puts out the gentle flame of devotion. The incense which rises round is pagan, and the belly god intercepts it for his own."

Anyway, Frank Buckland studied medicine and became a surgeon, but pretty soon his interest in natural history took

him away from surgical practice. Nor did he forsake his father's bequest, the leanings toward eccentricity.[2] As a child, he rode the corpses of dead crocodiles which his father gave the children of the family, instead of hobbyhorses, to play with. Early on, he kept a menagerie of his own. His best-known pet was a bear cub, whom he dressed in the ceremonial cap and gown of Christ Church at Oxford. His guests at his London home, 37 Albany Street, were served porpoise head, boiled elephant trunk, roasted giraffe neck, mice in batter, squirrel pie, horse's tongue, and other like delicacies. A biographer wrote that "his research consisted in eating the animal kingdom." This interesting field of investigation Frank Buckland called "zoophagy." He was also known to take out of his pockets rats and defanged snakes, just to enliven a reunion. Apart from these oddities, Frank Buckland was highly regarded as a lecturer on natural history. More a science popularizer than a hardcore academic, he wrote, among several other works, a treatise on the fishes of Britain, a study of fish hatching, and a four-volume work, *Curiosities of Natural History* (London: Richard Bentley, 1868). He died at fifty-four years of age.

Buckland the Elder was right: the stomach rules the world. The stomach comprises a mighty, universal force that is found ensconced in the abdomen of all animals. Not in vain, great thinkers of mystical bent extolled the power of this organ. The great Paracelsus (1493–1541; formally Philippus Aureolus Theophrastus Bombast von Hohenheim, a splendid name!), physician, full-time alchemist, heterodox preacher, and precursor of medical chemistry, thought that a "vital principle" dwells in us. This he saw as a force that links man, nature, and the universe, and is responsible for the reactions that take

place within living bodies (therefore ultimately responsible for all healing); in sum, a force necessary for the very continuation of life. This ineffable vital force he called the *archeus*. And where did he place it? Not inside the precious brain, as might have been intuitive for the many who consider the cerebrum the supreme ruler of the organism; nor in the heart, despite its enormous prestige as the preternatural pump that drives the vivifying sap to every recess of the body; but, of all places, in the stomach!—to one side of the heart; to be precise, in the so-called "cardiac" orifice of the stomach.

Not too many years later, the Flemish physician-alchemist Jan Baptist van Helmont (1580–1644) made his mark on the world. Although he was considered a disciple of Paracelsus during the first part of his professional life, in later stages he became progressively more critical of the Paracelsian works. Van Helmont was too much of an original, creative mind to bow unreservedly to someone else's ideas. Still, he agreed that the *archeus* is the supreme director of the bodily processes, and that it resides in the stomach. And two centuries later, when medicine had managed to jettison much of its encumbrance of superstition, including astrology, alchemy, and the like, eminent leaders in the healing arts still insisted in proclaiming the supremacy of the stomach. A French physician, François-Joseph-Victor Broussais (1772–1838), developed an extraordinary theory that placed the stomach at the very center of internal medicine. In his view, many diseases theretofore believed to be generalized or systemic from their inception started as local inflammation of the digestive tract, particularly of the stomach, and only later became widespread. Accordingly, he called the stomach "king of the bodily economy";

his ideas were said to establish the "kingdom of gastritis" in medicine.[3] Anyone who understood gastritis could be said to have mastered practically the whole of clinical medicine. Broussais's ideas had a profound, albeit transient, influence throughout the Western world, not excepting the United States of America.[4]

Edward Miller, an American physician, most likely under the influence of Broussais's doctrine, proposed that the stomach had the unique property of attracting all the harmful matter that penetrated into the organism, and that from this focal point the disease-producing factor was disseminated to other parts of the body. The typical example was rabies—or "hydrophobia," to use the term then current. The stomach, asserted Miller, was the first part affected; "noxious powers" attached to its surface and attracted the disease-causing elements immediately. The identical mechanism operated in other diseases. "Miasmas, contagions, and poisons" (this was the time before bacteriology) could enter the body via the nose or the skin pores, as in smallpox, or inserted by the bite of a sick animal, as in rabies. The stomach, "most movable and associable of all the organs," was the first to experience the harmful influences, and from here the disease spread out thanks to the "wide range of sympathies" that this organ enjoyed with the rest.[5]

On a grand biological scale, scarcely can we think of an organ more important than the stomach. Forget the brain or the heart; as to the former, experience in the world persuades us that the minimal amount of gray substance compatible with life is truly minuscule: in this regard, the British writer Roger Lewin published in 1980 an article in the prestigious *Science* magazine, with the colorful title "Is Your Brain Really

Necessary?"[6] Lewin, reviewing the work of the pediatrician John Lorber, showed that patients who had suffered massive losses of brain substance due to hydrocephalus displayed no symptoms and led normal lives. A case in point was that of a young man in whom the brain had been reduced to a thin, barely discernible film, the rest having been replaced by fluid. Still, the patient had obtained a mathematics degree at the University of Sheffield, and had a high IQ. Since then, at least one additional case of this nature has been reported.[7] The least that can be said about these findings is that they challenge traditional views of the role of the brain in cognition and memory. Since a huge amount of information is retained in the presence of no more than 5 percent of normal brain tissue, one possible logical inference is that information storage may take place elsewhere than in the brain.[8] Speculative, mystic-philosophical thinkers speak of an extracorporeal "soul" or "spirit." Skeptics are of the opinion that the minimal residual amount of brain tissue is sufficient to sustain a normal intellect, thanks to its wondrous organization, but that intellect remains the inalienable property of the encephalon. We are reminded of Nietzsche's utterance that the brain is merely an organ that serves to concentrate our thoughts, but in reality we think with our bones, our heart, our liver, and all our organs, but especially the stomach.

Our partiality for the heart is equally ill-founded, since throughout nature many animals live quite well without this organ. Nematodes (flatworms) do not have a heart; sea anemones also lack a heart; innumerable species (recall the millions of insects and microscopic organisms) don't seem to miss the presence of the much-vaunted pumping organ. In lower

organisms, nutritive fluids are distributed through the tissues by passive diffusion, or propelled by bodily movements, as in worms. But a stomach is a different matter. However high you climb, and however low you descend, in the zoological evolutionary scale, you will always find a digestive cavity that it is not inappropriate to call "stomach." From microscopic to gigantic living beings, from amoebas to killer whales, none will be found to lack a stomach. Naturalists of the past pointed out that some animals seem to be reduced to a gastric receptacle and little else; they exemplified this observation with the elementary structure of marine sponges, which give the appearance of being constituted by "a collection of swimming stomachs."

Today, if scientists discover primitive life forms that possess body cavities of various shapes connected to the outer environment, the first impulse is to call these cavities "stomachs" or "gastrointestinal" structures, since it is reasonable to assume that they are in charge of the digestion of engulfed matter. For instance, in 1986, Danish investigators on a research trip found intriguing organisms from the bottom of the sea, at depths of 1,300 feet and 3,300 feet, collected by dragging a suitable sled over the sea floor off the coast of southeastern Australia. The lead investigator, Jørgen Olesen, from the University of Copenhagen, immediately realized that these were previously undescribed organisms, akin to life forms that lived 600 million years ago. The scientists were puzzled about the correct classification of these specimens, which at first seemed not to fit into any of the categories of the tree of life. For a while, they thought of creating a new phylum or animal family. The organisms were shaped like

mushrooms, that is, composed of a discoid structure having a central stalk (fig. 2.1), but they were obviously animals. At the base of the "mushroom stalk" there was an opening, which would correspond to the "mouth" of the organism, in continuity with a tube ("digestive" canal) that bifurcated multiple times as soon as it reached the discoid top. The specimens

Figure 2.1

Mushroom-shaped marine animal called *Dendrogamma*. Image from the original 2014 communication by Olesen et al. published in *PLoS One* 9, no. 9 (September 2014) and since reproduced in many sites, including Wikipedia.

were assigned to a new genus, tentatively named in allusion to the branching pattern of the "digestive" tube, and a species, appropriately called *enigmatica*.[9] The research expedition returned in 1988, but they could find no more specimens of this kind. It was not until 2015 that a new expedition was able to collect more specimens, and with appropriate techniques of molecular biology it became possible to determine that the specimens corresponded to the phylum *Cnidaria* and the order *Siphonophorae* (of which the Portuguese man-o'-war jellyfish is a member).

Thus, in the mysterious *Dendrogramma*—which seems to have been in existence some 600 million years ago—there is no such thing as a heart, and no trace of a nervous system. But it surely has a digestive system, which the scientists call "gastrovascular" because digestion takes place inside this tubular space, whose motions help to distribute the tissue fluids. Hence it is not far-fetched to say that it had a primitive stomach. Now, since the most primitive forms of life are so provided, it was logical to conclude that a gastric pouch must have been the earliest organ to develop; hence we may say this organ was the most basic, the most elemental for organized life, and therefore the most important. Broussais and his followers were justified in proclaiming the stomach "King of the Animal Economy." We must all bow to His Digestive Majesty.

His Majesty the Stomach's power is owed largely to the fact that it starts the portentous transmutation of foreign matter into our own living flesh. Certainly, the first essential step of this miraculous transformation takes place inside this saclike structure, this muscular pouch whose shape the ancient anatomists compared to a bagpipe, a cornucopia, a

wineskin, a letter J, and other familiar objects. Yet it was not long before X-ray technology made it clear that no one shape can aptly describe this organ. Its elastic nature enables it to take all kinds of shapes, depending on its state of fullness, and the build and posture of the individual. But its semi-magical ability to transform matter, to alter the nature, appearance, structure, and use of the substances deposited into its cavity, was a constant property that induced the unreserved admiration of succeeding generations.

Unfortunately, every time a faculty of the human body is deemed admirable, we can almost predict that someone will try to abuse it, or to test it to the extreme. The digestive power of the stomach was no exception. In every age, men were found who endeavored to transgress the natural boundaries of the gastric function. Some eccentrics, as we have seen, aspired to digest everything. Digestive excess, however, has assumed diverse aspects throughout history.

Classical antiquity offers stupendous examples of this human folly. In terms of eating immoderately, the Romans stand alone. The same impetus that built the mighty empire seems to have burst forth at meal time. This was to be expected, for an empire reputed to be arrogant, tyrannical, and arbitrary had to be correspondingly wild and unrestrained at the dinner table. The chronicles of the times attest to the hallucinating nature of their menus. Their princes gave memorable banquets that seem fictional by virtue of their sheer extravagance. Seafood was brought inland at enormous cost, from as far away as Gibraltar, so that the emperor could taste his favorite kind of fish; and it was to be served in blue-colored seasonings, presumably the only color appropriate to ocean fare. Among

the exotic delicacies consumed, historical records list brains of peacocks and pheasants, tongues of flamingos combined with lamprey's milt (the reproductive organs of lampreys full of secretion), camels' heels, and other highly vaunted tidbits. The Roman Ælius Verrus invented a famous dish, the "pentapharmacum," composed of sow's udders, plus the meat of pheasants, peacocks, wild boar, and ham. Potentates offered banquets lavish of expenditure, if limited of refinement.

Historians speak of Roman dinners costing millions of sesterces, not only because of the enormous difficulty in procuring the rare ingredients of meals demanded by some semipsychotic tyrant, but also due to the squandering inherent to the banquets' preparation. Ground pearls were sprinkled on rice, like pepper. The tableware was made of costly, precious metals, which some guests received as gifts and others outright stole. Numerous slaves were at hand in expensive raiment. Raffles took place during the banquet, and the guests could cash the door prizes they had won, which they found inscribed on their spoons: "a sedan chair," "a four-horse chariot," or, by way of jest to enliven the merry gathering, "two hen's eggs" or "ten flies." But gifts were also offered by the host to his guests, and they could carry their presents home when the dinner was over. Such gifts, called *apophoretae*, consisted of food, pins, vases, etc. Gifts of this kind were especially common during the feasts of the Saturnalia.[10] It has been calculated that Emperor Vitellus spent about £3,200 at each repast. The archaeologist Deborah Ruscillo, in a learned and most interesting article, painstakingly calculated the cost of a 15-guest dinner in imperial Rome. She converted the ancient Roman silver coins (*denarii*) into gold pieces (*aurei*), then

converted these into American dollars, based on the price of gold.[11] The price of the banquet came to about $10,042.00 in today's market, not including "extras" like garnishes, perfumes, gifts, and slave services.

Little wonder that emperor Augustus (ruled 27 BC to AD 14) saw the need to issue strict laws against extravagant menus and dispendious excess in banquets. Such ordinances were eminently prudent, and aimed to preserve the health of the people; but gluttony prevailed, and the wealthy and powerful were the first to transgress the ordered restrictions. Emperor Claudius entertained no fewer than six hundred guests at his table. Aspicius, a member of the Roman elite, wrote abundantly on cuisine, and left more than 500 recipes, many with the most unusual ingredients. Nor was it only the love of food that explained the stubborn persistence of gourmandizing. There was also the social importance of impressing others with one's splendidness. Political favors were obtained and business arrangements were transacted—much more then than now—during these dinners. And then, as now, there were intellectuals ready to play the toady to the wealthy and influential. The Greek philosopher Heraclides of Pontus tried to justify the life of pleasure that the powerful indulged, on the premise that it made them more magnanimous, for a life of luxury, he maintained, "relaxes the soul," whereas one of privation and difficult labor belongs to slaves and mean men, who thereby become petty, small-minded, and of "contracted disposition."[12]

A celebrated dish deserves separate mention. It was introduced to Roman society by a patrician of noble lineage, Servilius Rullus, who named it "wild boar in the Trojan style," or,

as today's gourmets might snobbishly say, using French terminology, boar "*à la troyenne.*" This dish was remarkable not only for its colossal size, but also for its imaginative and laborious confection. Whether its taste matched the work needed to prepare it is something I cannot judge. It was first offered at a banquet to honor Cicero, who had just convicted Catilina, a Senator accused of conspiring to overthrow the government. Four Ethiopian slaves entered the banquet hall, carrying on their shoulders a huge silver tray shaped somewhat like a mortar, on which rested a roasted whole boar of impressive dimensions. Little baskets of figs hung from its tusks. This big beast was surrounded by little pastries in the shape of baby boars, artistically disposed and adorned. Amid the guests' joyous expectation, the cook appeared: a Sicilian, and the true creator of this dish. With great dexterity he carved the animal, to reveal a second boar inside it, and upon cutting this one, still a third; and there followed a series of delicacies of progressively diminishing size, one inside the other, like "Russian dolls." Hence the name "Trojan style" in reminiscence of the Greek soldiers who, according to tradition, hid inside a huge wooden horse during the siege of Troy (fig. 2.2). At the end of the series, a small bird—a *beccafico*, or fig-pecker, delicately cooked—was found. "It must be confessed," says a historian, "that such magnificence rather resembles folly."

If we are to believe the Roman historians, the Roman people had been as sober and frugal in times of the republic as were the warriors of the Homeric age. Dissolute mores and unhealthy refinements came together with increasing prosperity in the time of the empire. But, as I said above, a tendency to excess has always been present in people's minds; and

Figure 2.2
"Boar in the Trojan style." Description in the text. From A. Soyer, *The Pantropheon or History of Food* (London: Simpkin, Marshall, & Co., 1853), 406–407.

before culinary refinements were adopted it took the form of sheer barbaric voracity. Thus, we hear that in the heroic Greek age there lived a Theagenes of Thasos, Olympian boxer and runner of great fame throughout Greece, who ate a whole bull at a single sitting. The same feat was attributed to the wrestler Milo of Croton (now Crotone, in Calabria, Italy), in the sixth century BC. This is the fellow of whom a legend says that

he carried an ox on his shoulders daily, from when it was a newborn calf to when it became a full-sized ox. At length, the day came when he entered the Olympic stadium carrying the enormous beast on his shoulders, amid the thunderous acclamations of the crowd. His was a rather unorthodox training method for weight-lifting Olympic competitions. One wonders if the big beast he consumed at the table was the same he used to carry on his shoulders. If so, the man was a cold-hearted, ungrateful villain, incapable of feeling for the animal to which he owed his athletic honors.

The strange collection of narratives on ancient gastronomy by Athenaeus of Naucratis (flourished at the end of the second and beginning of the third century AD), called the "Deipnosophists" or "Banquet of the Learned," is considered by scholars a rich mine of information about many ancient social customs, but particularly the culinary and eating habits of classical Greco-Roman antiquity. In this work we read that Mithridates, king of Pontus,[13] once proposed a great eating and drinking competition, with a talent of silver as main prize. Presumably, the king won, yet he yielded the prize to the first runner-up. We are also informed that a Persian man named Cantibaris gave proof of unprecedented gluttony at one of those extraordinary eating gatherings. This is the way he proceeded: when he felt exhausted by the effort of continuous mastication, he asked his slaves to pour the food into his mouth, which he kept wide open while he remained passive and semi-recumbent, so that it was as if the slaves were pouring the food into an empty vessel.[14] Unbelievable as it sounds, this extraordinary method of self-cramming is not impossible. Physiology studies have shown that some people are able

to relax the musculature of the esophagus, which becomes easily distensible. This is probably the mechanism operative in sword-swallowers and other entertainers whose "performance" includes the swallowing of large solid objects.

Whereas the incident just referred to may have some shadow of verisimilitude, other accounts are so outlandish as to impress us as obviously legendary. Such is the story of Cambles, an episode which, according to Athenaeus, was written in the fifth century BC by the Greek historian and logographer Xanthus in his book *Lydiaca* (a history of the ancient kingdom of Lydia) that is now lost and known only by fragmentary allusions from other writers. In this story, Cambles, King of the Lydians, is depicted as a voracious eater and immoderate drinker. He was probably intoxicated after one of his usual binges when, having lost all measure of discernment and self-control, he killed his own wife, cut her up into edible pieces, and proceeded to eat her! When he came to his senses, he realized what he had done upon discovering a big piece of his wife's hand in his mouth. In one version of the story, he killed himself in atonement for his horrific crime. In another version, clearly the fabrication of cynical commentators, he regretted not having tried his wife-ingestion act sooner, for this heinous crime had allowed him to experience the taste of human flesh, which he found delicious.

In our highly industrialized, hygiene-conscious, deodorized, and sheltered society, do we have anything comparable to these ancient champ-and-gobble extravaganzas? Most certainly we do. We no longer have a goddess of gluttony, as did the Sicilians, who raised an altar to Adephagia, the deity of tucking-in devotees. But we still count among us

the emulators of Milo of Croton or Theagenes of Thasos. Few achieve notoriety these days, when concerns of greater urgency than gluttony occupy the public attention. Still, some big overeaters occasionally reach local, if not national or international, celebrity. The "true tall tale" still endures in Crystal Falls, in Michigan's Upper Peninsula, of Tom James, familiarly known as "Tom the Guts," who could never earn enough money to feed himself. It is said that he ate at lunch "seven quarts of Irish stew, two loaves of bread, four or five pounds of meat, and fifteen to twenty potatoes. . . . He would drink a keg of beer—an eighth of a barrel—in one pull. He once ate an eight-pound ham for a before-supper snack."[15]

Among the better-documented cases we may quote the gargantuan exploits of the American financier James Buchanan Brady (1856–1917), popularly known as "Diamond Jim Brady" on account of his propensity to acquire expensive jewels, an inclination that came second only to his love of gastric cramming. George Rector, celebrated Manhattan restaurateur and cuisine columnist, told an anecdote about this glutton. A delicious dish had been created at a plush Parisian restaurant called "Marguery." Rector was commissioned to go to Paris to learn how to cook the said delicacy. He averred that it took him "exactly two months of working 15 hours a day to get the hang of the dish." When a jury of seven strict culinary critics adjudicated his preparation perfect, he sent a telegram to his father, another celebrity in New York's restaurant milieu, telling him that he was returning to America on the first boat available. If we are to believe Rector, Jim Brady was waiting for him on the gangplank, shouting "Have you got the sauce?" And upon Rector assenting, that very same evening Diamond

Jim Brady was with his friends at his restaurant, where he devoured eight servings of the highly publicized delicacy, the so-called "sole Marguery." Not only that, but after finishing this impressive ingestion, Brady said, by way of compliment to the chef: "Right now, if you poured some of that sauce over a Turkish towel, I believe I could eat all of it."[16]

Jim Brady died at sixty-four, reportedly of a heart attack, during his sleep. His doctors said that his stomach was "six times as large as a normal stomach."[17] No hard evidence exists in support of this assertion, as no autopsy report exists to document the alleged gastric distension. Brady was not noted for gastric or intestinal troubles during life. He suffered from a prostatic affliction that caused him pain and difficulty on urination. An unspecified surgical procedure relieved this misery, and in 1912 the grateful patient rewarded his doctors at Johns Hopkins Hospital in Baltimore with a generous cash donation that allowed the foundation of the Jim Brady Urological Institute, which thrives even today. Thus, our man's digestive unrestraint may have incurred no punishment, but human frailty invariably takes its toll, and painful urinary dysfunction is no desirable alternative to gastric misery.

As to the eating competitions that we read about in Athenaeus' *Banquet of the Learned*, they pale in comparison with the events that are held in our day. Foremost among these is undoubtedly the American hot dog ingestion contest celebrated in the United States at Coney Island on the Fourth of July, the national Independence Day. The Greco-Roman contests took place in the palatial halls of some sybaritic satrap, and among his dissolute cronies. Today's American eating tournament is attended by over 40,000 people, and close to

three million spectators watch it live on the television sports channel. The festival opens with speeches by the mayor of New York and other notables. The television announcements—the MC-ing, as it is now called— is done with a unique flair that presumably enhances the enthusiasm of the telespectators. Thus, the contestants are introduced with picturesque rhetoric. George Shea, a colorful MC, used to compose epic eulogies in their honor, such as: "the man who, buried alive under sixty cubic feet of popcorn, ate his way to survival," or "the Houdini of Cuisini, Crazy Legs Conti."[18]

The company that sponsors the event, Nathan's Famous, now a chain of hot dog restaurants, receives a great amount of publicity, as do a number of other sponsors. The participants, among whom are the champions who may win a $10,000 prize, enjoy the idolizing and celebrity status of heroes, just like outstanding sports athletes. Nor is this an idle comparison, for eating has been elevated to the rank of a true sport. Like soccer, it now has a federation, the "Major League Eating" (MLE),[19] in charge of regulating all professional eating contests (close to 100 yearly), the marketing and publicity; and, through its parent organization, the IFOCE (International Federation of Competitive Eating), the ranking of the competitors, and the remunerations granted. Competitors without affiliation to these organizations are barred from the competitions. Mind you, there are ninety different kinds of competitions throughout the country; not all are related to hot dogs. A chicken wing competition is held in Buffalo, New York; waffle eating, in Atlanta; hamburger eating, in Chattanooga; among other foods featured in various competitions are pies, pizzas, ribs, oysters, boiled eggs, sushi, ice cream, and

so on. A "vegan hot dog competition" takes place in Austin, Texas, and a "tacos eating championship" in San Jose, California.

The contestants are professional "eaters" who sign autographs and may become "legends" to aficionados. Clearly, the "eaters" have moved from carnival freak shows to the mainstream of "entertainment": some make a substantial amount of money going from contest to contest. Take, for instance, Takeru Kobayashi, a scarcely 60 kg (132.2 lb), 1.73 m (5 feet, 6 inches) young Japanese male who one day appeared at the competition and pulverized the world record of twenty-five hot dogs in twelve minutes, by consuming in that time . . . fifty![20] Incredible as it seems, this young man nearly doubled the previous record. The new champion kept his throne for six years, only to be vanquished in 2013 by the challenger, a thirty-two-year-old American, Joey Chestnut, appropriately nicknamed Joey "Jaws" Chestnut, who was able to pack away sixty-nine hot dogs in the allotted time of ten minutes.

In former, more civil times, proper Victorian maidens, pale of complexion and prone to fainting spells, meticulously avoided the eating of meat, on the premise that meat consumption predisposed one to fierce and unfeeling "carnality." By this was meant cruelty, insensibility to spiritual needs, and, of course, the great taboo of those times: sex drive. Animal products generally, but especially meat, with its "bloody juices and raw horror," could stimulate in them the lowest and vilest of beastly instincts. Why, meat could transform a demure, shy virgin into a nymphomaniac! Of this they had been assured by a long list of vegetarian advocates that went back to Pythagoras, but had been of late reinforced by articulate

Englishmen, among them Joseph Ritson (1752–1803), William Lambe (1765–1847), Frank Newton (1752–1803), and, most incisively when addressing a young woman's heart, the romantic poet Percy Bysshe Shelley (1792–1822). Rare was the young maiden who could still feel like eating beef after perusing Shelley's passionate manifesto *A Vindication of Natural Diet* (1813).

How times have changed is readily apparent from seeing women compete in the Coney Island contest and similar extravaganzas. A Miss Miki Sudo, of Las Vegas, devoured 38.5 hot dogs in ten minutes. She regrets not competing alongside the men, for since 2011 the women's competition takes place separately, and receives less media coverage, being often overshadowed by the men's division.[21] Sonya Thomas, alias "The Black Widow," a Korean native, holds the record of 45 hot dogs in ten minutes. The rules of these contests may be quite strict. Competitors must maintain a relatively clean surface. Vomiting (euphemistically called "reversal" by competition organizers and reporters) automatically disqualifies the contestant. Food may be dunked in water or other liquid to soften it and make it easier to swallow, but there is a limit on the number of times a competitor is allowed to dunk the food.

Competitors are the first to avow that they do not think of their activity as "eating," at least not in the traditional sense. We generally associate eating with two basic, subtending ideas, namely, the satisfaction of the need for nutriment, and the bodily pleasure that accompanies the accomplishment of this satisfaction. In speed-eating encounters, food takes on a wholly *sui generis* meaning. It is no longer nutriment, and it ceases to be an agent of pleasure. It becomes a hurdle to

surpass, an obstacle to overcome at any cost. The champions speak of their endeavor as a test of drive, assiduity, firmness of purpose, and dedication. In order to become equal to the challenge, they must train. "Training" means subjecting themselves to grueling and dangerous routines. For instance, they drink several gallons of water daily, or eat an equivalent volume of solid food. The possibility of an accident—a tear in the gastric wall in consequence of excessive stretching, or sudden impaction of solid food in the larynx, producing asphyxiation—is ever present. They must proceed with extreme care and under supervision. The goal of this "training" is to transform the stomach from a muscular viscus to a flaccid pouch that can accommodate a vast amount of food without eliciting the sensation of satiety. This they achieve, but at a high price.

Very few medical studies have been done on professional speed-eaters, but from what scanty information has been obtained, it can be seen that a stomach changed into a loose, atonic bag may be the source of grave ills. A stomach whose muscular walls have become weak and quaggy has trouble propelling the digested food bolus downstream, into the first part of the small intestine. The stomach's flabbiness may progress to nearly complete paralysis (gastroparesis), for which no medical remedy is now extant; it may become necessary to surgically remove the organ, totally or in part. But a gastric wall so transformed is also unable to generate the nervous impulses which tell the brain that the normal end-of-meal distension has been reached. In other words, the neural signal proper to satiety is abolished. The long-term consequences of this condition are not known.

A young and healthy speed-eater contestant knows that in order to remain physically fit and able to win prizes, he must be prudent in his eating habits in the intervals between competitions. But what would happen to this person in later years, past the age limit for competitions, having lost the motivation of prospective victories, and unable to experience satiety after meals? Although there are no medical studies with long follow-up of professional eaters, it is reasonable to propose that, assuming other dangers (such as the terrible complication of a paralytic stomach) were successfully avoided, the professional eater runs the risk of falling into habitual, immoderate food ingestion. This, as everyone knows, leads to morbid obesity and its attending train of deadly complications.[22]

Eating competitions have elicited considerable descant from sociologists, anthropologists, psychiatrists, and other experts. These extravagant events have been thought of as a conscious ballyhoo of the wealth and prosperity of the United States. For although chomping-and-gulping encounters have been staged in Hong Kong, Australia, Canada, and other countries, they remain quintessentially American. Presumably, speed-eating contests are a flamboyant, unabashed display of overabundance.[23] "There are countries that suffer from lack of food," Americans seem to be saying, "but here, the opposite is true: we have food to provide, to consume, and additionally to waste, or to burn if we feel like it." Psychologists have suggested that participants are drawn to the competitions under varied motivations, such as exhibitionism, an affirmation of virility, or the desire for approval and recognition.[24]

Still other interpretations have been put forward. However, I confess a somewhat turbulent feeling which does not

allow me to consider the various intellectual presentations with equanimity. I was no stranger to poverty and deprivation in my younger years, and I am not yet cured of an intimate feeling of repugnance at the spectacle of mindless wastage and eager, senseless overconsumption. For, according to numerous international organizations, 795 million people in the world (10.9 percent of the world population in 2014) are afflicted with chronic scarcity of food;[25] almost half of deaths in children under the age of five, or 3.1 million a year, occur as a result of undernutrition; and globally,154.8 million children of this age were estimated to be stunted in 2016 because of lack of nutrition. When all of this is happening, I cannot find the ease of mind needed to canvass dispassionately the scholarly disquisitions that attempt to explain the behavior of groups of adult men and women whose main concern is trying to outgorge and outcram each other, while looking very much like pigs in their troughs.

The stomach rules the world. But this firm and steady "king of the bodily economy" has a less dependable prime minister, the brain. We are generally told that to depend on this organ's counsel is wise, and that it is our happiness we build when we trust its advice. Unfortunately, the brain is not always well balanced and precisely calibrated; often, its designs seem to originate more from rashness and caprice than real reason or common sense. It is the unbalanced brain, not the stomach, which misleads men and women into the aberrance of overindulgence, the depravity of gormandizing, and the freakishness of speed-eating competitions. But such imbalance may take a contrary sign: instead of leading to overindulgence, it may incline to the opposite extreme, that of

abstinence and self-starvation. It is all a matter of false inferences—in other words, of defective brain operations. This is illustrated by the following case, reported in the popular press and commented on only half-jestingly by an editorialist in a scientific journal.[26]

A German athletic trainer stopped eating out of a misguided concern for his health. It all started when he decided to quit eating meat, on account of the many reports that stress the deleterious effects of meat consumption. Why, with all those claims about the presence of toxic molecules (like Neu5Gc) in red meat, and the possibility that they might favor the appearance of colorectal cancer, the surest course of action seemed to be to stop eating red meat altogether. But red meat was not the only thing to avoid. Government studies determined that chicken and turkeys were being "pumped full of chemicals"—not to mention the awful way those poor animals were being processed. Moral sentiments had not been previously stirred in him on this matter, but now the growing activism of advocates of animal rights, and his concerns over the health hazards of meat consumption, made him decide that it was best to stop eating poultry. He still managed to have a healthy diet of fish, fruits, and vegetables. He had to eliminate fish, however. Toxic levels of mercury had been found in fish meat; and he read a study about the increasing pollution of the sea with chemicals known to be cancer-producing. That left him with fruits and vegetables. Needless to say, it soon became apparent to him what is common knowledge: namely, that these products are not safe to eat, because they are heavily sprayed with insecticides. Even tap water he learned to distrust, as it contained ammonia, chlorine, and traces of a

number of toxic substances from industrial plants in his area. Under this regime, says the report, "he turned into a walking skeleton" until finally, the autopsy official declared, "he starved himself to death."

3 THE INVISIBLE CLOUD OF SYMBOLS AND MYTHS AROUND THE BODY CONDENSES INTO RAINDROPS OF CURATIVE POWER

SECRETIONS AND EXCRETIONS

I. Saliva

Bodily fluids ever enjoyed a high prestige as curative agents. Holy Scripture informs us that Jesus' method of restoring a blind man's sight included spitting on his eyes, either directly (Mark 8:23) or indirectly, by first preparing a paste of saliva and mud, then anointing the blind person's eyes with it (John 9:6). It is true that interpreters are quick to point out that Our Savior did this only for the form, so to speak, since divine might had no need to resort to any physical means. But such means He did use, because the people, the Romans, and the Jewish rabbis expected it, saliva being then considered a legitimate agent in ophthalmological therapy.

Considering the magnitude of men's hubris, it comes as no surprise that some pretended to emulate the divine miracle. The Roman emperor Vespasian (AD 9–79), while touring in Alexandria, spat upon the eyes of a blind man who implored him to do so, allegedly at the prompting he had received in a dream from the Greco-Egyptian god Serapis. Chroniclers tell

us that a lame man also came and begged for a cure, asking the emperor to touch with his foot the withered limb. At first, Vespasian shrank from doing either in front of a large crowd, but his doctors advised him to go ahead. This he did, and, to believe the chroniclers, both petitioners were cured. However, Tacitus[1] remarks that the doctors had previously determined that the blindness of the one was partial, and the lameness of the other only a dislocation. The physicians figured that the emperor had nothing to lose. If the attempt was successful, Vespasian's prestige would be raised to the skies; if unsuccessful, the sick wretches would be covered with ridicule for asking what was manifestly absurd. Clearly, the universal motto of politicians was then, as now, "Accept all of the credit, none of the blame."

Pliny the Elder praises the therapeutic powers of human saliva in his *Natural History* (Book XXVIII, vii). Not only is it the best of all safeguards against serpents, he says, but daily experience teaches that many other advantages attend its use. Surely the ancient Romans were sensitive to such notions: they spat upon the victim of an epileptic fit, and they spat to ward off the "bad luck that follows meeting a person lame in the right leg." If deemed guilty of too presumptuous hope, they asked forgiveness of the gods by spitting in their own bosom. They spat into the right shoe before putting it on, for good luck; and, of course, they treated ophthalmia by applying a saliva-based ointment every morning. Pains in the neck were treated by applying fasting saliva (interestingly, to be useful the saliva had to be obtained during fasting) with the right hand to the right knee and with the left hand to the left knee.[2] So powerful was the force attributed to saliva, wrote Pliny,

that the Romans believed that spitting three times before taking *any* medicament sufficed to enhance its curative power.

The healing powers of oral secretion kept their good renown throughout history. Albert the Great (Latinized name, Albertus Magnus: 1193–1280), regarded by some as the greatest theologian and philosopher of the Middle Ages, extolled the medicinal properties of human saliva, especially that obtained during prolonged fasting which included abstention from liquids. Its beneficial nature, said the *doctor universalis*, is reflected in its ability to kill asps and other venomous creatures: it suffices that we spit upon them, or touch them with the tip of a rod that has been wetted with the liquid from our mouth, for all the nefarious vermin immediately to die. This idea did not originate with Albert: it carries echoes of Pliny and his predecessors. However, the medieval sage adds that further proof of the wondrous salivary virtue lies in the observation that wet nurses use their own saliva to cure the newly born of all sorts of cutaneous inflammations, furuncles, and impetigo by rubbing the lesions with their spittle. And he quotes the reports of Arab physicians who affirm that, once mixed with mercury, its therapeutic powers are so greatly enhanced that a victim of the plague may be saved by simply inhaling the mixture's emanations.[3]

As late as the middle of the nineteenth century, we find the therapeutic prestige of saliva undiminished. Nicholas Robinson, an English medical author who signs his book simply as "A physician," extolls enthusiastically the virtues of saliva, which he calls a "recrement." This word, according to the *Oxford English Dictionary*, has been in circulation among the English-speaking peoples at least since 1599, with the

meaning of "the superfluous or useless portion of any substance," and is still employed, however rarely, to designate the dross, the unessential. Our medical author, however, points out that recrements are to be distinguished from excrementitious discharges; the latter are thrown out of the body and are of no further use to it, whereas the former serve many necessary purposes in the life of the organism. Saliva, like pancreatic juice and other fluids, is one of these indispensable "recrements."[4] But the three "grand recrements of the body are the saliva, bile, and seed," for not only do they preserve life and health in the individual, but the last named is "that sacred balsam that has continued the species from the beginning of the world to this time, and which will so continue it to the latest period of nature."

After this rhapsodic preamble, Robinson enumerates the wonderful therapeutic properties of saliva. As in historical and scriptural precedents, its ability to relieve sore eyes is brought to the fore: eyelids red, angry, and inflamed are a cause of much distress, but one has only to touch them with a preparation made of chewed bread mixed with the "fasting spittle" to find sure relief.

The central thesis of the treatise is that great salutary effects may be derived from saliva obtained in the morning, during fasting. Since the benefit can be shown to be great if it is applied to external parts of the body, we should expect comparable efficacy when it is conveyed to the entrails. Indeed, the author avers that the fasting saliva is improved in its nature, properties, and actions once it is mixed with the bile and the pancreatic, gastric, and intestinal juices. The saliva's role is not only to soften food; we are all aware that eating

would be difficult and uncomfortable in the absence of salivary lubrication. But mixed with digestive secretions, saliva serves crucial ends in the organism. It "dissolves all manner of viscous humors and fabulous concretions" that obstruct the mouths of the lacteals, impeding the passage of the chyle, and in this manner facilitates the disposal of "all corrupt humors to discharge by stool, urine, and insensible perspiration."

Thus, the author advises sufferers from diverse ailments to take a piece of bread crust while fasting in the morning. Fasting confers optimal curative strength (the prescription of abstinence, we suspect, introduces a note of mystical self-mortification agreeable to the idea of healing). The reasons adduced to justify the choice of bread crust as the preferred agent to convey the "fasting spittle" down the alimentary tract need not distract us here. Not that bread has any health-restoring powers: it acts merely as conveyor of saliva. The important point is that saliva, mixed with secretions of the digestive system, becomes "one of the greatest dissolvent medicines in nature; and at the same time one of the safest that ever was communicated to mankind; a remedy that, if steadily pursued, will cure both the gout, the gravel, the stone, the asthma, and dropsy."[5]

Today's medical scientists, it must be owned, do not share this kind of salivary enthusiasm. Still, the observation that all animals instinctively lick their wounds, and that wounds in the oral mucosa (for instance, after a tooth extraction) heal much faster than those of skin or other sites, led researchers to suspect the presence of a healing principle in saliva. Indeed, a number of beneficial substances were already known to exist there, such as antibacterial and antifungal compounds, and

factors that promote blood clotting,[6] but those that speed up the healing of wounds remained elusive for a long time. It is of no small interest that researchers have of late identified some, such as *epidermal growth factor* (EGF),[7] histatins, and leptin.[8]

Although lacking the fervor of Albert the Great, or the hyperbolic enthusiasm of the nineteenth-century advocate of the matutinal "fasting spittle," present-day investigators have been sufficiently impressed by the bactericidal effects of saliva to wonder whether being licked by pet dogs might be, after all, a clean and salutary practice.[9] Not so, they concluded after due investigation: the bacterial flora in the saliva of animals is radically different from that of humans. Therefore, beware: amorous effusions from man's best friend may pass on to you exotic infections worse than any you could get from a similarly demonstrative fellow human being.

Fortunately, the human salivary defense mechanisms identified are so numerous that they now outnumber the digestive factors.[10] Saliva contains immunoglobulins; lysozyme (actually a family of so-named powerful enzymes which damage the cell walls of bacteria); mucins that protect the oral mucosa and cause selective adhesion of potentially harmful bacteria and fungi; plus a growing array of antibacterial peptides; all these are constituents of an impressive and effective barrier to infectious agents in saliva.

There is little doubt that important, new therapeutic agents will be found in saliva. At the present time, however, the main interest of biomedical experts focuses on its diagnostic potential. This fluid is increasingly recognized as a "mirror" or a "window of the state of the body,"[11] whose analysis promises to become more informative than that of urine or even blood

samples in many conditions.[12] For one thing, compounds of medical interest travel in the blood usually bound to protein or modified in various ways, whereas their detection in saliva reflects more precisely the biologically active molecules. Moreover, saliva samples are obtained noninvasively and painlessly, which is no small advantage to patients. Thus far, one problem has been that molecules at the cellular level exist in minute amounts, of the order of pico- and nanograms.[13] The extraordinary advances in nanotechnology and the exquisitely sensitive amplification techniques used in molecular biology will certainly favor the use of saliva in diagnostic testing. The biomedical analysis of saliva may become an extraordinary, unprecedented advance in the accurate diagnosis of a great variety of diseases.

In striking contrast to the wonders that the ancients fancied in the salivary fluid, and the high esteem with which medical science presently views it, the general public's recent attitude in the West has been one of neglect, if not outright disdain. Saliva is joined to ideas of offense, vulgarity, or impudence. Spitting in somebody's face is universally considered a serious affront, an expression of hatred and disdain. Spitting on the floor in public is generally viewed as ill-mannered, although it was not always so. The fact that saliva is being constantly produced must have engendered in some people the feeling that they needed to rid themselves of some of it by ejecting it forcefully, wherever they chanced to be. This perception was so prevalent that the spittoon, or receptacle for spittle, also known as "cuspidor" (from the Portuguese *cuspir*, to spit), became a very common presence. Those of us who grew up in the first half of the twentieth century remember that

spittoons were obligatory in bars and taverns, and frequently found in stores, banks, railway carriages, waiting halls, hotels, offices, and many other sites. In China, spittoons date from the time of the Tang dynasty (AD 618–907), and some were fine artistic objects in porcelain, decorated with traditional pictorial motifs on the outer surface. Although still produced, spittoons are now rare, and often present simply as decoration: they figure as part of the décor in the Senate Chamber of the United States. In the Supreme Court of this country, each Justice has a spittoon next to his or her seat in the courtroom, mostly out of respect for tradition. Since the spitting habit is largely lost, and the young are unacquainted with the traditional form and function of spittoons, these receptacles are likely to be used as wastebaskets.

The perceived urge to expel saliva manifested anywhere, regardless of the availability of spittoons. In consequence, the custom of spitting on the floor became widespread. Its frequency varied in different cultures; people in most Western countries did not think of it as impolite until the early 1900s. In China, the habit persisted longer among the older generation. The Chinese leader Deng Xiaoping kept a spittoon by his side even at important diplomatic meetings. A newspaper photograph shows him in conversation with the British Prime Minister in Beijing in 1984; a white spittoon is visible on the floor at his feet. As late as the second decade of the twenty-first century, China's Vice Premier Wang Yang lamented the extended custom among Chinese citizens of spitting on the ground. Together with other tokens of ill-breeding, he felt this habit debased the worldwide image of China.[14]

In the West, hygienic and biomedical considerations were the chief factors that put a stop to the habit of spitting on the floor. Tuberculosis was a scourge that devastated European populations throughout the nineteenth century and beginning of the twentieth. Weighty scientific studies and international meetings of experts concluded that the abolition of floor-spitting, and of public spitting in general, by reducing the risk of spreading the airborne bacilli, would stave off the progress of tuberculosis. In the United States, the American Lung Association undertook a veritable "crusade" against spitting. Children in schools were given a list of nineteen rules to observe, all of which hammered, in various tones, the injunction to avoid spitting: "1.—Do not spit. 2.—Do not let others spit. . . . 19.—Last, as well as first, DO NOT SPIT."[15] Brigades of boy scouts distributed notices and fixed posters with anti-spitting slogans. This campaign was still active in the 1940s (fig. 3.1).

In 1922, the French Senate approved a law that prohibited this unhygienic practice. It said: "Article One: It is expressly prohibited to spit on the ground in all the establishments and locales open to the public. Article Two: In every establishment, notices will be affixed in sufficient numbers and in conspicuous places reminding the public of the interdiction mentioned in Article One. Article Three: In the same locales, the supervisors or managers of the establishments are obligated to dispose of the spittoons that answer to the necessities of hygiene, and which shall be constantly maintained in a state of cleanliness. Article Four: Any infraction to the disposition of any of the preceding articles shall be

Figure 3.1
Anti-smoking placard of the American Lung Association, 1944.

prosecuted in accordance to article 471, paragraph 15, of the Penal Code."[16]

The French, however, have long flaunted a collective propensity toward open rebellion against unpopular authority, which they call, not without pride, their *tradition contestataire*. The prohibition of spitting was implemented only after considerable resistance. Satire aiming at the anti-spitting

signs and proclamations flourished. Theatrical comedies, popular songs, and humoristic publications liberally dispensed their mordant mockery targeting the very measures intended to enforce the prohibition. A popular ditty, appropriately named "Forbidden to Spit," described the consternation of a passenger on a bus who feels the urge to spit on the floor, but the conductor stops him briskly, pointing at the sign recently affixed inside the bus. He then tries to direct the spittle at the window, only to be reprimanded harshly. Should he spit on the roof? On the conductor, perhaps? The man aims at various targets, only to be vigorously rebuffed each time as a filthy and ill-bred boor. At that moment, a vendor of French pastry goes by with a basket full of cakes on his head. He happens to be within range of the frustrated spitter, who, without giving it a second thought, ejects the saliva on the tasty vol-au-vents. The ditty ends here with this consoling thought: "At least it [i.e., the spittle] was not wasted!"[17]

Early in the twentieth century, a Parisian lampoon magazine farcically pretended that an American "professor of salivation" had introduced a course in spitting, whose aim it was to increase the dexterity of spitters. This was much needed, because governmental constraints and prohibitions forced the citizens to develop a better control on their ways of ejecting saliva.[18] Several allusive caricatures illustrated the progressive degrees of spitting skill pursued by students (fig. 3.2).[19]

In sum, the collective attitude toward saliva may be characterized as one of ambivalence. Biomedical science has long pondered over the hidden curative principles that this secretion may contain, and in recent times uncovered a dazzling potential for its use in medical diagnosis. Contrary to the

Figure 3.2

Spitting lessons. *Left frame*: First lesson, for beginners to learn to spit away from their own persons. *Middle frame*: Fourth lesson. Exercise to develop the ability to spit at a distance. *Right frame*: Sixth lesson. For advanced students, who try to sketch a portrait of Monsieur Camille Pelletan by means of spitting. The sketch should be of such resemblance that a person fortuitously encountering the sketch should be moved to exclaim: "For goodness' sake! That *is* Monsieur Pelletan!" From *Le Rire* (Paris), no. 88 (October 8, 1904).

importance conferred on it in past centuries, popular opinion has more recently held it in a negative light, as a contemptible bodily product—admittedly useful in the early phases of food digestion, but otherwise fit to be thrown in a rival's face. Its role in the transmission of contagious diseases—instanced dramatically, as we saw above, by tuberculosis about a century ago, and in our times by viral respiratory infections of pandemic proportions—did not help to burnish the image of this fluid.

II. Urine

Urine is the bodily fluid whose alleged benefaction stands foremost in the collective mind. "Urinotherapy," or "urine therapy," a term understood to mean the actual drinking of one's urine, has a very long history. Its origin is usually traced

to India and its culture. A several-times- millenarian Tantric religious text is said to contain the first reference to urine as a diagnostic and therapeutic agent.[20] Contrary to the dominant Western idea that urine is a "waste product"—that is to say, something useless that is best cast off the body through a natural emunctory—other cultures have attributed a different and more dignified meaning to this fluid. It has been thought of as a distillate of the body that carries with it a health principle or some form of vital energy. Hence the high-sounding names given to it, such as "elixir of long life," "water of life," or "gold of the blood."

This notion led ancient Egyptians to sprinkle seeds with a woman's urine instead of water as a pregnancy test: if the seeds sprouted, the test was considered positive. Not only did they try to ascertain the presence of pregnancy, but they went further: they thought they could guess the sex of the unborn by this method. This was done by taking barley and hard wheat that the woman moistened with her urine daily, and placing them in separate sacs containing dates and sand. If only the barley grew, this signified a male child; if only the wheat, a female child. The predictive ability of this method was limited. If both the wheat and the barley grew, it could only mean that the birth would be normal; if none grew, it would not be normal. Scholars have wondered about the origin of this strange test. One explanation given is linguistic, based on the similarity of pronunciation of the words "barley" and "father" (both pronounced *it* in ancient Egyptian); therefore the barley would announce the birth of a child of the same sex as the father. Also, the word "barley" is masculine in gender in Egyptian grammar, whereas "wheat" is feminine.[21] Some modern

researchers were so intrigued by this method that they decided to reproduce the procedure. At least one German investigator found that wheat grew more rapidly when mixed with the urine of a woman pregnant with a boy; and barley grew more rapidly, again mixed with urine, when the child turned out to be a girl. Thus, the results were exactly opposite to those claimed by the ancient Egyptians.[22]

In the West, Pliny the Elder wrote about the presumed therapeutic uses of urine. In book XXVIII, chapter xvii of his *Natural History*, he asserts that the urine of eunuchs helps to promote fertility in females, by counteracting malefic charms designed to curtail it. Also, the urine of children who have not yet reached puberty is a powerful remedy against the venom secreted by the asp known to the Greeks as "ptyas," which has the fearful ability to spit its venom at a distance. Pliny was referring to "spitting cobras," which include various species that can project their venom as far as 2 meters or 6.6 feet.[23] To believe Pliny, youngsters' urine was also helpful against "albugo," a disease of the eyes in which an opaque white spot forms in the cornea. Its usefulness extended to the treatment of burns; and, when boiled together with a bulbed leek in an earthenware vessel, it formed a decoction that worked wonders in promoting menstrual discharge (in technical terms, it became an efficacious emmenagogue). Mixed with niter (potassium nitrate, KNO_3), it was prescribed for the cure of ulcers of the head and cancerous sores; and when kneaded with ashes, for the treatment of rabid dog bites. But the point that Pliny emphasizes in particular is that every person's own urine is the best for his own case, especially when applied immediately after voiding, and unmixed with anything else.

In the collection of writings known as the Hippocratic Corpus, of which only a small portion is credibly attributed to Hippocrates himself, urine's alleged curative properties take second place to its usefulness in diagnosis. A very long and rich tradition of urine examination for the diagnosis of various diseases originated in the Hippocratic school and subsisted, becoming ever more elaborate, for thousands of years.

On the testimony of Diodorus Siculus (c. 80–20 BC), the Celtiberian people living on the Cantabrian coast of Spain had the custom of washing their teeth with their own urine. "Careful and cleanly as they are in their ways of living," says Diodorus, "nevertheless they observe [this] practice, which is low and partakes of great uncleanliness."[24] The ancient geographer Strabo (c. 64 or 63 BC–c. AD 24) jotted down (in book IV, chapter 16 of his *Geography*) some rather unkind comments about the inhabitants of the Cantabrian Spanish coast. He describes them as most uncivilized, passing their days in poverty, and acting on animal impulse. He says that they do not care for luxury and refinement, unless anyone thinks that it is refinement "to wash themselves in stale urine kept in tanks, and to rinse their teeth with it, which they say is the custom both with the Cantabrians and their neighbors."[25]

The Roman poet Catullus (84–54 BC) ridiculed a Spaniard, a certain Egnatius (who may have been a fictitious personage invented by the poet) for "brushing his teeth with Spanish piss."[26] The Romans probably realized that the ammonia in urine helped to whiten the teeth. Supposedly the use of urine as dentifrice was predicated on this property. Catullus renews his satire on Egnatius in poem XXXIX, accusing him of smiling all the time, just to display the whiteness of his

teeth. However, Diodorus and Strabo insist that the practice of the Celtiberians was not merely a beautifying technique, but a sanitary measure to improve the health of gums and teeth. Nor are we to believe that this practice is a thing of the past. As recently as September 2018, a Twitter note informed the social networks that Leah Sampson, a forty-six-year-old woman from Alberta, Canada, used her own urine to brush her teeth: a photograph shows her applying the yellow fluid for this purpose.[27] Unlike the ancient Celtiberians, however, she used an electric toothbrush, and extended the use of urine to washing her hair, and even rinsing her eyes with a few drops of it. No one can tell how prevalent this practice may be in our time. There are reasons to believe that our contemporaries have taken it to extremes undreamed of by the ancient Romans or their Cantabrian colonials. Such was the case of an unnamed woman who drank her dog's urine and filmed the entire process: from taking the dog for a walk, to collecting its urine in a cup and drinking it. The video "went viral," as is now said, on Facebook.[28]

In seventeenth-century France, the spiritual lady and brilliant letter-writer Madame de Sévigné (1626–1696) was a devotee of urine therapy. On June 13, 1685, she wrote to her daughter that she used to take regularly several drops of extract of urine, to treat her "vapors." At one time, she said, this medication interfered with her sleep, but this side effect was transient, and thereafter she swore by the curative virtue of her medicament. One of her contemporaries, Moyse Charas, an apothecary of the French Royal Academy of Sciences, recommended urine as a therapeutic agent for neurological maladies from epilepsy and convulsive seizures to "vapors."

But the extract of urine had to be prepared from "the freshly voided urine of young people who drank wine."[29]

The concept of urine therapy did not lose momentum in the eighteenth century. A poetical metaphor that gained currency among physicians of the Enlightenment compared urinary excretion to the formation of a river. As a river grows running down the mountain slope, being joined by tributary streams that carry the sediments plucked from the different rock species encountered, just so the urine volume gradually increases as the blood flows through the different organs, extracting from each whatever needs to be excreted, Thus, urine contains all the elements that emanate from the diseased organs, but also those that indicate the vigor and good state of other organs. Implicit in this metaphor is the thought that urine is not only a waste product of the blood, but also a precious distillate containing useful substances. Hence the belief in its curative powers.

Urine has been employed to prevent the health breakdown caused by one form of malfeasance in the long list of atrocities due to man's inhumanity to man: the use of chlorine gas during World War I. The first chemical weapon used by the German army was chlorine, which debuted during the battle of Ypres in April 1915. Unprotected soldiers who inhaled this pale green, dense, pineapple-like-smelling gas died as the gas combined with water in the lungs, formed hydrochloric acid, and destroyed the lung tissues. However, chlorine is soluble in water: it was soon learned that combatants without a mask could minimize the damage by placing water-soaked rags over their mouths and noses. In the appalling conditions of the trench war, water was not always available, and some poor

soldiers resorted to the use of urine-soaked cloths instead. The Scottish writer William Boyd, in his novel *The New Confessions*, narrates a harrowing episode of the war in which a sentry spots an advancing cloud thought to be the deadly gas; he yells a warning, and this triggers a panic that results in numerous urine-drenched faces, only for it to emerge that the cloud was just a drift of dense mist.

Advocates of urine therapy have proliferated beyond all expectations. There are those who take a few drops diluted with water, and some who, like Sylvia Chandler of Great Britain,[30] in order to remain youthful take it straight: a pint a day, warm and just out of the bladder. American teenagers have been known to apply urine topically to treat acne, with disastrous results.[31] Applying urine to the skin, to make it fair and healthy, has a long history in folklore medicine. In the late 1990s, Mary Beith (1938–2012), an extraordinary journalist, social activist, and historian from Scotland, recorded a custom in the Scottish Highlands that consisted in wiping a baby's face with its own recently wet nappy in order to prevent acne later.[32] She claimed that a friend of hers who had four boys followed this practice unwaveringly, "and none of those boys became a spotty teenager."

In Cameroon, one's own water was considered a panacea effective against conditions as varied as baldness, hemorrhoids (via enema), diabetes, arthritis, and cancer. Here, the public's enthusiasm became so fervent that in 2003 the authorities were compelled to pass a law prohibiting any form of promotion of urine therapy under pain of imprisonment. This draconian measure was deemed necessary after a man telephoned a radio station to inform the listeners that his elderly

grandmother had been bitten by a venomous serpent whose bite is almost always lethal, but the good lady had escaped death thanks to the opportune drinking of her own urine.[33]

But the place with the longest and strongest tradition of urine therapy is, of course, India, the country where it probably originated. I am old enough to remember that about one half-century ago, Mr. Morarji Desai, then Prime Minister of India, on a visit to the United States, declared, while being interviewed on television by the popular journalist Barbara Walters, that he used to drink his own urine every day, convinced of the many healthy consequences of this habit. At that time, the American public, still a stranger to the ways of globalization, reacted with surprise and ill-concealed disgust. But in India urine has long enjoyed a high medicinal prestige. It is said to be the elixir of choice of a number of holy men who claim that to drink one's morning urine under certain conditions enhances meditation. A possible explanation is as follows. Melatonin, a hormone secreted by the pineal gland chiefly at night (since light suppresses its synthesis and secretion),[34] is present in the urine.[35] This hormone, which marks the tempo and helps to organize the physiology of our sleep-wake cycles,[36] is used in the treatment of sleep disorders.[37] Therefore, it might contribute to induce a state of relaxation and a sense of well-being that foster meditation.[38]

Failures of urine therapy have been attributed to the inability of most people to follow the strict discipline and daily routines of the yogis. Some yogis take urine via the nose (a few drops in both nostrils, inhaled deeply); an incommodity, perhaps, but "when done traditionally, [urine therapy] is a wonderful rejuvenating process which . . . protects the

body from disease and bestows longevity."[39] There is also an ancient tradition in Buddhism about drinking auto-urine, said to increase resistance to diseases and promote a sense of wellbeing.

Classical Ayurveda texts evaluate the therapeutic value of the urine of different animals, including humans. Their properties differ according to the source. Cow's urine is the most precious. One of the most striking practices using cow's urine in India in centuries past was described and illustrated by Bernard Picart (1673–1733), an engraver who never left Europe, a fact which did not stop him from describing—and illustrating—the religious customs and ceremonies of all the world religions. He did this by reading the chronicles of travelers and explorers, or by hearsay from the accounts of ocular witnesses—and, we may suppose, aided by an effort of his florid imagination. His *magnum opus* was published in ten volumes between 1723 and 1743. Although Picart's secondhand descriptions are of dubious anthropological or historical value, and although one must take everything he says with more than a grain of salt, his work is undoubtedly interesting, were it only to show how a well-educated European viewed the "exotic" religious practices of the Orient. This is what he has to say about urine therapy, as practiced in "the Coromandel" (a vast coastal region of the southeastern Indian subcontinent, which today is said to include the northwestern coast of Sri Lanka):

> They put the face of the dying next to the derriere of a Cow, then they lift the tail of the animal & stimulate it to expel the urine on the face of the patient about to die. This is [considered] an excellent purification. If the urine flows over the face

of the patient, the assembled people break out in joyous exclamations. But, says our traveler, if the Cow is not in the mood to urinate, they are saddened. Although the traveler did not say this, it seems that the Indians have a way to repair this untoward eventuality, by prayers and the payment of alms, which help to repair the inauspicious development [fig. 3.3].[40]

Needless to say, this type of therapy is wholly out of the mainstream in Western medicine, but in India interest in the therapeutic value of cow's urine (called "gomutra") remains strong in an important segment of the medical profession. Investigators in the Mandsaur district evaluated the efficacy

Figure 3.3

Illustration from Picart's treatise on religious ceremonies, showing his idea of urinotherapy in the Coromandel coast of India. A dying patient's face is bathed in freshly ejected cow's urine. In the background, another dying patient is being submerged in the waters of the Ganges, to obtain a premortem purification.

of cow's urine in 68 patients with proven cancer of various anatomical sites, and concluded that there was a distinct clinical benefit for those patients who submitted to the therapy uninterruptedly for at least two to three months.[41] This report, deficient in its data presentation, full of references to ancient Ayurveda and Sushruta medical concepts, and to abstruse mystical texts unfamiliar to most Western medical experts, is unlikely to influence medical opinion in our part of the world. However, there are other, better-documented communications, vouched for by Indian investigators familiar with the scientific methodologies standard in the West, who insist upon the alleged therapeutic value of urine. In particular, the existence of an anti-cancer substance in human urine has been hypothesized on the basis of animal experiments using tumor-bearing rats treated with urine extracts, and clinical observations of spontaneous cancer regression in human patients under certain specified conditions.[42] While the reasoning behind this hypothesis is appealing, and the factual observations alleged to support it are intriguing, there is, at the present time, no conclusive evidence that urine therapy can cure cancer. The American Cancer Society is quite firm in stating that "available scientific evidence does not support claims that urine or urea given in any form is helpful for cancer patients."[43] Equally strong denials have come from anti-cancer institutes in Europe. All of this does not suppress the need to further investigate the action of the many bioactive molecules known to be present in the urine.

From a biomedical perspective, the presence in the urine of compounds that retain their biologic action is a remarkable fact. A case in point is the enhancement or prolongation

of the psychedelic effects produced by a toxic fungus known popularly as "fly agaric" (*Amanita muscaria*). Despite its poisonous nature, the Koryak people of the Kamchatka Peninsula, in the easternmost region of Siberia, ingest it to induce a hallucinogenic experience. The next day, they drink their own urine, having found this expedient effective (and remarkably inexpensive) in prolonging a "high," which otherwise would last only 12 to 24 hours. In other words, the inebriating compound has not been destroyed by metabolic processes; it is found intact in the urine, and thus able to reinforce or prolong the initial intoxication. As first revealed by the eighteenth-century Swedish explorer Filip Johann von Strahlenberg, impoverished Koryaks craved the fungi but could not afford them; they were very hard to procure, and therefore quite expensive: the price was one reindeer per dried mushroom cap! Consequently, Strahlenberg wrote:

> Those who are rich among them, lay up large provisions of these mushrooms, for the winter. When they make a feast, they pour water upon some of the mushrooms and boil them. They then drink the liquor, which intoxicates them. The poorer sort . . . post themselves, on these occasions, round the huts of the rich, and watch the opportunity of the guests coming down to make water; and then hold a wooden bowl to receive the urine, which they drink off greedily . . . and by this way they also get drunk.[44]

In our part of the world, urine reached the zenith of its medical glory not in therapy, but in diagnosis. Just as the prudent navigator inspects the stars to direct his course along an unknown sea, said a hackneyed metaphor, so the physician tries to discover, by examination of the urine, the cause of

the patient's disease; for a venerable medical idea proposed that this fluid contains all the morbid principles that serve to undermine a person's health, and those that herald a recovery.

III. The Flesh Itself: Mummies as Marketable Pharmaceuticals

If the liquid excretions of the organism, which are mere distillates, seepages—oozes, as it were, from the interior of the body—contain precious elements that contribute to promoting our health, what powerful substances might not be locked in its very essence! And why not try to profit directly from the source, instead of contenting ourselves with the derivatives or sediments that leak out? This was the question posed by the men who triggered one of the most fantastic chapters in the history of Western medicine; an episode to which, nevertheless, very little attention has been paid. Namely, the consumption of human flesh as medical therapy, or, as some scholars named it, "corpse medicine."

It never ceases to amaze us to learn that Europeans have a history of cannibalism. Yet the evidence is irrefutable, and is now corroborated by an important body of scholarly work, that the eating of mummified human flesh was fully integrated into "mainstream" European medicine for several centuries. Most notably throughout the sixteenth and seventeenth centuries, but, in more restricted fashion, it extended into the eighteenth, the so-called century of the Illustration. This bizarre practice started innocently enough, partly as the consequence of a linguistic confusion, as I explain in what follows.

Bituminous substances had been used since ancient times in the Middle East to treat traumatic lesions and a number

of internal maladies. Bitumen (in North America, the words "asphalt" and "bitumen" are used interchangeably) is an oily, sticky, naturally occurring substance. Its consistency is compared to that of cold molasses. Various natural deposits of this substance exist in the world. Famous in antiquity was the *Judaicum bitumen* from the Dead Sea. As it turns out, bituminous substances were collectively designated as "mumiya" (*mum* = wax) in Arabic literature.[45] The great Persian physician Rhazes (died in 923) is thought to be the first to have used the word "mumia" in connection with bitumen. This term is the ancestor of the English word "mummy" for an embalmed Egyptian corpse, because, in the West, the notion was widely held that bitumen was used by the ancient Egyptians to embalm dead bodies.[46] The high praise lavished on bitumen as a medicament in the Middle East may have facilitated the confusion that eventually led people in the West to ingest not the embalming material, but the embalmed bodies themselves.

Because of its importance, the therapeutic use of bitumen in the Orient deserves some comment before I discuss medicinal cannibalism in Europe. The remarkable German naturalist, physician, and traveler Engelbert Kaempfer (1651–1716) left us a fascinating record of the use of bitumen in Central Asia and the Middle East during the seventeenth century. In 1681, before starting his long travels, Kaempfer visited Uppsala in Sweden, where his intellectual acquirements won the admiration of the university faculty, and notably of King Charles XI. It was from this monarch that Kaempfer obtained permission to join the embassy sent to the Shah of Persia in 1683. In his capacity as Secretary to the Swedish ambassador,

Kaempfer first traveled to Russia and the court of Moscow, making a number of interesting observations along the way. After a perilous crossing of the Caspian Sea, he traveled widely in Persia, where he recorded the way of obtaining bitumen or "mummy." His report includes the following description.

The collection of mummy/bitumen is quite a ritual. At the appointed time, high officers from the provinces of Lar and Darab meet at a rocky place close to the city of Darab. There, they set up a luxurious tent, then walk to the site of a cave whose entrance had been previously occluded by a huge boulder. A whole bevy of strong men is needed to roll it out of the way. Once this is done, the worker in charge of collecting "mummy" (i.e., bitumen) is lowered into the depths of the cave by means of a rope. He is armed with a spoon-like tool devised for scraping the material off the rock whence it exudes. Mind you, he is going to collect bitumen/mummy of the very first class: a stuff reputed to work therapeutic miracles. Because this material is scarce and difficult to procure, only a small amount is kept in the royal palace for the use of the supreme leader and his family. Thanks to the unbounded generosity of the sublime suzerain, a little of this AAA-mummy may have trickled down to the chosen few among his favorites. But no one else is supposed to appropriate any of it, under pain of death. This is why the following strict precautions are taken:

The collector goes into the cave totally naked, save for his private parts, to preclude the likelihood of hiding the material in his clothing. He is given some water, which he must keep in his cheeks to avoid the chance of hiding the mummy in his mouth. When he comes out of the cave, the first thing he

must do is to spit out the water into a jar in front of the government officials, so that they can all inspect it and make sure it is the same water he was given initially. This ensures that he has not replaced the water with his own urine, a method of deception known to have been used by workers who actually had ingested some of the precious material while inside the cave. Finally, says Kaempfer in his narrative, fingers go into his anus, to make sure he is not concealing the precious mummy inside his rectum.[47] Modern asphalt workers are known to face the risk of developing cancer of the lung or of the throat and mouth from daily exposure to cancerogenic fumes. But a daily rectal examination? This is an occupational hazard for which there is no parallel in the history of organized labor!

If all these precautions were taken, it was because the mummy from the district of Darab was deemed the very best. Kaempfer asserts that there are two kinds of bitumen: a choice one of nearly miraculous powers, and a secondary kind, of weaker virtue. First-class Persian mummy is so effective in uniting broken bones that, provided the fracture is first reduced, the limb will be firm and strong enough to be used in two or three days. If the fracture is very serious, external and internal treatment is recommended. A small amount of mummy is liquefied with a specified amount of butter. Part of the liquid is given to the patient to swallow; the remainder is anointed externally to the properly reduced fracture, then fastened with bandages smeared with the bitumen. No need for a plaster cast.

The German naturalist was not one to accept facts merely on hearsay. He tells us that it was his custom, with all alleged wonders of nature, to experiment for himself. That is precisely

what he did in this case. He bought fowl, broke the legs of the poor birds, and treated them with mummy. Except he could get only the inferior stuff, since "primary" mummy was generally unavailable. Accordingly, his results fell short of the hyperbolic praise of the mummy advocates. One day, he was berating as excessive the alleged benefits of mummy, when he was heard by the governor of Lar, who challenged him to attend a public demonstration where the excellence of royal mummy (he was among the few fortunate men who owned some) would be vindicated. Kaempfer consented, and recorded the proceedings thus:

> He took a quantity of precious Darabic mummy, the size of a small chickpea (two or three grains), and added to it three times the amount of secondary mummy for a larger subject. . . . A six-month-old fowl was brought out and I was assigned the job of breaking either of its legs. I completely broke one leg so that the bone protruded from the broken skin. I reduced the fracture, placed a warm band smeared with our balsam around it, and bandaged it firmly. The remainder of the liquefied balsam I poured down its gullet . . . and the fowl was kept in a dark place. The next day . . . the fowl was brought forth from the darkness and set free after its bandages had been removed. The fowl spread its wings, flapped them in joy over its freedom, and ran off spryly in search of food but with an ever so slight limp such as might be brought even on a healthy foot by the pressure of the bandages. Soon it gave evidence that it was completely free from pain by dashing for the grain scattered about and by the fact that it boldly attacked other fowl in an attempt to drive them away from the food. Those of us who had doubted the mummy's powers stood in awe.[48]

Kaempfer dissected the area of the fracture and confirmed that the bones had begun to unite by normal callus, the formation of which he judged to be taking place at an accelerated pace. Encouraged by this result, he actually tried the treatment on a human subject, using the mummy (presumably of "secondary" class) he had purchased while traveling in Persia. That he laconically dismisses the experience in a single line indicates that the outcome was far from encouraging. No one has since been able to obtain the extraordinary therapeutic results described by Kaempfer.

How did the term "mummy" change meaning, from bitumen or a bitumen-based remedy to a corpse that had been embalmed according to the ancient Egyptian custom? During the Middle Ages, when the great Arabic corpus of medical literature was translated into Latin, the term "mumia" was transferred with the meaning of "[waxy] substance used in embalming"; for, as I said above, it was a common belief that the ancient Egyptians had used bitumen in the embalming process. "It is the substance to which the celebrated Egyptian mummies owe their indestructibility," pontificated the author of a pharmacological treatise.[49] Subsequently, various translators asserted that this material was "mixed with the liquids of the cadaver." As new translations were added, the original meaning was further distorted. In short, from bituminous material, the word came to signify a mixture of aloes, bitumen, and exudates from an embalmed corpse. Ultimately—by a process of transference that is not hard to understand—the word "mummy" was applied to the embalmed bodies themselves.[50] Egyptians tended to be dark-complexioned, thereby

accentuating the confusion between the blackish embalmer's material and the flesh imbued with it. Ironically, a modern scholar contends, contrary to the reports of ancient historians, that the ancient Egyptians never used bitumen in the process of embalming, but used resin, which may simulate bitumen.[51]

In addition to these circumstances, the social and medical context of the times helps us to explain the success of the use of the body as medicament. Historians tell us that even in the seventeenth century, the bodies of different animals were still frequently used in the preparation of medicaments. Jean de Renou, physician to King Henry IV of France, stated: "We utilize various whole animals, including cantharides, sowbugs, small earthworms, lizards, ants, vipers, scorpions, frogs, crayfishes, leeches. Concerning their parts, our physicians maintain that they are endowed of various and admirable virtues."[52] The famous surgeon Ambroise Paré declared: "Rightly the ancients affirmed that all medicaments come from plants, from the earth, from water, from beasts, and the parts and excrements of these ones." A member of the Academy of Sciences toward the end of the seventeenth century stated: "Apart from the preparations that can be made of the skull of man and of his other bones, of his blood, of his flesh, of his 'mummy' or desiccated body, one can also prepare his nails, his hairs, his urine and his excrements."[53]

It was predictable that mummified bodies would become an immensely popular source of ingestible medicament. For the very word "mummy" evokes mysterious ceremonies, and secret, arcane manipulations performed on cadavers by artisans belonging to the sacerdotal class, who labored deep in some dark, secluded chamber. Ordinary people probably said

to themselves: "Surely bodies so prepared must have supernatural curative virtues!" What could not have been anticipated was the magnitude of the acclaim with which mummy medicine was received in the West—not only by the poor, mired in ignorance and superstition, but equally by the best-educated, the elite of Western societies.

Eating human remains (albeit embalmed)—or, to call it by its proper name, cannibalism—was not a phenomenon confined to fringe social groups. It occurred even among the most privileged and well-to-do. Among the supporters of this practice were Queen Elizabeth I of England, the distinguished Elizabethan surgeons John Banister (1533–1610) and John Woodall (1570–1643), the physician-astrologer-mathematician Robert Fludd (1574–1637), and no less an intellectual luminary than Francis Bacon (1561–1626), philosopher, statesman, jurist, author, and chief promoter of the scientific method in his time. In France, King Francis I would not go out on horseback without carrying a small sac of powdered mummy, whose fame as healer of fractures, wounds, and contusions was immense. It could be administered by mouth, via the rectum as an enema, or externally applied to wounds or ulcers. In America, the Reverend Edward Taylor, an English pastor who became a physician after graduating from Harvard in 1671, had a high regard for flesh, blood, heart, and other parts of the human body, which, he said, could be obtained dry in "shops of Mummy." His handwritten "dispensatory" shows that he often prescribed such medicaments to his patients.[54]

Mummy devotees spared no praise for its therapeutic effects. John Parkinson (1567–1650), great English botanist

and apothecary to King James I, affirmed in his monumental work "Botanical Theater" (*Theatrum Botanicum*) that mummy was "of much and excellent use in all the countries of Europe." The illustrious French chemist Nicolas Lémery (1645–1715), to whom we owe the modern concept of acidity and alkalinity, discoursed on the excellence of mummy as a curative agent, but warned against the existence of what today would be called "pirate mummies," that is, fraudulent versions sold as the authentic Egyptian product, but prepared at home by con men eager to cash on the prevailing high demand. He wrote that the "white mummies" had no curative power whatsoever. Those were the corpses of people who had died in the desert and been desiccated by the hot sun after being buried in the desert sand for a long time. Such mummies are no good; therefore, Lémery gives out this prudent advice: "You should choose the mummy that is neat, beautiful, black, shiny, with a strong odor that is not disagreeable. . . . It is detersive [cleansing], vulnerary [i.e., good for treating wounds and contusions], it opposes gangrene, it fortifies, it is good for contusions and to stop the blood from clotting inside the body."[55]

Throughout the Renaissance, the demand for mummies increased to such a point that their importation became a very lucrative business. Predictably, greed spawned all manner of frauds, impostures, and knaveries. The exportation of mummies was prohibited by the Egyptian authorities, but bribery has a way of discovering that, as someone once said, "a civil servant is civil to everyone but a servant to the devil." So it is that in 1586, an Englishman, John Sanderson, was able to ship 600 pounds of embalmed bodily parts, plus a whole body, whose fragments would be sold to English apothecaries.

A German traveler declared that it was possible "to buy an entire person in Cairo."[56] Two hundred years later, it was still possible for a private individual to purchase "an entire (mummified) person" in Cairo, as shown by the following anecdote.

A French antiquarian under King Louis XV made a trip to Egypt and bought a mummy that, in his estimation, was some three thousand years old. The conditions of travel at the time determined that the antiquarian's absence from home should last several months. When he disembarked at Marseille on his way back, he was very anxious to see his wife again, even though (or perhaps because) she was far from being an antique. He saw to it that his trunks and suitcases were transferred, and hurried to take a fast coach. In his haste, however, he forgot the precious mummy amid the boat's cargo.

Not long thereafter, the customs inspectors discover a wooden box of an unusual shape, open it, and . . . surprise! Inside they find a human body, apparently of a woman, all wrapped up in tight linen bands. Remember, this is southern France. No more is needed to suspect a crime of passion. Perhaps a disgruntled lover or a jealous husband murdered the unfortunate woman and hoped to stealthily take her for burial somewhere.

The chief of police is summoned, accompanied by the police department's physician; both, we assume, equally unversed in Egyptian archaeology. In the eighteenth century, Egyptology has scarcely reached the popular mind. They draft an act in which the crime is set down, corroborated, and, in a sense, made official. The box and its contents are sent to the morgue, in case the friends or relatives of the deceased come to identify her. It is a safe bet that they never came.

Meantime, the antiquarian recognizes his lapse, hurries back to the boat, and is told that the box has been transferred to the morgue. He appears there, and is confronted by the chief of police flanked by two police officers who arrest him *ipso facto*. They take him to a magistrate to make his declaration, according to current procedure. The accused demands an explanation.

—It is you, my good man, who owes us an explanation for the crime that you have committed.

—What is this? What crime are you talking about? May the devil take me if I understand a word of all this!

—Oh! The cheekiness of this man! Oh, the shamelessness! Enough of this! You should know that we have found the *corpus delicti* in your possession. Yes, we found the body of the victim, the woman whom you murdered and locked up in a big box, as described in the official record that has already been drawn up.

—Ah! So, *that* is what this is about?, says the antiquarian, unable to restrain some laughter.

—I would advise you, for your own good, to quit that mocking tone. This is serious business. But, if that is the way you wish to proceed, I will conduct the interrogation, and you give me the answers. Tell us, then, who placed that woman in the trunk in which we found her?

—I did, Sir.

—Write that down, Mr. Secretary! Who wrapped her with linen bands all around her body?

—I did, Sir.

—Write that again, please. The accused confesses his crime.

—That, Sir, is saying more than I said.

—We shall see who is right. Now, tell me, how old was that woman?

—She was quite young, she must have been between nineteen and twenty-three years old.

—Where was she from?

—From the Egyptian city of Memphis, I believe, although I am not sure.

—What a shame! To have come from so far away, only to be killed. . . . But, tell us, how long has she been dead?

—I figure about three thousand years.

—Ah, so, you want to continue playing the funny guy? Officer, bring the manacles, we are going to teach this clown a few more gags.

—If you dare to do that, Sir, this whole affair would cease to be funny. But, since you want me to be serious, I will tell you that you have given proof of an incredibly enormous ignorance. How could you not have realized that you were making a legal case on the suspicion of the murder of an Egyptian mummy?

—A mummy!

—Yes, Sir, a mummy. And if you had known how to conduct an interrogatory in the proper way, you would have found out that I am Count X**, and that, in my capacity as member of the Royal Academy of Inscriptions and *Belles Lettres*, I enjoy no little influence at court, where some very high personages will be most displeased to learn that in this municipality there are policemen and forensic physicians that can misestimate the date of a decease for about three thousand years.

The incident finished with the representatives of justice humbly asking for a thousand pardons, and the antiquarian recovering his mummy . . . after paying customs taxes and the

legal expenses incurred. For, as the chronicler drily comments, "Madame Justice never yields anything free of charge."[57]

It is not clear if the imported mummy in this anecdote was destined for the apothecaries of France. The incident took place when mummy as medicament was on the wane. We may get an idea of the state of mummy business at its peak from another anecdote, this one from the life of Guy de la Fontaine, physician to King Antoine of Navarre, who was sent in 1564 to investigate the famed mummy remedy in Alexandria. He located the principal Jewish merchant connected with the sale of mummies, and was taken to a warehouse where there was a large pile of bodies. We can easily imagine the conversation. The physician says:

> "I would be grateful to you, and I give you my word that my sovereign shall reward you generously, if you can let me know the ancient method used in this country to embalm corpses. I assume these here are the bodies of persons of quality, dignitaries, or rulers of some province of this country, since it was seen fit to preserve their remains and laboriously prepare them for posterity. I take it the ancient method is still in use."

To which the merchant rejoins, laughing:

> "Dear me! How can the Gentiles be so naïve? Your lordship will excuse me, but these are no ancient bodies. Why, I prepared them myself! Right now you are seeing here some thirty-seven or forty that are ready for shipment to the Christian lands, which seem so avid for this kind of fare. I've been at this for a good four years, since the business is booming and allows me and my family to have a good life."

> "You prepared them yourself, you say? But how could you get hold of the mortal remains of important personages? Don't

Egyptians care to revere and embalm the remnants of the men and women who served the country well, or, in general, of those who achieved fame somehow?"

"Famous? What are you talking about? These poor wretches were slaves, or executed criminals whose cadavers were left out to rot, or indigent men, or foreign, unknown individuals who died on the road and no one claimed them. It is true that in this country, with a little ingenuity and the proper means . . . if you know what I mean . . . it is possible to obtain the cadavers of exalted personages as well. But, fortunately, I did not have to do that. My stock, you see, has always been well supplied, without any need to resort to extraordinary measures."

"But, if what you say is true, that means you are sending over cadavers of people who died of terrible diseases, who were probably filthy and full of parasites, some perhaps victims of leprosy, or even of the plague!"

"I cannot deny that. But, for the life of me, I cannot understand why Christians would want to eat dead bodies. They seem to consider them a delicacy. Anyway, once embalmed, no one can tell if they are male or female, much less what they died of. Those who die are bound to have some disease, is that not true? But if that is what the people of your country want, and are willing to pay for it, I say fine. Let them have it!"

The great surgeon of the Renaissance Ambroise Paré (1510–1590) wrote that he talked to Guy de la Fontaine, who described for him the method employed by the merchant to embalm the bodies. This consisted in removing the brain and the viscera, deeply cutting into the muscles, filling the incisions with some type of asphalt, bandaging the whole body with linen soaked in the same bituminous substance, and then placing it in a kind of furnace where it could be

"cooked" slowly for two or three months. Moreover, it was impossible that the corpses sent to Europe should be those of the ancient kings of Egypt (as vendors commonly pretended), for the region was now "inhabited only by Turks, Jews, and Christians, who do not have the custom of an embalming ceremony. This was done when the Kings of Egypt still reigned there." Paré caps his indictment of therapeutic mummies with this no-nonsense fulmination:

> By these words of the Jew [i.e., the merchant interviewed by Guy de la Fontaine] we can see how they make us swallow, brutally and dishonestly, the stinky and infect carrion of the hanged, of the vilest riff-raff of Egypt's population, the syphilitic, the plague-stricken, or the thieves; as if there were no other ways of saving a man contused and wounded after falling from a height, than by inserting, as if pushing into his body, another man; or as if there was no other way to make him recover his health, except by a more than brutal inhumanity. Anyway, if this remedy was efficacious, truly that would be a reason to use it. But the fact is that this mean drug does nothing for the sick, as I have seen by experience in those who had been made to take it, but rather causes them a great stomach pain, with malodorous mouth and much vomit, which in turn commotions the blood, and makes it come out more from the vessels, instead of stopping it.[58]

Although there were always critics who, like Paré, spoke out strongly against the abominable practice, it is amazing how long it lasted. Samuel Johnson's dictionary, under the entry "Mummy," reads:

> We have two substances for medicinal use under the name of *mummy*: one is the dried flesh of human bodies embalmed with

myrrh and spices; the other is the liquor running from such mummies when newly prepared, or when affected by great heat. . . . What our druggists are supplied with is the flesh of any bodies the Jews can get, who fill them with the common bitumen so plentiful in that part of the world, and adding aloes and some other cheap ingredients, send them to be baked in an oven until the juices are exhaled, and the embalming matter has penetrated.[59]

The abbreviated reference at the end of this article says: *Hal's Mat. Med.* Therefore, mummy as a medicament was still mentioned in a *Materia Medica*—that is to say, a standard medical treatise—as part of the English pharmacopoeia almost at the dawn of the nineteenth century, since the date of publication of Johnson's dictionary was 1799. According to a present-day scholar, a German publication on folk medicine stated, as late as 1908–1909, that the highly respectable and renowned Merck-Darmstadt pharmaceutical company still offered in its catalog: "genuine Egyptian mummy, as long as the supply lasts, 17 marks 50 per kilogram."[60] In the medicine bazaars of the Middle East, it was still possible to buy mummy as late as 1927.[61]

THE BORDERLINE BETWEEN THERAPEUTICS, MYSTICISM, AND CANNIBALISM

It is a cruel irony that Europeans branded cannibalism as the ultimate manifestation of brutal, "uncivilized savagery," yet they engaged in it themselves. For a man to eat the flesh of his fellow was deemed a heinous crime than which no worse form of depravity could exist. It was in order to abolish vices

such as this that the conquest and subjugation of American indigenous peoples was predicated. Jurists and theologians engaged in painstaking labors to demonstrate that men who lived like beasts, as shown by the practice of anthropophagy, acted contrary to natural law. Therefore, Christian rulers had the right—nay, the moral obligation—to make war on them, to subjugate them, and to teach them good customs in accordance with the high moral values of Christian life.[62] The depredations, the ruthless destruction of their social structure, traditions, religion, and ancestral customs: all this was justified, although not without controversy, in the name of suppressing the "abominations" attributed to Amerindians, of which cannibalism was touted as the most detestable. In reality, acts of cannibalism among them were not the wild, frenzied orgies that the conquerors represented to the world. Bloody they undeniably were; but they were also highly ritualized ceremonies in which bits of flesh of the sacrificed subject were consumed only by priests, or by members of the nobility. Among the ancient Mexicans, the ritual, in the words of an English scholar, "took the form of a communion feast on the corpses of prisoners dedicated and offered to the gods."[63]

There was no lack of symbolism in the ways of European cannibals. It has been remarked that the poor wretches whose bodily parts were going to be used as medicaments were executed in ceremonies reminiscent of Aztec rituals. Public hangings in England were not silent and somber events: they were actual festivities, in which thousands of attendees applauded and jeered. The ceremony started with the procession of the criminal on the way to the gibbet; vendors set up carts and

booths; balconies and houses with a view of the gallows were rented at a well-calculated price.

Many scholars now acknowledge that the practice of cannibalism may have arisen out of sheer hunger, but was soon invested with a symbolic or religious sanction, so that at a later time, wherever anthropophagy remained, only exceptionally was it caused by hunger, or constituted a cruel act of vengeance.[64] A physical reason alone is insufficient to explain its occurrence. Most often, an ideology may be found behind it: that is, human flesh being consumed as part of religious ceremonies, or, as among Europeans, because of its assumed medicinal properties. The irrational mind senses the presence of arcane forces in the body—the hidden vital principle, a divine essence that pervades all things in the world, of which Schelling once said that it "sleeps in the stone, dreams in the animal, and wakes in the man." This is what the imagination sees in living flesh and yearns to capture. And what better way to appropriate it than to eat it? For, as Freudians would have it, to incorporate orally the objects of desire is to obey a primeval, deeply rooted instinct present at the core of our being.

For the imagination, death itself does not exhaust the ineffable energies believed to exist deep inside the parts of the body. The powerful, vital principle that dwells within a living body—especially a healthy, vigorous body—although assumed to flow out when its life is interrupted abruptly, yet remains susceptible of being absorbed into another body, there to exert its healing powers. Hence the many "cures" attributed to dead bodies. In nineteenth-century England, the treatment of wens (sebaceous cysts) was simple: all one had to

do was to rub the affected part thrice over against the hand of a hanged man. This remedy was "always attempted with complete success," according to a report. On execution days at Northampton, crowds of sufferers gathered around the gallows, so that they could receive what was quaintly called "the dead stroke." However, as months, then years, went by, the number of attendees decreased—not because the people had become better educated and less superstitious, but because the hangman was demanding a higher fee to let people touch the cadaver, or to touch the sick himself.[65] Indeed, in the absence of a cadaver the touch of the hangman was considered appropriate—second-line therapy, we would say today.

In the same English district, no remedy for toothache had greater efficacy than a tooth taken from the mouth of a corpse, which was often enveloped in a little bag and hung round the neck. The wide prevalence of this superstition across countries may be inferred from an etching by the Spanish master Francisco de Goya (1746–1828), entitled *A caza de dientes* ("Hunting for teeth"). In it, a woman is attempting to pull out a tooth manually from the mouth of a hanged man still suspended from the rope with which he was executed. The scene is strongly affecting: it takes place at night, in dismal surroundings; a lurid light falls upon the two personages; the woman averts her face and leans back in terror; she is trying to conceal the sight of the repugnant presence by interposing a veil with her left hand, while with her right she still struggles to pull out the tooth from the cadaver's mouth (fig. 3.4).

It is not difficult to see in these superstitions a close connection with the veneration of the relics of saints in centuries past. If the body of common mortals is endowed with

Figure 3.4
Etching titled *A caza de dientes* (Hunting for teeth) by Francisco de Goya y Lucientes (1746–1828). From Metropolitan Museum of Art (Public domain), https://www.metmuseum.org/art/collection/search/378019.

so mighty a healing principle, the body of the Saints, much closer to God by virtue of their supreme moral excellence, had to possess extraordinary sanative virtues. Nor is it possible to overlook the relation of these ideas to the Christian dogma of transubstantiation and the Eucharist. The Catholic teaching is that during the Mass, the bread and wine that are offered in the sacrament of the Eucharist are miraculously transformed—transubstantiated—into the body and blood of Jesus Christ, although our senses are unable to perceive this change. The recipient, who takes the host by mouth, is thus granted an incomparable salvific gift. It is no small irony that Protestant physicians strongly decried this Catholic dogma of transubstantiation, denouncing it as sheer cannibalism, while at the same time liberally prescribing mummified bodily parts to patients.

A seventeenth-century physician, described as a "sincere Protestant," drew a striking parallel between Christ's Eucharistic body and mummy therapy. He wrote that Christ's disciples did not eat and drink the Redeemer's fleshly humanity, but only his spiritual humanity, "his own Mumia, in which was the Divine and Human power."[66] The suggestion has been made that, for Protestants, the eating of mummy or other bodily products might have functioned, at some psychological level, as a substitution mechanism for the dogma of transubstantiation.[67]

The scholar Kenneth Himmelman has pointed out that the body stands at the crossroads between the physical self and the spiritual, between positive and negative forces, between good and evil.[68] Indeed, the body is the substrate of our loftiest spiritual exaltations, but also our most material, down-to-earth

experiences. This hybrid and ambivalent nature explains why the body is a perpetual source of bewildering dilemmas. A modified version of therapeutic cannibalism exists today, says Himmelman. It is not so much a "sublimated" as a "mechanized" version, but the end point is the same: parts of someone else's body are made to become part of a recipient body. This is what is accomplished with organ transplantation. Not surprisingly, this new form of body appropriation is accompanied by the same quandaries that have always attended our corporeal nature.

Transplant medicine only accentuated the fundamental contradictions that thrive in our embodiment. On the one hand, the language of medicine says that the organs of the body are material entities without personal identity. If a man about to receive a kidney transplant is worried because the donor is a woman, the doctors will tell him not to worry: the kidney is *only* a machine in charge of excreting waste products; it works equally well in both males and females. If a woman about to undergo cardiac transplantation timidly inquires whether she will feel the same affection for her husband and her children after the operation, the physicians will tell her that the idea that love resides in the heart is pure superstition; for the heart is *nothing more* than a muscular machine in charge of propelling the blood. Organs, therefore, are contrivances, machines, engines; in a word, things—incredibly complex gadgetry, if you will, but things nonetheless.

On the other hand, these "things" are alive. A high rhetoric is used to encourage organ donation. It speaks of "giving the gift of life" (it goes higher yet, as some say "the miracle of life"). What is this marvelous or "miraculous" gift that

may be given, if not the portentous healing powers which an ancient belief situates inside bodily parts? By the same token, it is usually said, to the surviving kin of a deceased person whose organs may be used for transplantation, that through this donation their beloved will "live on" in another body. But how can this be, if the transplanted organ, a mere thing, a machine, does not carry with it the identity of the donor? The wording used to promote organ donation as an altruistic act openly contradicts the language of clinical medicine, which, by restricting the organs to the purely material domain and dismissing as "unscientific" any attempt to attribute to our anatomical parts the transcendent character of something other than "things," tends to "disassemble and dehumanize the body," as some writers have stated.[69]

The contradiction becomes plainer when we realize that even those directly involved in the technology of organ transplantation are just as confused as everyone else. It is reported that a cardiac transplant surgeon, having heard that a debate was taking place regarding the possibility of obtaining the organs of prisoners sentenced to death and transplanting them to needy patients, expressed his reservation by saying, with embarrassment: "I wouldn't like to have a murderer's heart put into my body."[70] So much for the scientific conceptualization of organs as mechanical contraptions devoid of personal identity!

This goes to show that, for all our talk of bio-techno-human hybrids (cyborgs), electronic-powered, faultless synthetic organs, genetically engineered body parts, and other marvels, we have not even begun to answer some fundamental questions about what it means to live our life as *embodied*

beings. One such query addresses the very core of our perplexity. It was formulated with admirable conciseness by the American philosopher and psychologist William James (1842–1910) when he asked: "And our bodies themselves, are they simply ours, or are they us?"[71]

4 HAIR: IS IT A DISTILLATE OF HUMAN ESSENCE OR A DISCARDABLE REFUSE?

HAIR'S ASCENT: FROM SOOTY CRUST TO INWARD-GROWING BADGE OF SUPERIOR VITALITY

One of the physiological theories of centuries past which I find particularly striking refers to the nature of hair. The savants of bygone days thought it was a waste product, or, as they commonly put it, "an excrement"—in the pristine acceptation of this term given by the *Oxford English Dictionary*: "that which remains after a process of sifting or refining: the dregs, lees, refuse." As early as 1565, always according to the authoritative *OED*, the word was used in physiology with the sense of "that which is cast out of the body by any of the natural emunctories." Hence, when applied to hair, it soon acquired the meaning of something superfluous which must be expelled or excreted.

According to the ancient physiologists, this is how the hair formed: the blood carried in solution a sooty or soot-like ("fuliginous") part, presumably a result of combustions throughout the body. This fuliginous "excrement" was

vaporized and pushed by the heat of the body to the surface, where it condensed, and was pushed out via the skin pores. The hair, therefore, was not considered a part of the animated body. In consequence, it grew not by addition of fluids or living substance, like any other part of the body, but by "juxtaposition." In other words, as each new part of refuse is added, it thrusts the old forward. The parallel with the digestive system's manner of elimination seems unavoidable. The alimentary refuse is eliminated in the way we all know, with this difference: that the elimination is always accompanied by more or less conscious effort; the "fuliginous" refuse, in contrast, is cast out insensibly, through the skin pores.

Presumably, the theory that hair is "excrement" occurred to the experts because when the hair is cut it soon grows again: the elimination must needs be constant, day after day. Hair regrowth occurs even in extreme old age, as well as in states of debilitation and marked emaciation. The rest of the bodily economy may wither in a sorry state of disrepair; it does not matter, the hair will continue to grow, apparently with undiminished vigor.

If, as the physiologists of the olden days proposed, the formative elements of hair are present in the blood, one would expect to see abnormal states in which such fuliginous matter condenses before reaching the body surface. Accordingly, classical antiquity reported some celebrated instances in which hair, instead of occurring in its natural place on the external surface of the body, grew in its interior. One of these case reports we owe to Pausanias, in his *Description of Greece* (book XIV, 7, xv); it concerned a Greek hero named Aristomenes, who was a citizen of Messenia, a region in southwestern

Greece. Unhappy to live under the yoke that Sparta had imposed on his fatherland, Aristomenes rebelled against the oppressors and led a bloody guerrilla (about 625 to 600 BC) which caused them a great deal of concern. Pausanias compares this man of action, bold and fearless to the point of temerity, to none other than Achilles, he of the indomitable temper in the *Iliad*. To the Spartans, Aristomenes was more than a mild irritation. If we are to believe the chroniclers, he alone slew no fewer than three hundred Spartans. Twice he was captured, and twice he escaped. Pliny narrated these daring escapes. The first time he was severely wounded, taken prisoner, and confined to a cave in the quarries. He broke away by following the narrow passages used by foxes. The second time, "when the guards were fast asleep, he rolled to the fire and burnt off his thongs, burning his body in the process."[1]

Having foiled all efforts to keep him down, Aristomenes was truly a thorn in the flesh to the Spartans. Only Spartans, to his misfortune, were not the sort of enemies one could grow complacent about. The day came when the Messenian hero fell for the third time into Spartan hands. His captors put him to death, opened his heart, and found it full of hair. We are not told whether it was of the same color and texture as that which grew on the fallen hero's scalp. A colloquial Spanish expression equates a man's chest hairiness with manliness: *Un hombre de pelo en pecho* ("A hairy-chested man") is one who is virile and always undaunted. Aristomenes clearly took this saying to a ridiculous extreme.

Several traditions had it that other valorous men shared this characteristic. Among them, the best known is Leonidas, the Spartan general who led a party of three hundred men

in an attempt to defend the Pass of the Thermopylae against hundreds of thousands of Persians. While the Greeks were at dinner, the "barbarians"—that is to say, the Persians—fell upon them. Leonidas' memorable reaction was to invite his men to "eat heartily, for they were going to sup in another world." This, at least, is the way Plutarch recounted the event in his *Parallel Lives*. Leonidas perished from the many wounds received in combat. But before he went to sup in another world, he was brought before Xerxes, the Persian king, and there the Spartan enacted one last show of his incredible boldness: he tried to take Xerxes' crown from his head. Predictably, he died in the attempt. Xerxes, angry and full of spite, ordered his body to be cut into pieces, and that is how Leonidas came to be diagnosed as having cardiac hirsutism. From all of which Pliny concluded, in his *Natural History* (XI, 184–185), that a hirsute heart is the appanage of the fierce and bold-spirited.

On the other hand, a hairy heart could be present in men of more peaceful and quiet disposition. This was the case in Hermogenes of Tarsus, whose claim to fame was consolidated not on the fields of battle, but in the more civil halls of rhetorical debate. According to one biographer,[2] Hermogenes was a sort of boy prodigy of rhetorical studies. Barely in his twenties, he had caused such a stir in Rome's intellectual circles that the philosopher-emperor Marcus Aurelius came to hear him speak, and was so impressed with his performance that he showered him with gifts and benefits. Then, suddenly and without clear explanation, his mind crumbled. From the brilliant rhetorician and moving orator that he had been, he was transformed into a babbling and incoherent dunce. So pitiful a change allowed one of his rivals to mock him, saying

that "he used to be old among the boys, and now he is a boy among the old." Scholars wonder if he suffered some kind of mental breakdown. Alternatively, he may have fallen prey to one of the many infectious diseases that were the scourge of classical antiquity.

Unfortunately, the science of pathology did not exist yet; no pathologist was there to examine Hermogenes' remains and tell us the cause of his demise or the status of his heart. Nevertheless, cases of this nature kept on being reported. Antonio Benivieni (1443–1502), Florentine physician, one of the founding fathers of the specialty of anatomical pathology and a pioneer in the use of the autopsy in medical studies, found a "heart stuffed with hair" in the cadaver of an executed criminal. Probably influenced by the ancient tradition, Benivieni interpreted this finding as "a sign of rare fortitude."

In the sixteenth century, dissection of an executed man in Venice revealed what was called *cor hirsutum*, although we lack its detailed description or graphic representation. Additional cases continued to occur along the years. A medical historian has reviewed them recently under the reasonable assumption that when the authors of times past speak of a heart "stuffed with hair" we should understand "covered with hair," since the term "shaggy heart" has long been in use to designate a specific appearance of the heart in pericarditis.[3] Indeed, "shaggy heart" is a term, familiar to experts, that vividly describes the appearance of an inflamed pericardium, the membranous sac that encloses the heart and covers its external surface.

Briefly defined, "fibrinous pericarditis" is a form of inflammation of the pericardium that may accompany numerous

diseases, such as infections, cancer, trauma, and others. Nor is this really a discovery of contemporary medical experts. In the late eighteenth century, the great Swiss physiologist Albrecht Haller (1708–1777) noted that pericardial fluid may form filaments that attach to the heart and look like hairs. Today's pathologists, with an unseemly but inveterate taste for gastronomical comparisons, often refer to the appearance of inflamed pericardium as "bread-and-butter pericarditis."[4] Fibrin, a large, insoluble fibrous protein that forms a mesh during blood clotting, deposits abundantly upon the pericardial membrane in these cases. It forms a thick, usually yellow coating (hence the graphic name those gluttony-oriented pathologists were pleased to give it) in which fibrin molecules assemble into numerous visible fibrils which end up imparting a veritable "shaggy" appearance to the pericardium.

I find it surprising that apparently no ancient medical writer ever used the reports of "hairy hearts" as confirmatory of the theory that hairs originate from fuliginous products of the blood. This is all the more surprising when we reflect that the heart was not the only internal bodily part in which hair was supposed to have grown. Girolamo Cardano (1501–1576), strange genius of the Renaissance, was quite direct: he claimed to have seen hair in the blood of a Spaniard. Unfortunately, one never knows what to think of the sayings of this bizarre savant, who combined profound observations with the most singular, idiosyncratic reveries. Of him it was said that "in some things he was above human intelligence and in others beneath that of children." The eminent Dutch physician Boerhaave put it in Latin, as was natural for medicos in the past, stating that Cardano behaved as "a wise man where no

one had wisdom, and like a madman where no one erred" (*sapientor nemo ubi sapit, dementior nemo ubi errat*).

The Portuguese Jewish physician João Rodrigues de Castelo Branco (1511–1568), better known by his Latinized name, Amatus Lusitanus, is often credited with having reported the growth of hair in the tongue. No one says he was using metaphorical language to describe the patient as too reserved or retiring; for in Portugal, Spain, and Italy, "not to have hairs in the tongue" means to be plain-spoken, unrestrained, and blunt. One Eustachius (not further identified) has also been credited with the observation of hairs in the tongue, except that in this case the tongue in question was that of a dog. The discovery was made in the dog belonging to Alexander the Great. Soon after the animal died, it was dissected, and hair was found in its tongue. We have no reason to doubt that it was real hair. Hair follicles, duly authenticated by biopsy, have been rarely demonstrated in the canine tongue.[5]

Lusitanus and other early observers may have seen what clinicians have colorfully known as "hairy tongue," a benign and fairly common condition, especially prevalent in the elderly, and more in men than in women. The top (dorsal) surface of the tongue is normally provided with small, thin projections or "filiform papillae." Due to poor oral hygiene, to a natural predisposition, or other causes, there is a build-up of keratin on top of these formations. Normally, they do not exceed one or two millimeters in length; but, as keratin accumulates, they acquire the appearance of true hairs, on occasion one or more centimeters long. Growth of fungi and bacteria among the keratin debris may impart a vivid color to these overgrown structures. Just as it is sometimes said that

"tongues of hair" come out of the head, so now it may be said that the tongue bears its own "head of hair." This may be black, blond, auburn, reddish, or, in some cases, strikingly green, blue, or otherwise brightly tinctured, depending on the kind of fungi and bacteria that proliferate on the papillae. This abnormal appearance, although striking, is generally inconsequential and without symptoms.

But of all the internal parts of the body, none is more susceptible to develop hair, and none more impressive when subject to this occurrence, than the ovaries. The ovary becomes the seat of the hair-containing abnormal growth that has come to be known as "dermoid cyst," which is now accepted as a member of the family of tumors technically designated as "teratomas" (from Greek *teras* (gen. *teratos*), a wonder, monster, monstrosity + *oma*, a tumor). By definition, these tumors are composed of a variety of tissues that are not native to the sites where they occur.

Few specimens elicit the singular emotion present in those who view one of these tumors for the first time. It is a mixture of revulsion, curiosity, dread, uneasiness, and fascination. The mass consists of a cyst of rather thick wall and white-grayish external surface; the internal surface is usually grainy and described by authors of the past as "tomentose" (a word meaning "covered by densely matted hair"). The cyst wall looks like macerated skin. Such, in fact, is its nature, since the microscope reveals that it contains hair follicles, sweat glands, and other skin adnexa. This makes it unlike the wall of any other cyst of the ovary. The cavity of the cyst is occupied by an oily sebaceous material, relatively firm, that has been secreted by the wall, and in which masses of hairs aggregate into veritable

locks or tufts of variable length. Whether these hairs are of the same color and texture as those of the patient who bears the tumor is not something apt to preoccupy today's researchers. In the past, however, investigators deemed it a point worthy of attention,[6] as we will see shortly.

After the initial shock subsides, the question surges inevitably in the mind of the observer: how is it possible to have hair in the ovary? But the puzzlement rises to the point where one can scarcely believe one's own eyes upon discovering, in the midst of this mass, one or more well-formed teeth, or in some cases a more or less complete mandible, with its teeth nicely ensconced in their respective alveoli. Still more: there may be fragments of bone of perfectly normal structure, debris of cartilage, and, not uncommonly, brain substance or tissues that, under the microscope, look like the rough draft of an eye. Hair, teeth, brain, eye tissues, bone, and cartilage grow in the ovary? Yet other tissues, completely foreign to the ovary, like intestinal tissues, are sometimes found to be part of these tumors.

Few questions have excited the curiosity and taxed the sagacity of investigators more than the origin of teratomas. An early hypothesis proposed that a teratoma was, in essence, a modified form of conjoined twinning. Two early embryos developing in parallel could produce two distinct individuals that might become fused at various points: such are conjoined ("Siamese") twins. But if development was not parallel, one of the embryos, lagging behind the other, could remain rudimentary and be englobed by the other. The coalescence of the two would produce what the ancient terminology—with little regard for political correctness—referred to as a "monstrosity"

in which one of the embryos will develop into a normal individual; the other, incompletely developed, and having tissues completely disorganized, would be a "parasitic" twin, or a teratoma. Nineteenth-century authors called this the "fetal inclusion" hypothesis of the origin of ovarian teratomas. One advocate of this hypothesis wrote:

> To demonstrate that the ovarian dermoid cysts were really *Double Monsters*, I tried to ascertain the COLOR of the hair in every case of cyst of this nature, although my research is not complete. In effect, it is known that in the double monsters (especially those that survived), as well as in identical twins, the hair is always of the *same color*, by virtue of the same origin of the fetuses and their great physical resemblance: If, therefore, one day it is confirmed that in a certain number of cases there is identity of color between the hair of the patient carrying the cyst, and those of the dermoid cyst, it will be at least a beginning of proof [of the "fetal inclusion" hypothesis].[7]

A short note on this same subject was published by an English physician. It was inconclusive: the hair present in a dermoid cyst was "of two distinct shades, very dark brown at one pole and tawny at the other. The patient's hair was very dark, streaked with grey, and "she could not tell the color of her father's hair, as he was already grey in her earliest recollection."[8] It will be noted that, according to the "fetal inclusion" hypothesis, the tumor is, strictly speaking, the patient's brother or sister.

In view of the multiplicity of tissues found in ovarian teratomas, it was proposed that they were out-and-out pregnancies anomalously developing inside the ovary. In support

of this hypothesis was the fact that the majority of dermoid cysts of the ovary occur in women during their reproductive years. The problem arose when young virgins were diagnosed with this condition. No matter: the physiological turmoil and upheaval of strong erotic emotions was enough, declared the learned doctors, to initiate tumor formation. Consummate Latinists that they were, one of them coined the expression "*Lucina sine concubitu.*" Lucina, in ancient Roman religion, was the goddess of childbirth. Hence the expression meant "childbirth without sexual relations."[9]

In time, it became known that the human female reproductive cell, the *ovule* or "*ovum*," normally quiescent until the time of fecundation, may sometimes start dividing without any need for the male element. This happens in *parthenogenesis*, a normal reproductive process in some invertebrates. The human ovum, too, can undergo spontaneous parthenogenetic multiplication, but never succeeds in fashioning a complete fetus. An old hypothesis would have it that parthenogenesis accounted for the mass of distorted and disorganized tissues that compose a teratoma. We seem to hear an echo of Aristotle's ideas. For the Greek sage maintained that in human generation man contributes the master plan, so to speak, of the new individual; and woman contributes the building material, but by herself, alone, she can fashion only disarrayed, chaotic masses of flesh. We should note that, according to the parthenogenetic theory, the tumor is, in strict sense, the patient's son or daughter.

The origin of teratomas, a fascinating biological process, is alien to our purview. Suffice it to say that today's researchers, having on hand the astonishing resources of molecular

biology and biotechnology, have ascertained different origins for teratomas of different sites. Their studies have attained such a degree of sophistication that the old concern about the color of the hair in teratomas is made to appear irrelevant, backward, and even childish. Still, the concept of "fetal inclusion" remains current, and the distinction between an "included" twin (called "fetus-in-fetu" in medical terminology) and a true tumor (teratoma) continues to be a subject of controversy.[10] Firm criteria to distinguish the two are lacking, and intermediate forms exist.[11] Both characteristically display a large number of tissues; but hair, so prominent a part in ovarian teratomas, receives scant mention in reports of "included" twins. Sometimes, however, it has figured prominently, as illustrated by the following report from mid-twentieth-century medical literature.

A nine-day-old male infant was discovered to have a small tumor inside the abdomen, qualified as "the size of a small egg"; it was mobile, and completely painless to palpation. The local physician recommended a watchful wait. Twenty months went by without incident. One day, as the toddler was running around in his parents' apartment, he suddenly doubled down and cried for a long time. Reexamined, the tumor had grown to "the size of a cantaloupe melon." It was spheroidal, quite mobile, and painless. X-ray examination revealed the presence in it of structures compatible with an ill-developed fetus: there were bones suggestive of skull, limbs, and a vertebral axis. At operation, the surgeon encountered a tumor, "large as two adult fists," made of a cystic pouch that contained some liquid and a solid mass. The solid portion consisted of what the surgeon, with rather optimistic conviction,

declared to be a "perfectly recognizable" fetus measuring 14 centimeters (5.5 inches) from top to bottom. Allowing for the surgeon's reassuring enthusiasm, it is true that limb buds and some suggestion of facial primordia are recognizable, although the report provides us with a drawing of the specimen, not a photograph (fig. 4.1). After the operation, the boy maintained excellent health.

The likely explanation of this medical curiosity (fetus-in-fetu is said to occur once in every 500,000 births, and fewer than 100 cases had been reported worldwide at the start of the present century)[12] accords well with the "fetal inclusion" hypothesis. A very early twin embryo, unable to implant in the womb for whatever reason, could penetrate into the body of its co-twin during the second or third week of gestation, when the body wall is still unclosed. Alternatively, a cluster of highly

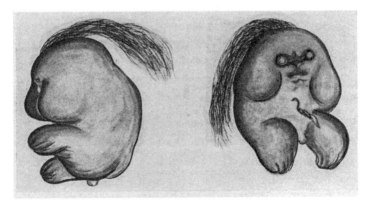

Figure 4.1
Drawing of fetus-in-fetu found in the abdomen of a twenty-month-old boy. From P. Lombard et al., *Bulletin de l'Académie Nationale de Médecine* (Paris, November 24, 1953), 574.

potent cells of one embryo detaches and implants somewhere within its own developing body as a "parasitic" twin. Cases have been documented of a fetus "included" inside the skull of his partner. (The reporting physicians could not refrain from wondering whether the mythical birth of Athena could have originated from observation of one such case).[13] The conditions for development are always suboptimal anywhere outside the maternal womb. This would explain the stunted, thwarted, grossly deformed features of the abnormal fetus.

The feature that most caught my attention in the drawing of the "included" fetus[14] shown in Figure 4.1 was the hair. A long tuft of hair surges panache-like—gaudy, ostentatious, flamboyant—from what is presumably the cephalic end of the distorted fetus; and we see it streaming down for a length equal to the largest dimension of the fetal body. Other tissues may have seen their development aborted; some no doubt were totally blighted, and disappeared. But the hair emerged feracious, luxuriant, as it is wont to do in the young. Human hair will lose his growth impetus with the years. Caducity is its nature: more pronounced in men than in women, yet perishable in both. But for at least a part of the life of the individual, its growth seems irrepressible. This could be explained only by proposing that hair was not just a waste product, but a living part of our own selves, with its own period of abundance and vigor, followed by waning and obsolescence. As the Enlightenment arrived, most scientists were of this opinion.

Contrary to medieval scholars, for whom hair was, in their words, "an excrement," naturalists now agreed that every hair "does properly and truly live." The famous *Encyclopedia* of Diderot and D'Alembert, states: "The moderns believe

that each hair and perhaps each fiber that composes it [each hair was thought to be composed of an aggregate of five or six small microfilaments enclosed in a sheath] lives in a strict sense; that it receives a fluid that fills it and dilates it, and that its nutrition does not differ from that of the other [body] parts."[15] Hair grows, affirmed the biologists of the Enlightenment, not by "juxtaposition," as formerly believed, but by "introsusception" (today more commonly said "intussusception"), a pompous term by which they meant growth and distension owed to the nutritive fluids that arrived into the hair via the tiny canal or tube that each individual hair was believed to bear in its center. Hairs lived, and, like all living things, they inevitably arrived at their own stage of decline. Naturalists pointed out that when the withering phase came, the hairs whitened as a whole, not beginning at the roots and progressing to the extremities, but the entire length of the hair at the same time, which shows that there is a direct communication between all parts of each hair.

On the other hand, they had to admit that the life and growth of the hair are different from those of the rest of the body; for the body may decline in disease and old age, while the hair keeps growing, seemingly with unabated vigor. The hair's nutriment came from the body, but surely not from the same juices that sustained all the organs. In the absence of a satisfying scientific explanation, they came up with a poetic metaphor. The growth of human hairs is like that of plants. Have you not seen a green shoot sprouting out of a fallen, decaying tree trunk? Plants may grow from the parts of others, from which they derive their nourishment. So does hair, whose sustenance comes from some juices of the body and

manages to live an independent life, even when the body may be starved.

THE PEAK OF HAIR'S GLORY: ITS ASSOCIATION WITH MAGIC AND BEAUTY

This relentless growth, unfaltering in disease, unwearying through fatigue, hunger, or psychic distress, could not have failed to impress the reflective and titillate the imaginative. Hence the creation of fantastic stories about the hair's proliferative potency. An often-quoted report in this context came in 1680 from Germany. Various authors attribute it to a chronicler named Wulferus, who, in his work *Philosophical Collections*, gave the account of a woman buried at Nuremberg, whose grave was opened forty-three years after her death.[16] Her hair had continued to grow all these years, and so luxuriantly that it was found to cover the whole extent of her body. During the exhumation, as soon as the black-painted coffin appeared, it was noted that her hair had managed to grow out of it through the interstices it had encountered. When the cover was removed, it looked as if the body had retained its shape, but this was a deceptive appearance; for when the grave-digger tried to handle the head, everything crumbled. There was no skull or any other bone: all had turned to dust. All that remained in the grave-digger's hands was hair; solid, long, thick, and curled hair.[17]

So great was the vitality attributed to hair that many people believed it continued growing even in carcasses. More than one far-fetched account described men who were hanged, left suspended as a public example of the power of justice and a

deterrent to potential criminals, and their hair continued to grow while the decomposing body was left exposed on the gallows.[18] Another Kafkaesque story dates from the eighteenth century. It concerns a Frenchman, Professor Tamponette, eminent "man-midwife" and self-appointed naturalist, who possessed a private collection of nature's curiosities. Included in it was the cadaver of one of his students, an exceptionally hirsute and thickly bearded young man, whom the professor embalmed, it was said, according to the method used by the ancient Egyptians. One day, the beard accidentally caught fire, and the originator of this accident, one of Tamponette's students, was desperate. To remedy the mishap, he thought of no better expedient than to take out his own razor blade and soap, and *ipso facto* shaved off the mummy's beard entirely. The next day—miracle!—the beard had grown back, and continued to grow so vigorously that it had to be shaved weekly, for years, to the unbounded admiration of the many visitors to Tamponette's collection.[19] A note in an English encyclopedia included, with British circumspection not lacking irony, a note warning the readers that "some moderns deny the authenticity of this and similar instances."[20]

Today, forensic pathologists, coroners, physiologists, and other experts agree that claims of postmortem growth of hair and nails are false. During life, nails grow at a rate of 0.1mm/day, or 0.12 inches/month; and hair, about 0.35mm/day, or approximately 0.4 inches/month. As with all bodily structures, this growth depends on cellular activity. The cells that produce the material of which hair and nails are made require oxygen. In death, the blood circulation ceases, and so does the supply of oxygen to the cells. Continued output of their

products is therefore a biological impossibility. But in death there is also desiccation of tissues, a consequence of which is shrinking; and as the skin dehydrates it retracts from the base of hair and nails, creating the optical illusion that these have grown. These trivial facts have become widespread knowledge, but it is difficult to completely eradicate old beliefs, especially those once endorsed by the best-informed elements of society.

An example of the diffusion of this fiction began on October 16, 1840, when the British government, in an apparent act of reparation, gave up the body of Napoleon Bonaparte to the French nation. Dr. Remi-Julien Guillard, the physician appointed to supervise the arrangements, prepared a report after examining the remains of the great hero, nineteen years after his death (Napoleon died on May 5, 1821). Decomposition had been delayed, probably due to the characteristics of the place of interment and the hermetically closed triple coffin that had been used. The doctor wrote that the facial tissues were remarkable for their soft, supple feel and whitish color, except those of the chin, which "were slightly blue, and derived that color from the beard, which appeared to have grown after death."[21] This simple, guarded statement sufficed to trigger a whole series of affirmations about the remarkable postmortem growth of the fallen emperor's hair. His faithful valet, Louis-Joseph Marchand, was heard commenting that he had personally clean-shaved his master a few hours after his death, yet at exhumation the face was covered by a beard whose growth, in his estimation, must have taken weeks. A medical treatise of 1847 roundly declares that hair grows after death, and that the beard grows faster "because of the habit of cutting it off."[22]

A bodily part perceived as possessing a death-defying potency inspires awe. But the inherent vital power of hair manifests in other ways. Cardano, the aforementioned eccentric Renaissance genius, described a Carmelite monk who, every time he combed his hair, caused sparks to shoot out of it. This uncanny feature earned him great popularity. People invited him to feasts so that he could demonstrate it, to the merriment of the other guests. By the same token, the Italian scholar Julius Cesar Scaliger (1484–1558) described a noblewoman whose hair, as it was combed, seemed, as he put it, to "vomit fire."

A jaded age such as ours, upon hearing these stories, rejoins: So what? Everyone knows that static electricity is generated by hair; and anyone who strokes a cat's fur against the grain, in the dark, is apt to see a similar phenomenon. But the ages that preceded ours were undoubtedly more susceptible to poetic flights of imagination. They took pleasure in accumulating stories of this kind, and embellished them with colorful details. The Jesuit Father Petrus Faber claimed to have seen a noble and beautiful lady who, as she combed her hair in his presence, produced so many sparks that they flew into her lap "like stars falling from heaven." And we are told that this phenomenon so scared her that she fainted, and those who saw it had to comfort her by joking with her about the incident.[23]

As eminent an authority in spiritual matters as St. Augustine of Hippo wrote that there are men so constituted that they differ from the rest of mankind; that their bodies seem to be disengaged from obedience to the laws of nature; and that they are capable of actions that no one thought possible for beings made of corruptible flesh. The examples that

he summoned in support of this idea are neither unique nor truly exceptional. He said he knew of men who could swallow incredible numbers of hard objects, then elicit a slight contraction of the diaphragm and recover them all intact; men who—*without moving their head*—could make their hair fall onto their forehead, and then in the opposite direction, toward the back of their head; and men who could fart at will, without a stink and musically, "as if they were singing from their behind."[24] Again, all these things would leave our satiated age in its usual state of insensitiveness and indifference. Swallowers of knives and stones we have seen at cheap roadshows; scalp-movers may be rare, but we would not think them shocking; and "vocalists from behind" were once epitomized by Joseph Pujol, the incomparable "fartiste" who during the *belle époque* drew big crowds to the Parisian Moulin Rouge nightclub, to hear him intone "O sole mio" without using his mouth or his vocal cords.

How could people refuse credence to accounts of the prodigious, when the worthiest and most reliable historians, not excluding figures of the stature of St. Augustine, seemed ready to back these reports? Hence, stories about the ability of hair to spontaneously burst into flames did not seem all that incredible. Livy, in book I, chapter 39 of his *History of Rome*, tells us that there was once a boy, named Servius Tullius, whose head burst into flames while he was asleep. The outcry was so strong that people ran to bring the king and queen to watch this miraculous phenomenon. A servant had brought a pail of water, and was about to pour it on the sleeping boy, but the queen, Tanaquil, checked him and said that the young lad should be left to sleep until he awoke by himself. She then

drew her husband, King Tarquinius Priscus (fifth king of Rome, from 616 to 579 BC), aside, and, citing the precarious conditions in which the boy was being reared (for his mother was a foreigner and a slave), and the preternatural occurrence of which he had been the subject, convinced her royal spouse to adopt him. This was done. The boy was reared with all solicitude. The king betrothed his daughter to him, and eventually Servius Tullius became the sixth and penultimate king of Rome, who ruled with universally acknowledged benevolence from 575 to 535 BC.

Another event of this kind was said to have taken place during the second Punic War, in the third century BC, in Hispania, as Spain was then called. Rome was battling for territories against her enemies, the Carthaginians. By 212 BC, the Romans had been victorious several times, and felt overconfident, so they decided to divide their army into two contingents. But fortunes then turned against them, causing their defeat and the deaths of the two commanding generals, the two Scipios: Publius Scipio and Gnaeus (also written Cneius) Scipio. Great sorrow and discouragement seized the Romans, for their forces seemed utterly destroyed, and the enemy was fast approaching. Yet there was among the Roman troops a young man so superior to the others in distinction, influence, and courage that the leaderless men, by unanimous vote, decided to confer on him the supreme command. His name was Lucius Marcius.

Livy says that as Lucius Marcius passionately harangued his soldiers, it was seen that flames came out of his head without his being conscious of them, and without causing him any harm. After seeing this prodigious occurrence, the soldiers

recovered their former valor. Valerius Maximus, Roman historian of the first century AD, wrote that, infused by new impetus, the Romans slew "thirty-seven thousand of the enemy, took a great number of prisoners, and captured two camps

Figure 4.2
Lucius Marcius' hair bursts into flames as he harangues his soldiers. From *Histoires prodigieuses extraictes de plusiers fameux auteurs grecs et latins, sacrés et prophanes, mises en nostre langue par P. Boisteau surnommé Launay* (Paris: Charles Macé, 1575). From Wellcome images. Wellcome L0025541.jpg, https://wellcomeimages.org/indexplus/image/L0025541.html.

full of Punic riches."[25] This story so captivated people's minds that we find it as a favored literary topos nine centuries later.

Today, the advances in biology have been so great that new vistas, formerly inconceivable, have opened up before us. We no longer view hairs as some kind of inanimate "excrement," as did medieval scholars; nor filaments that live like plants, as did naturalists at the onset of the Enlightenment. Our own concept (not to say our current fantasy) is eclectic in this regard: mature hair shafts, which protrude above the skin surface, are non-living fibers; the part that exists beneath the surface—the hair follicle—consists of living cells that produce the shafts and are constantly engaged in alternating cycles of growth, quiescence, decline, and renewed growth. The number of synthetic processes of which these cells are capable, and their exquisite coordination, staggers the mind. These processes are just beginning to be understood at the molecular level. Laboratory examination of a single hair may yield a great deal of information about its bearer: presence of drug abuse; evidence of poisoning; congenital diseases; and more. This information may be so intimate and so personal (for instance, genetic information) that in the United States the courts of law have been urged to protect individuals from the unauthorized taking of their hair. Unauthorized hair-taking has often been done under the pretext that hair is a waste product, and hair-taking a minimally intrusive procedure eliciting negligible pain.[26]

Each hair is a microcosm. In times past, this realization would have profoundly impressed us. For anatomical knowledge was cultivated not in view of scientific or utilitarian ends, but for the moral improvement that it was believed to

accomplish in the learner. It was reasoned that contemplation of the exquisite perfection of the body structures necessarily induced humble reverence and religious awe. The unique fitness of every part, and the arrangement and coordination of the whole, plainly revealed the supreme wisdom of the Maker of all things. Only today, not everyone is apt to see the divine sapience traveling in a single hair. Nor is everyone convinced that the universe is created by design, let alone through the agency of an omniscient, beneficent designer.

What could possibly convince men of the majestic power of hair? Only lovers have traditionally acted as if the hair of the beloved possessed the might to enchant, command, and subdue. Under love's passion men saw in hair the symbol and cipher of feminine beauty. A woman's hair was deemed so great and necessary an ornament that she was nothing without it. Writers went so far as to claim that even surrounded by the Graces, with troops of little Cupids fleeting about her, and wearing the very girdle of Aphrodite (which, according to myth, rendered the wearer irresistible), she could never please if she lacked hair. For then she would be incomplete, and, in Ovid's words, "like a beast without horns, a bush without leaves, and a field without grass."[27] But here, our contemporaries would be right in protesting. It is absurd to make of a single feature the symbol and compendium of the complex mystery of feminine attractiveness. Not to mention the currents of misogyny that flow inside that judgment.

The fact is, sex appeal is closely linked to fashion, and fashion, as everyone knows, is nothing if not changeable. Western men may go into raptures before a luscious, silky, and abundant head of feminine hair. To the ancient Egyptians,

in contrast, no more intense erotic experience was conceivable than to caress the rasp-shaven, bald pate of the beloved. And those who think that only remote and exotic cultures could find sensuality in women's baldness would do well to recall that women have shown over and over again that their charm-net is not made solely of capillary fibers. To quote only one recent example: Ioanna Palamarcuk, a young German woman, had her hair trimmed down to a couple of millimeters, and with head thus ungarnished appeared at beauty contests. Unadorned pate notwithstanding, she was acknowledged to be one of the most beautiful women in Germany, for she won the titles of Miss Hannover and Miss Niedersachsen, and was a finalist in the competition for Miss Germany 2018 (fig. 4.3).

Wer schön sein will, muss leiden: "Anyone who wishes to be beautiful must suffer" is a saying from her own country whose truth Miss Palamarcuk discovered, to her chagrin. (There is an identical French saying: *Il faut souffrir pour être belle*.) Soon after her triumphs, she received abundant hate mail mocking her, disparaging her victories, and perversely dubbing her haircut "the chemo[therapy] style."[28]

HAIR'S DECLINE AND FALL: LIKE ALL THINGS HUMAN, IT MUST PERISH

In sum, today's popular mind appears to take no notice of the fundamental importance of hair, or the high esteem to which it ought to be raised. Long-held beliefs, like its ability to grow after death, or to ignite spontaneously, are now largely discarded. Events formerly regarded with astonishment, like

Figure 4.3
Ms. Ioanna Palamarcuk during the 2018 Miss Germany beauty contest. Image is a still from the promotional German film *Das komplette Finale mit Rebecca Mir & Alexander Mazza*, https://www.youtube.com/watch?v=Hz2hjFYmaPI.

the generation of sparks, are now ascribed to trivial physical phenomena. And neither the unending discoveries of science nor the deep emotional turmoil of love succeed in shaking off the smugness that leads most people to place the hair very low in the scale of perceived importance of our body parts. Yet, in the symbolic realm, the hair plays a most powerful role. Its

influence, although generally overlooked, is felt at the core of our psychic personas. Its true value is revealed only in critical situations, as is often the case for what we ought to cherish most. Two anecdotal-historical episodes, one from ancient China, the other from our own time and place, set into relief the profoundly human symbolism of hair.

In the seventeenth century, the Chinese Ming dynasty (1368–1644) was replaced by Manchu rulers. Differing from the ethnic Han majority, the Manchu invaders were keenly focused on ensuring their dominance. To this effect, they imposed their own ways and customs upon their subjects. The Han were forced to obey not only new sumptuary rules, but other fashions and styles that included the way to wear their hair. Thenceforward, they were supposed to shave the front half and sides of the scalp, and to gather up and plait the remaining hair into a long braid or "queue" that hung down the back. This was the Manchu style, and woe to those of their subjects who refused to adopt it! A queued Chinese man (the fashion was specifically male) became the stereotyped image of the natives of the Middle Kingdom during the Manchu or Qing dynasty, which lasted until 1911.

What the Manchus did not anticipate was that the Han Chinese were profoundly influenced by Confucian philosophy. Confucius, as is well known, was more a moralist than a philosopher, and a central stay of his morality system is so-called "filial piety." This concept includes the rules, meticulously described, on how children should behave toward their parents, and in general how one should behave toward elders and the sovereign. Confucian teachings on filial piety were collected by his disciples in the *Xiaojing* or "Classic of

Filial Piety," a short work (it contains only 1093 characters) thought to have been written toward the fourth century BC by an unknown author(s). This book states, in the down-to-earth Confucian manner: "All our body, down to the thinnest skin and the last one of our hairs, we have received from our parents; awareness of our duty to respect it and to preserve it is the beginning of filial piety."[29]

The predicament of the Han Chinese at the start of the Qing dynasty is readily understandable. It was their sacred duty to preserve their head of hair—down to the last single hair. But the Manchus were not joking. Their injunction was clear: wear it in the prescribed mode, on pain of death. With characteristic concision and dark humor, the Chinese translated the ultimatum: "Lose your hair and keep your head, or keep your hair and lose your head." Still, not everyone obeyed. Resistance to the Manchu prescription was bloody. Two major revolts took place, in 1622 and in 1624; many lost their lives. That some chose to lose their head rather than default on their filial duty of keeping their hair shows how profound can be the significance of hair in the human psyche.

The second anecdote is closer to us. In 1989, the Holocaust Memorial Museum in Washington, DC received a great number of objects for its exhibits. These objects had been shipped from the museum that now exists at the site of the former Auschwitz concentration camp, in Poland, where 1.2 million prisoners, of whom ninety percent were Jews, were murdered in the early 1940s, during the Second World War. The items received were personal objects of the victims: toothbrushes, mirrors, razors, shoes, clothes hangers, suitcases, and so on. But there was one large cardboard box that contained

about twenty pounds of human hair. The administrator in charge of receiving the objects at the Washington museum, Mr. Jacek Nowakowski, declared, at first, that this hair was regarded simply as one more item to be shown among the exhibits. But then, when the Content Committee of the museum met to discuss the arrangement of the displays, it was immediately apparent that the hair was not just one more item to be exhibited. It was unique and entirely different from the rest of the objects: something to be considered apart. In the words of Mr. Nowakowski, "Hair is a highly personal matter. It is not just part of the human body: it is also a part of the human personality—part of one's identity. . . . Hair is so simple—but it is so fundamental."[30] Nothing could have better expressed the weighty symbolic significance of hair than these simple words.

Laboratory examination of some of this hair revealed the presence of cyanide. This is the deadly compound present in Zyklon B, the gas used by the Nazis in their heinous mass executions of camp prisoners. The hair was therefore a piece of evidence, a human testimony of the atrocities committed at Auschwitz. It was a mute witness during the trial of Rudolf Hess, the Nazi commander at Auschwitz, who was tried and condemned to death on April 2, 1947. The manner of his execution was by hanging, although not, as an inflexible poetic justice might have wished, on a rope made of human hair. Morbid ideas of this tenor have sprung up in the mind of decadent poets. Efrén Rebolledo (1877–1929), Mexican poet and diplomat, wrote a sonnet in which a desperate lover strangles himself with the blue-black hair of his mistress while she sleeps.

Given this background, one can easily understand the emotional tension that developed in the Washington Holocaust Memorial museum during planning of the arrangement and disposition of the exhibits. The committee members were scholars, religious leaders, and museum administrators; some among them were Holocaust survivors. One of the latter objected to making the hair a part of the exhibition, saying: "For all I know, my mother's hair might be in there. I don't want my mother's hair on display."[31]

To forcibly remove the scalp hair completely has been a hateful practice meant to humiliate the victim. Prisoners destined to forced labor at Auschwitz had their hair shorn as they first entered the camp; those judged unfit for work, like women and children, were immediately gassed and their heads were shaved after death. The masses of hair thus obtained were gathered in twenty-kilogram bales and then sold to various companies, which put them to a number of industrial uses, like the fabrication of ropes, textiles, boot linings, and other items. Those unfortunates who had their heads shorn at Auschwitz or other places of confinement have described the experience as one of deep humiliation and depersonalization. Before hair clipping, they could regard each other as Mr. A, or Mrs. B. After their head had been polled, they say, they were nothing but bodies: fat or thin, male or female, healthy or infirm, but woefully destitute of that intangible aura that composes the individual personality.

More than a ton of human hair is kept at the Auschwitz-Birkenau museum. Conservators have been perplexed, not knowing what to do with it. They are committed to preserving the appearance of the concentration camp, that it may

serve as a living memory of the genocidal horror perpetrated here. To this end, millions of dollars have been contributed by the various countries that, either deliberately or through complicit silence, abetted the enormity of such wickedness. But hair is a part of the human being: philosophers and humanists opposed plans to exhibit it to public view. To make a photograph of a panoramic view of the many big bales in which the hair is contained, and then exhibit the image, was also deemed inappropriate. For this hair is human, and therefore entitled to be treated with dignity. We are not in the habit of taking pictures of the remains of our deceased family members and displaying them for anyone to see.

Like all things human, the existence of hair is transient. Year after year the stored hair loses its original characteristics: its color fades, it becomes brittle, and it is easily infested by parasites, particularly insects. To protect it from these invaders, naphthalene was used. Visitors to the museum perceived, upon entering the area where the hair bales were being stored, the unmistakable, strong aromatic odor of this insecticide. For a while the hair was placed on vibrating platforms, to shake off the dust and any adherent filth contaminants. But these and other measures were impotent to stave off the depredations of time. In 2015—seventy years after the Germans retreated before the advancing Red Army that liberated the ignominious Auschwitz camp—it was reported in the press that the museum had decided not to preserve the human hair any more. The decision was to let it decay on its own.[32]

Hair is human. It is meet that it should go to where all humans go: "All came from the dust, and all return to the dust" (Ecclesiastes 3:20). Thus, insofar as hair belongs in the

biological body, it is destined to annihilation. But, insofar as it belongs in the "body fantastic," which is made of symbols, hopes, desires, and assorted feelings, it may fly over death; glide nonchalantly, uncomprehendingly, over the accident of death. For paradoxically, our corporeality sits astride in two realms at the same time: that of biology and that of symbolism: the former made of perishable and putrescible matter, the latter of an ethereal, immaterial energy, a strange dynamism that dares to stand its ground against death. Not forever, assuredly, But the mass of symbols that composes the body fantastic (Valéry's "fourth body") coalesces into a promise of survival; a voice which proclaims that our material body will fall into the dark pit of death, but beyond this darkness there will be a new, luminous dawn.

Perhaps the chief function of the body fantastic is the generation of hope. And this hope transfigures our hearts.

5 OUR AQUATIC PAST: THE BODY FANTASTIC DREAMS OF A RETURN TO ITS WATERY CRADLE

Father Benito Jerónimo Feijóo y Montenegro (1676–1764) was a Spanish Benedictine monk with the well-earned reputation of a scholar and an indefatigable combatant against ignorance and superstition. Although no major discovery or scientific innovation is attributed to him, he is nonetheless a leading figure among the intellectuals who carried the spirit of the Enlightenment into Spain. Feijóo tirelessly promoted scientific concepts against widespread obscurantism and prejudice. Yet he was very much a man of his epoch; therefore, it is not altogether surprising that he should have believed in the veracity of the following fantastic story that circulated in his time about an "amphibian man."

THE AMPHIBIAN OF LIÉRGANES

One day in the year 1674, a group of adolescent boys walked along the bank of the river Miera, which flows toward the Atlantic Ocean on the Cantabrian Spanish coast, not far from Bilbao. One of the boys, named Francisco de la Vega

Casar, known for his fondness of swimming, took his clothes off, rushed into the water, and disappeared. His companions waited for him a long time, but he never came back. They concluded that he had drowned and announced the terrible news to his mother, Maria del Casar, a widow who resided with her two other sons in the village of Liérganes. She cried disconsolately, but had to accept the inevitable when a long time passed without any news of her son.

Five years later, in 1679, a group of fishermen in a coastal town close to the city of Cádiz caught sight of a strange being, of human shape, that swam marvelously, now jumping out of the water, now sinking again into the waves, quite like a dolphin. The next day, they were able to approach this singular creature and were amazed upon realizing that it was a man. They caught him in their nets by placing in them loaves of bread to attract him; for they had previously observed that when they threw pieces of bread at him, he grasped them and ate them avidly. They took him ashore, and asked him many questions, in different languages; but he answered none of them. The fishermen consulted with a respected medical doctor, who conjectured that long habitation in sea water had injured the man's brain. But this conclusion was arrived at only after the monks at the convent of St. Francis practiced a ceremony of exorcism—an important preliminary, since the doctor's chief differential diagnosis had been demoniac possession—that yielded no evidence of devil infestation. Then, after several days of captivity, the young man pronounced the word "Liérganes." As luck would have it, one of the fishermen had friends in that town. After some investigation, it became known that there had been quite a commotion

in Liérganes years before, when a young boy had disappeared in the sea, leaving no trace.

The local authorities decided to send the "fish-man" to Liérganes. A Franciscan monk named Friar Juan Rosende, who had just come back from Jerusalem and was touring the area asking for alms, offered to take him there. Off they went, and about a quarter of a mile before arriving, the monk asked him to lead the way. Without speaking (for he had not pronounced a single word since he was captured), our uncanny swimmer conducted the Franciscan directly to the home of the de la Vega family. There, Doña Maria del Casar, upon seeing him, exclaimed joyously: "This is my son, whom I lost on the way to Bilbao!" and embraced him most tenderly. His two brothers, who were present, recognized him as well, and embraced him no less effusively. As for him, he manifested no emotion and said nothing. He had learned to articulate a few simple words, such as *pan*, *vino*, and a few others, but seemed to attach no meaning to any of them. Asked if he wanted any of these things, he made no answer. Friar Rosende left the young man, by now identified as Francisco de la Vega Casar, in his family home. There he stayed for approximately nine years, during which he was trained to do some simple errands, such as to take letters and messages to friends and relatives in neighboring towns. According to the original narrative received by Father Feijóo from a person who said he met the fish-man: "if they gave him something to eat, he took it and ate whatever it was; if nothing was offered, he asked for nothing; so that he looked like an inanimate thing, unable to converse, and animated only to obey; incapable of speaking, save for the few words aforementioned, which he pronounced

sometimes, but without a purpose and without coherence."¹ A description of this singular being portrays him as "six feet tall [it is not clear what a 'foot' meant at that time and place], with a proportionate corpulence and well formed; the hair reddish and short, as if it had just started growing; the complexion white; the nails used up, as if corroded by brine. He always went barefoot. If they gave him some clothes, he would wear them; otherwise, to him it was the same to be dressed as to walk around naked."²

After the nine years that Francisco spent with his mother and two brothers, he disappeared again. There were reports that he had been spotted in a port in the region of Asturias, but this was unconfirmed. The legend of the Liérganes fishman—or "amphibian," as he was called—survived down the ages. Today, visitors to the Cantabrian region of Spain, if they approach the little town of Liérganes—which, according to the 2007 census, counted 2,193 inhabitants—will see a most venerable, moss-covered, medieval bridge spanning the Miera river; from there, they will descry two symmetrically disposed hills, Marimón and Cotillamón, quaintly known by the townspeople as "the two breasts of Liérganes"; and they will admire other beautiful sites. But if they chance to wander a bit toward the outskirts, they will discover, on the site of an ancient mill, by the Miera, the statue of a naked man, sitting, with his left knee flexed and elevated almost to the level of his shoulder. His left arm rests on this knee, while he looks wistfully ahead, toward the distance, in the direction of the sea. This is none other than Francisco de la Vega Casar, the fish-man who put Liérganes on the world map (fig. 5.1).

Figure 5.1
Statue of Francisco de la Vega Casar, the "fish-man" of Liérganes. Photo credit: Nuria Llopart.

Father Feijóo makes several "philosophical" reflections, as he calls them, on this strange personage. He begins by letting us know that his informers were all persons of unimpeachable morals. One was the Marquis of Valbuena, a resident of the city of Santander, who had commissioned one of the royal court ministers, Don José de la Torre, to conduct detailed investigations among any and all individuals with first-hand knowledge of the life of the celebrated "amphibian." Feijóo even obtained an affidavit by another grandee, Gaspar de la Riba, Knight of the Order of Santiago, attesting to the truthfulness of all the narrated circumstances. To these pieces of evidence must be added the declarations of no less than the Archbishop of Zaragoza, Don Tomás Crespo Agüero, who apparently was among those who had seen the fish-man at one time or another.

The good friar is careful to let us know that the case was so outrageously outlandish, so "exorbitant from the regular order of natural phenomena," that he was strongly reluctant to believe it. However, the number and quality of the attestations he received, and the conversations he had with natives of Liérganes who claimed first-hand knowledge of the facts, persuaded him of the truth of the story. With the imposing apparatus furnished by "eye witnesses and gentlemen of the highest honor," the Benedictine points out that all the independent witnesses coincided on the details. It seemed to him very difficult to venture the suggestion that the story might have been a hoax, or that any of the honorable informers could have been lying.

Next, Friar Feijóo discusses aspects of the life of the "fish-man" that impressed him as uniquely extraordinary. The

"amphibian" of Liérganes disappeared in the Atlantic Ocean and was recovered in the Mediterranean. Could a man swim such a great distance? It is true that we don't know how long it took him to cover the distance. But when appropriately trained, certain athletes can perform astounding feats. Some have been known to traverse, swimming, straits, bays, lakes, or other watery spans so wide that a normal person would find it almost impossible to traverse walking in a continuous, unbroken stride.

The most serious objection, of course, was man's incapability of prolonged survival under water. Here, Feijóo must resort to high-flown speculation. Air breathing is considered indispensable to life, he says. Yet the fetus lives inside the maternal womb without any need to breathe; and even when out of the maternal enclosure, as long as it is enclosed in the fetal membranes and swimming in amniotic fluid, it continues to live. This means that nature has some form of expedient, some *quid pro quo* that is put to use in some cases. And who can tell if this *quid pro quo* (even though we do not know what this *quo* is) may be granted under special conditions to some adults endowed with a unique conformation of their bodily organs? We must remember, in extenuation of Father Feijóo's idea, that he was writing this decades before the discovery of oxygen in 1772 by Carl Wilhelm Scheele, and independently in 1774 by Joseph Priestley. The physiology of respiration was not based on gas exchange until at least 1779, when Lavoisier understood the role of oxygen in the body, and discarded the old phlogiston theory.[3]

Feijóo had "managed to escape from popular superstitions only to fall headlong into 'scientific superstition,'" in the

words of the eminent Spanish physician-writer-cum-historian Gregorio Marañón (1887–1960). For the Benedictine seems to have been incapable of discarding the idea that Francisco de la Vega, the "amphibian" of Liérganes—whose real existence was perfectly well documented by Feijóo's research—was the possessor of a preternatural physiology that allowed him to live the hybrid life of a half-human, half-marine creature. This friar, an ardent defender of the scientific method, was also a believer in the true existence of tritons, Nereids, mermaids, merrows, selkies, and other mythological, half-human and half-aquatic beings. Can we blame him for this?

Intellectuals of the very first rank have been known to entertain utterly absurd beliefs. William Harvey (1578–1657), discoverer of the circulation of the blood, probably believed in witches, although his apologists insist that he only pretended to do so; in any case, his testimony exonerated some women accused of witchcraft. But Sir Thomas Browne (1605–1682), Harvey's contemporary, and arguably the most inquiring mind of the seventeenth century, definitely believed in witches, and, worst of all, in 1662 gave evidence against two women charged with witchcraft who were convicted and hanged. A critic said that Browne's curiosity was desultory and attracted to fables, contrary to Newton's organized and systematic spirit of inquiry, proper to a peerless scientist. But Sir Isaac Newton believed in alchemy, and dreamed of finding the "philosopher's stone," *lapis philosophorum*, thereby to attain immortality. Closer to our own times, the great Welsh naturalist and explorer Alfred Russel Wallace (1823–1913), a man who arrived at the theory of the natural selection of species independently of Darwin, and is also the founder of

the field of biogeography, believed in spiritualism and was prone to attend spiritualist seances. Still more recently, Albert Einstein (1879–1955), mathematical genius and physicist creator of the theory of relativity, considered one of the mainstays of modern physics, was not above entertaining shameful racial prejudices, particularly virulent against the Chinese, as his diaries posthumously revealed.[4] And within our own lifetime, Francis Crick (1916–2004), co-discoverer of the structure of DNA with James Watson, was subjected to criticism for presenting, with all the trappings of a plausible scientific hypothesis, the highly speculative proposal that life on earth originated from living seeds or microbes sent to our planet in spaceships by some intelligent civilization somewhere in the universe ("directed panspermia").[5] This list of prominent researchers and thinkers of unmatched excellence, who nonetheless fell for unorthodox, scientifically unproven theories, and sometimes outright ridiculous notions, could be greatly prolonged. All of which should make us look upon Feijóo's credulity with a more lenient eye. He is only one more example of the weakness of the human mind, which fancies itself flying majestically when it actually hobbles, and totters, and trips every time.

Gregorio Marañón (1887–1960) wrote an erudite and eloquent essay in which he outlined a "modern version" of the fish-man of Liérganes.[6] His essay presents us with a medical-physiopathological explanation of this prodigy. According to Marañón, Francisco de la Vega was afflicted with cretinism. In support of this hypothesis, the Spanish physician-writer summons the following arguments. Endemic cretinism, a disease caused by iodine deficiency which injures the thyroid gland

and impairs its capacity to produce thyroid hormone,[7] was highly prevalent in mountainous areas of Southern Europe. Liérganes, the birthplace of the famed fish-man, was certainly one of the foci where this disease held sway. The presence of reddish hair and "corroded" nails is frequently observed in the affected persons, and these features were present in the marvelous swimmer of Liérganes. His hair was reddish and short, as if it had just begun growing; and his nails were "used up" as if worn down by brine.

We are to suppose that in this personage the disease was not expressed with the utmost severity, because he was described as being "well formed" and six feet tall (although what the foot as unit of measure was in seventeenth-century Liérganes is not clear), whereas advanced cretinism characteristically produces stunted growth. However, mental illness is a common, unfortunate consequence of cretinism, and this was clinically evident in the Liérganese swimmer. His mutism and idiocy could very well have been a manifestation of cretinism.

Much talked about was the appearance of the skin of the Spanish fish-man. The ocular witnesses were divided in their opinions: some said he had squames like a fish, others denied that he had a squamous complexion. Feijóo tried to reconcile the two: prolonged living in sea water, he wrote, must have provoked the emergence of fishlike squames in the skin. Those who saw him freshly fished out of the sea were impressed by the scaly nature of his epidermis. But after he was brought back to his native town, he lived entirely on dry land, and gradually the scales disappeared, leaving only some roughness to the skin surface. According to Feijóo, statements affirming or denying that Francisco's skin was squamous depended on

the time at which the observation had been made. Doctor Marañón, for his part, notes that the skin in patients with endemic cretinism is commonly dry, thickened, sometimes scaly, and may adopt a pattern that resembles "fish scales." Physicians recognize this appearance at a glance, and apply to it the graphic term "icthyosis" (from the Greek ιχθύς *ichthys*, fish). Today, the interpretation of this clinical observation has become very complex. Icthyosis now designates a skin appearance that includes many clinical variants and encompasses a large group of diseases, genetically determined or spontaneous. But, written in the early 1930s, an epoch closely familiar with endemic cretinism, Marañón's diagnosis on the fishman of Liérganes did not seem far-fetched.

As for the most problematic question—namely, the alleged ability of this marvelous swimmer to withstand prolonged periods of submersion underwater—Marañón marshals persuasive arguments to support his diagnosis. He tells us that in endemic cretinism, as in thyroid deficiency in general, the metabolic rate is slowed down. Consequently, the consumption of oxygen in the tissues is also slow, and one result is that cretins exhibit a much higher resistance to asphyxia than normal individuals. Some physicians, including him, had observed that in coastal cities where boys dive into the water to recover the coins tossed therein by tourists, these youngsters are not uncommonly hypothyroid cretins. By the same token, the inhabitants of high-altitude places, where the air is rarefied and poor in oxygen, have adapted to this circumstance and often manifest clinical signs of thyroid deficiency. But, not content with empirical observations, he quotes experimental research done contemporaneously by German

investigators. These researchers surgically removed the thyroid of experimental mice, and placed the animals so treated under pneumatic bells from which the air was extracted. They noted that, in comparison with normal animal controls simultaneously treated in the same way, the animals deprived of their thyroid glands resisted asphyxia much longer than the normal controls. This resistance was severalfold greater than that of animals treated with toxic levels of thyroid hormone. Moreover, animals injected with the blood of a hypothyroid cretin acquired a remarkable resistance to the vacuum produced in the pneumatic bell, whereas the same animal, when injected with the blood of a hyperthyroid patient, became much more sensitive to oxygen deprivation.[8]

Marañón was engaging in "retrospective diagnosis," an activity that medical doctors with a liking for history find irresistible. There are two great advantages in diagnosing what is past. First, contrary to what happens in actual medical practice, this kind of diagnosis harms no one if it is wrong; in second place, few are interested in disputing it. Whether the fish-man of Liérganes suffered from cretinism is a moot point. What little interest in this matter may exist today is but a reflection of the enduring, unremitting engrossment incited by the myth of the fish-man. For we are faced here with a universal mythical figure: the piscine or amphibian humanoid.

OF PISCINE HUMANOIDS AND HUMANS WHO WOULD BE PISCES

Best known in female form—as Nereid, mermaid, or similar beings—the myth exists in every gender and everywhere.

Thus, there is a *vodyanov* in Slavic mythology, a male water spirit that looks like an old man with a frog face, a green beard, and a scaly body covered with algae and moss; a *yacuruna* in the Amazon region (from the Quechua words *yacu*, water, and *runa*, man), a manlike creature that inhabits the waters and has built great palaces deep under the surface; there is also a *ningyo* in Japan, a monkey-faced being that, in addition to inhabiting the deep sea, is edible, and anyone who eats it will attain great longevity. But the Japanese also have "conventional" fish-men or *gyojin*, hybrid beings, half-men, half-fish, inspired by the *ningyo*. The list of humanoid aquatic races that have haunted the human imagination is long. Examples may be drawn from ancient religions, mythology, literature, fiction, cinema, and diverse manifestations of modern popular culture.[9]

Some of the old reports make us smile on account of the serious air with which they present obviously imaginary things, as if they were rigorously factual observations. Profuse details are given, such as time, place, name of the participants, etc., in order to enhance the verisimilitude of the narrative. Thus, the *Dublin Journal* of October 12, 1725 (i.e., about the time when father Feijóo was writing on the "amphibian" of Liérganes) reported the sighting of a "sea monster in the figure of a man" off the coast of Brest, France: eight feet tall, with large teeth as white as ivory, black curly hair, the skin brown and tawny without scales, and in all members "proportionable to his stature without deformity." The *Weekly Journal* or *British Gazetteer* of London (December 11, 1725) adds further precisions. It was 10 o'clock in the morning when the monster was first seen on larboard. A shipmate named William Lomone

tried to pull him up with a grappling iron, but the captain, whose name was Oliver Morin, deemed this maneuver too dangerous, and stopped him. However, Lomone had struck the monster on the back, and the creature, in anger, held the ship's rudder with his two hands, forcing the ship onto the wrong course for some time. Then, he swam (as men do, not like a fish) to the forepart of the ship. There, fixed to the prow, was a wooden figurehead in the shape of a beautiful woman. It must have spurred his sexual desire, for he jumped out of the water several times, as if urged by the need to possess her. The journalistic note ends up with this sentence: "Which is certified to be true by Captain Oliver Morin, John Martin, pilot, and the whole crew consisting of two and thirty men."[10]

The fish-man thus described must also have been rude, uncouth, and obscene; for Marañón quoted other reports which said that this monster, angry at the crew that had tried to pull him onboard the ship, turned his back toward it as he was swimming away, and defecated in full view of the sailors: this disgusting gesture was his way of mocking them and foisting upon them his most passionate scorn. Marine male monsters seem to have shared an oversexed temperament. One, as we have seen, was maddened by desire to the point of wishing to assault a female ship's figurehead. Of another monster fished out from the sea close to Exeter, a report said it had "a body resembling that of a man, with a genital member of considerable size," together with such monstrous features as fins at his thighs, and spout holes behind his eyes through which he ejected water, like a whale, up to 30 or 40 feet high. This fantastic description was dutifully reported on July 29, 1738 by the weekly publication, in the epistolary style, known as

Common Sense or The Englishman's Journal [Common Sense? Ironic title!],[11] *being a collection of letters, political, humorous, and moral* (fig. 5.2).

The watery milieu has been, and still is, hostile to us common mortals. Despite technological advances that permit ever deeper and longer-lasting submersions, descending below the water surface and staying there for a long time remains a difficult and perilous act. Our physiology imposes severe limitations; breath-hold endurance is the obvious one, but even with breathing apparatuses, other hazards (cold exposure, hydrostatic pressure on the body, barotrauma of ascent, decompression syndrome, sensory impairment, etc.) cannot be ignored. Even for skilled and well-trained divers, submersion below 40 meters (130 feet) is generally restricted. Wearing an atmospheric suit, a diver can go down to 610 meters (2,000 feet) or more, but the logistics are quite complex, and the expense is considerable. Manned submersibles have permitted exploration of the deep sea. As recently as March 26, 2012, James Cameron (born 1954), a Canadian filmmaker and sea explorer, went down to the deepest point on earth in an Australian-built, deep-diving submersible. He descended a record 10,898 m (35,756 feet) in the Mariana Trench, in the Western Pacific, and spent three hours exploring the bottom.[12] Yet, regardless of all these advances, life underwater is at present not suitable for human beings. Relatively few people explore the seas' interior, and exceedingly rare are those who have had the experience of penetrating into the great marine depths.

Human beings can hold their breath only so long. In competitions of so-called "static apnea" (where the person

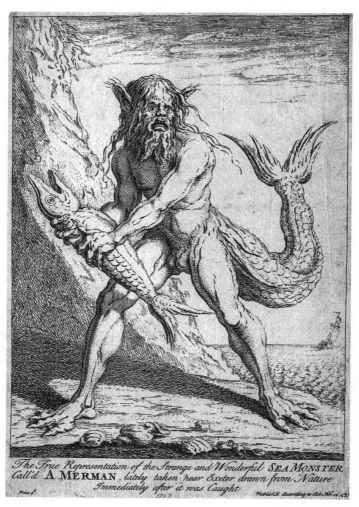

Figure 5.2

Drawing said to be "true representation" of an oversexed sea monster caught near Exeter in 1738. From Sarah Murden, "Legends of the Sea," in *All Things Georgian* (blog), https://georgianera.wordpress.com/2016/07/14/legends-of-the-sea/.

stops breathing underwater and remains immobile, without swimming or performing any other muscular activity), the latest world record was 11 minutes and 54 seconds for men, and 9 minutes and 2 seconds for women.[13] But the desire to push the limits of any human endeavor has led competitors to try all manner of techniques, including some dubious maneuvering. It is known that some drugs can prolong the duration of apnea by reducing the cardiac rate, cardiac output, and blood pressure. Therefore, illegal "doping" is a temptation to which some contestants succumb. Breathing pure oxygen for half an hour makes it possible to prolong the apnea. After hyperventilating in oxygen, a man was able to stop breathing for 24:03 minutes, thus breaking the previous record. This is done outside of competitions, solely for the purpose of setting new records.

In sum, we are not made to live inside a liquid environment. In consequence of our physiological constitution, we have remained alien to the ocean depths. Feijóo lamented this estrangement. How many marvelous things the fish-man of Liérganes must have seen, he wrote, and what a pity he was mute and could not speak to us about them! How many splendiferous constructions of reefs and corals may rise from the sandy bottom, which we cannot see; and these stand amid hallucinating plants and animals that we cannot know. How many amazing, mind-boggling things we are condemned to ignore that happen in "the republic of the fishes." But it does not matter; for each time the body is pulled down by the heavy ballast of reality, the mind soars in a free, unstoppable flight. Hence our imagination has spawned so prolific a race of hybrid beings, mixtures of human and aquatic races. Some

of these creatures are so well integrated into the local folklore as to become emblematic of the country or region of their birth. This is clearly the case with a southern Italian natatorial prodigy, whose story I outline next.

THE LEGEND OF COLAPESCE

In one of the oldest neighborhoods of the city of Naples, next to the sea, once stood the office of a venerable institution called the "Seat of the Port" (*Sedile di Porto*), dating from the thirteenth century in its modern form. The Neapolitan "Seats" (*Sedili*, also called *Seggi*) were local "parliaments," i.e., edifices where noblemen used to gather to discuss matters concerning the administrative governance of the different areas of the Kingdom of Naples. Some claim that the early form of the "Seats" can be traced as far back as the late Roman Empire (fourth century). Little wonder, then, that the buildings of this institution have all been mistreated by the triple insult of time, negligence, and historical contingence. But old walls sometimes resist these depredations for a long time, or else the authorities preserve those parts deemed worth preserving. Anyway, the curious can still see, carved in relief on a stone slab, on the corner of the Neapolitan streets of Mezzocanone and Sedile di Porto, the figure of a giant who carries what is thought to be a long knife in his right hand, its tip directed downward. His body is completely covered by what some interpret as squames and others as a shaggy animal fur (fig. 5.3).

The figure represents Orion, a giant from Greek mythology who was a huntsman of great strength, and about whom

Figure 5.3
Ancient stone slab with a relief representing a mythical personage on a Neapolitan street building. (Explanation in the text.)

there are many stories. At least, this is what the plaque at the feet of the figure says. Zeus placed him among the constellations after his death, and this is how the name of the constellation of Orion originated. This stone slab with the image of the

strange man was found during the excavations for the foundation of the building of the "Seat of the Port," which happened to fall precisely on the site of an ancient little temple of the Greco-Roman era in Naples. The figure, therefore, represents Orion, the mythical huntsman. This is the best-accredited version among scholars.[14]

Yet the popular imagination, never satisfied with the staid stories put forth by academics, has attributed other, more colorful identities to this strange figure. Some have claimed that it represents a wolf-man or a feral man found in the woods, where he grew up bred by wolves, without any human contact. But by far the most popular story, one that has become practically universal among the people, is that that the figure depicts a fish-man named Nicola (or Cola) Pesce. According to this version, the rugosity of his body surface is due not to an animal fur, but to fish scales; and the tool that the strange man carries in his right hand is not the club of Orion, but a knife which the fish-man used to cut open the abdomen of the large fishes in whose bodily interior he sometimes traveled. Thus, when Neapolitan children ask who the strange man they see in the stone relief might be, the answer they hear most often is that the figure represents Nicola Pesce, the fabulous fish-man.

This story, of remote and varied origins, has more than one version in the several cultures (different cultures, but with shared, common roots) that arose on the Mediterranean shores. Thus, Italian scholars have noted that the legend of Cola Pesce had a great resonance in Spain,[15] where ancient versions of the story existed. Moreover, great literary figures of Spain's "Golden Century," such as Lope de Vega, Luis Vives, Pedro Mexía, and Cervantes, refer to the fabulous

fish-man.¹⁶ But the story of Cola Pesce acquired a certificate of naturalization in Sicily, where it is among the most beloved legends. Along the years, it has been put in words by several distinguished Italian writers, each one in his own way. The philosopher-historian Benedetto Croce (1866–1952) narrated it several times between the years 1885 and 1915.¹⁷ The essayist, politician, and playwright Leonardo Sciascia (1921–1989) repeated it in a thoroughly Sicilian short story titled "The Fire in the Sea" ("*Il fuoco nel mare*"). In more recent times, it was picked up by Italo Calvino (1923–1985), who included it in his comprehensive collection of folktales from different regions of Italy, and by Raffaele La Capria (born 1922), who recounted it charmingly for his young daughter before she was able to read, "the ideal condition, he said, to listen to the fables that I invented for her."¹⁸ The principal facts of the legend, allowing for many variations according to different narrators, are as follows.

Once upon a beautiful Sicilian morning, the sky was of a delicious, uninterrupted blue; the air was tepid, luminous, and clear; and an emerald-green sea shot multiple, fleeting glimmers here and there, from the crests of the waves. On the shore, groups of fishermen mended their nets and did other chores in preparation for their sea journey. In this delightful setting, a worried old woman, dressed in black, scurried along looking for her son, a boy named Nicola. He was approaching adolescence, which in his coastal village meant that everyone expected him to begin helping his father in the family store. But Nicola did not think of that at all. He could not be made to attend the store and learn the work that his father did, and which he was supposed to take over in his father's old age.

This he would not do. At the first opportunity, he escaped to the beach and spent all day basking in the sun and swimming in the sea.

Nor could he be made to attend school. Not for him to sit in class listening to things he found immensely boring. No, sir! During the whole lesson he gazed longingly through the window at the glimmering sea, whose attraction he found irresistible; and no sooner did the teacher have a moment of distraction than Nicola vanished from his bench, amid the ill-suppressed giggling of his classmates. Where was he? At the beach, of course; or rather, at sea, for most of the time he was in the open sea, diving into the agitated waves, and swimming underwater, and turning and maneuvering in the liquid element with such nimbleness and dexterity as if he were a marine animal, not a boy.

His absences from home were becoming longer and longer. Not only did he spend all day carousing in the water, but a good part of the evening, until late at night. Hence the look of worry on his aged mother's face when she came looking for him.

"Have you seen my Nicola?" she inquired of some boys of his age, who knew him.

"He was over there an hour ago," answered one of them, pointing at a place where the sea waves broke against large rocks amid abundant white spume and no little din. That site was dangerous for swimmers: people said that the ablest could be dragged down and trapped at the bottom by thick algae. Because many had drowned, the superstitious villagers were prompt to invent the story that the place was inhabited by evil spirits. But Nicola had developed such swimming skills,

by constant practice, that he ventured where neither boys nor grown men dared to go. And truly, he seemed quite at ease in the middle of the raging waters. The fact is, he felt more comfortable and self-confident in those perilous currents than on land.

It was with great difficulty that the old woman approached the rocky promontory. Watching intently, one minute she thought she could descry her rebellious son in the distance, but the next minute she was not sure. She shouted at him: "Nicolaaa!, Colaaa! . . ." But the boy had swiftly slithered farther ahead, into deeper waters. "Slithered" is the right word, for one might have said he was a sea serpent, or an eel, so fast and smooth was his displacement. His mother shed bitter tears and desperately shouted over and over again: "Nicolaaa!, Colaaa!" But by now what she took to be her son was only a distant dark point amid the waves. And this dark object seemed repeatedly to emerge for an instant and dive again, as if advancing in the water by leaps. The few boys who had come behind the old woman were themselves in doubt. They watched the rapidly receding object and looked at each other, utterly confused. Was it Nicola, or was it a dolphin they had seen?

Soon thereafter there was nothing to be seen. The woman stood there long after all the boys had gone back home. For some time only her voice resounded amid the noise of the waves: "Colaaaaa! Colaaaaa . . . !" But no one answered her call. This was the last of the many times she had come hoping to bring her son home, to no avail. In her frustration, she exclaimed: "Cola, for the suffering you have made me endure, and seeing how much you like the sea, may you remain in the water and turn into a fish!"

Now, almost anywhere else this kind of remonstrance would have passed for the utterance of a frustrated mother driven out of patience by a rebellious son. But in Sicily, and in the legendary times of this story, the exclamation was more than that: it was the curse of a mother cast upon her son. And, if we allow that the mother had a little of the witch in her, it should surprise no one that the curse took effect. The boy noted that his toes had become joined by the growth of membranous skin between them, so that his feet resembled those of ducks; the same change was taking place in his hands. The skin of his arms acquired a kind of narrow, stiff redundancy that looked uncannily like the fins of fish. His whole skin took on a harder consistency, and became rubbery, very smooth, resembling that of dolphins. All these transformations suited him fine; for he realized he could swim more nimbly, dive deeper into the water, and stay underwater much longer than before. In sum, instead of becoming alarmed by the strange changes affecting his own body, he exulted; for now he could do much better what he loved to do. He never went back home. His mother, saddened by her loss and seeing all her maternal dreams destroyed at once, died of grief not long thereafter.

It did not take long for word to spread throughout the whole region of Messina (the area of Sicily where the boy could be seen swimming most of the time) that a miraculous creature, half-boy and half-fish, inhabited the seawaters. The inhabitants had glimpses of him when he emerged to breathe, or simply leapt out playfully with incredible energy, like a dolphin, before diving again with a splash. They were proud to count a prodigious being among their compatriots, and took

to calling him "Colapesce," a nickname made of the last syllables of his name, "Cola," as his mother used to call him, plus the word *pesce*, Italian for "fish." Thus, Colapesce became a local celebrity: boys of his age remembered him when he was not yet transformed, and already surpassed them all in every swimming prowess; fishermen spoke admiringly of his natatorial speed, by which he, alone, could leave behind a boat propelled by ten oarsmen.

Word reached the King of Messina, who did not take kindly to being among the last to learn of the existence of a marvelous fish-man hybrid creature in his own dominion; for kings are known to encompass water, not just land, in what they arrogantly call their dominion. He made it known that he wished to speak to Colapesce. So, the first time fishermen saw Colapesce swimming alongside their boat, they shouted at him: "Colapesce, listen, the King of Messina wishes to speak to you!" The fish-boy was intrigued, but he was inclined to obey the king's orders. For he had become largely fish without ceasing to be human, and his human identity included being a subject to His Majesty, the King of Messina. In consequence, he swam immediately toward the king's castle, and, taking up once again his half-forgotten human deportment, he appeared before the ruler, who received him most affably.

"Colapesce," said the king, "I have called you because I want to entrust you with a matter of the utmost importance for this our beloved fatherland."

"What would that be, Your Majesty?" asked Colapesce.

"Well, I have reason to believe that a huge earthquake may soon come that could lay our beautiful country in ruins. As you know, Messina is uncommonly prone to suffer

earthquakes. We have had so many! You are aware that Messina is separated from the Italian mainland—from the 'tip of the boot,' you might say—by a narrow strait, the Strait of Messina. From ancient times, many men have thought about constructing a bridge between the peninsula and us, but this has been impossible. The ablest constructors, top architects, and foremost engineers say that the ground is too unstable. There are too many earthquakes. But no one has been able to determine why this is so. . . ."

Here, the King of Messina made a short pause, and offered some wine to Colapesce, who, as most fish would have done, refused it. The king continued:

"I have appointed a scientific commission to investigate the causes of this odd instability. The Chaldean magician-scientists of the commission think that our periodic earthquakes are caused by quarrels of their gods, who settled in the depths of the ocean in this part of the world. They say that Vul, a strong god, lord of canals, has a running feud with Nergal, giant king of war, and their periodic altercations result in our earthquakes. Other sages speak of stellar influences, and how the conjugation of various stars produces energy waves that shake the earth of this island. But, to be frank, I find all these hypotheses too fantastical. In my view, the Greek scientists in the commission have produced the most believable hypothesis. I will spare you their complex reasoning, and simply tell you their conclusion: they say that the island of Sicily is sitting on a shaky foundation. Only the nature of this foundation is not clear, and this is why I need your help. I want you to swim around this island and report to me what sort of ground is supporting it."

This was a Herculean task. Colapesce was not sure that it was within his power to swim around the entire island of Sicily, which is truly very large. But, conscious of the great responsibility devolved upon him, he obeyed the king's order. For a whole week he swam indefatigably, day and night, taking only very brief rest periods. In the course of this exhausting journey he discovered many things that he, an expert submarine explorer, had nonetheless ignored until then. He saw magnificent valleys, tall mountains, volcanos that spew hot lava, making the water boil, a flora of exquisite beauty, and exotic animals whose strange design and bizarre customs seem part of a dream, and in some cases, a nightmare. He saw fish that emit light, as if their body was an electric lamp; others that shoot out deadly charges by which they strike dead their enemies; odd marine animals of which he found it impossible to tell where was the head and where the body; and others whose body was transparent, as if made of glass; and a great many other wonders that he punctually reported to the king.

But when the monarch questioned him closely, he was forced to avow that there was an area he could not explore thoroughly. This was the part of the island that protrudes into the Strait of Messina, where a lighthouse had been built. Here, the sea was so deep that he could not reach the bottom. Peerless swimmer and unsurpassable diver that he was, he was fear-stricken, for it seemed to him that in that place opened a bottomless abyss. He told the king that he had encountered cold water first, then hot water, and deeper yet, fresh water, which flowed out of rivers that run far down, issuing from the very core of the earth. The king did not believe him, but the fish-human boy offered to make a new dive into this region

after being provided with some large empty bottles. He went down again, and when he resurfaced he brought with him the bottles full of the water he had encountered at each of the aforementioned submarine levels.

He thought that this evidence had persuaded the king, and that the matter was settled. But he did not take into account that the king now had a veritable obsession: the monarch wished to find out at all costs the nature of the base on which Messina was sustained. Thus, the king increased the pressure, impressing upon Colapesce the life-and-death importance of his mission. He *absolutely* had to go down once more. The future of the country depended on finding out the cause of the earthquakes.

"How long will it take you to go down and come back?" asked the king.

"How should I know?" answered the fish-boy. "It will take at least one whole day of continuous descent to reach the bottom—assuming that there is a bottom—and at least the same amount of time to come back up to the surface."

"Throw yourself into the sea from the top of the lighthouse," said the king. "I'll be waiting for you on the third day, at the base of the lighthouse."

Colapesce braved the risks once again, and accomplished what seemed impossible. On the third day, he came up to where the king was expectantly awaiting him. Poor Colapesce! This time he seemed as pale as a shroud and was trembling with fright. Questioned by the king, he reported that he had seen a huge marine monster, and had barely escaped its jaws. It was so big, he said, that a whole fishing boat, like those used by fishermen in his native village, unfurled sails and all, could

easily fit in the monster's maw. But the king was so impatient to hear the description of Messina's grounding that he did not let Colapesce recover completely from his fright, and pressed him to say what else he had seen. "What is there at the base of Messina's lighthouse?" "How is our island sustained?" asked the king anxiously. This time, the hybrid fish-human diver had solid information. He had seen how Sicily was supported at that particular site.

"Messina," he said, "is supported by three thick granite columns. One of these seems solid and intact. I was barely able to hide behind it when I saw the big monster about to devour me. The second column is cracked, although still standing. But the third one is broken: there is no remedy to it, it is in pieces."

Upon hearing the bad news, the king was stunned. Overwhelmed with confusion and hopelessness, he exclaimed: "O Messina, Messina, it is your fate to be so wretched!" (an exclamation which naturally sounded better, and rhymed nicely, in its original Italian: "*O Messina, Messina, Un dí sarai meschina!*"). While saying these words, the king, in a gesture of despair, raised his hands to his head, as if he wanted to pull out his hair. Only, in the process of executing this gesture, he toppled the royal crown he was wearing, which fell into the sea and, being made of solid gold and adorned with big precious gems, sank immediately.

Now the king was in a frenzy of despair and anger: "You fool! See what you have done! You made me topple my crown! You must go back into the water immediately and recover my royal crown. Do you realize that without a crown I cannot be king? And do you know what it means for Messina to be

without a ruler? You wretch! You scalawag! The land of your birth will fall to lawlessness, to civil war, to death and devastation. Your family will suffer, like all the families of Messina. There will be famine, chaos, disorder, and untold suffering for thousands upon thousands of innocent people . . . unless you recover my crown right now. Dive, dive again, and bring back my crown! I will be waiting for you right here."

Colapesce may have been an exhausted, affrighted, and confused fish-human creature, but he was still a loyal Messinese. The words of his ruler weighed heavily upon him. He said: "Your Majesty, in the condition in which I find myself now, I really don't know if I will be able to do what you ask of me. But I will always acknowledge my loyalty to you, my legitimate sovereign, and will try to follow your orders. I only wish to ask you a favor. Please give me a fistful of lentil seeds in a bag. These I will carry with me into the abyss. If you see me coming up to the surface again, be assured that I will be bringing the royal crown with me. But if I cannot make it, you will know it when you see the lentil seeds floating up."

The nonpareil diver and unsurpassed swimmer got his lentil seeds, climbed up atop the lighthouse, jumped therefrom, and plunged into the waters of the Strait of Messina headfirst. He was never seen again. We do not know how long the king waited for him, even after he saw the lentil seeds floating at the site where he expected the diver to come up. Messina continued to lead a tranquil life, which is a manner of speaking, for it was interrupted now and then by recurring earthquakes. But there was no civil war. A new crown, albeit of inferior materials, was quickly fashioned, and no one

seemed to mind the substitution. The king soon died, presumably of frustration and old age.

As for Colapesce, different versions exist concerning the manner of his end. But because legends are a way devised by humans to counteract the many causes life offers for despondency, the optimistic, happy-end version enjoys the greatest popularity. In this rendition, the fish-boy, fed up with the vexatious and pesky demands of an importunate king, decided, upon reaching the bottom of the sea, to open the bag with the lentil seeds in order to deceive the ruler. The fish-boy was letting the King of Messina believe that he, Colapesce, had perished, while in reality he was very much alive. He settled in a magnificent mansion made of coral, and was generally well liked by all the marine creatures, who saw him as an immigrant willing to leave his dry-land ways to live among them. Down there, at the bottom of the sea, there are magnificent gardens made of coral; the sand is strewn with precious jewels, valuable weapons, and other objects from the many boats that have been shipwrecked in the course of centuries. Better still, there are no human beings. There are only skeletons amid the wrecks of the sunken boats, and it is well known that skeletons are peaceful fellows, never an infinitesimal part as troublesome as living humans. And Colapesce, content with the sympathy and adulation that surrounded him, at times tried the golden crown on his head, just for swank, or as a game, and fancied himself the ruler of an aquatic dominion. But this was merely an innocent amusement; for he respected and loved the creatures of the sea, and never dunned anybody with exacting, unreasonable, or vexing demands.

This, of course, is the optimistic version of the story, aimed at children. A darker version has the king ordering his soldiers to fire cannon shot far out into the sea, and Colapesce is ordered to go retrieve the cannon ball. The loyal man-fish obeys, dives deep, very deep, in search of the ball, and suddenly finds himself in a mysterious, silent, waterless space, where the water is solidified above him, and seems to cover him like an immense, sepulchral marble slab. In vain he tries to regain the watery domain: he is irrevocably trapped, and dies down there.

In still one more version, perhaps the commonest of this ancient legend, Colapesce disappears from sight heroically, but not necessarily to annihilation. Having discovered that one of the massive columns that prop the island of Sicily is irremediably broken in pieces, he decides to take its place, thereby condemning himself for eternity to the role of substitute stay. For the good of Sicily and its people, he is still there, we are to assume, ever reinforcing the island's support. Can he do this all the time? No, he must rest now and then. Once in a while, Colapesce chooses to take a break. It is then that the land becomes unsteady, and the Sicilian people are temporarily shaken by an earthquake.

BRIEF NOTE BY WAY OF EPILOGUE

The nature and function of myths is an extremely complex matter, clearly beyond the scope of this work. But without attempting to broach such a formidable field, it may be said that the legend of hybrid, aquatic-terrestrial beings—mermaids, Nereids, amphibian-hominids like the Liérganes boy, fish-boys

like Colapesce, and the like—is a universal, descriptive myth. It is descriptive in the sense that it tells what people "can never witness by themselves," no matter how clever and observant they are: in this case, the origin of the human race.

The pre-Socratic philosophers Anaximander (c. 610–c. 246 BC) and Thales of Miletus (c. 624/623–c. 548/545 BC) promulgated the idea that human beings originated in the sea. Anaximander colorfully speculated that men lived in embryonic form inside fishlike animals until they reached puberty, when they sprang out and could fend for themselves.[19] This idea was no doubt rooted in oral traditions whose origin gets lost in the mists of time. Yet ancient myths cast their powerful shadow over succeeding ages, and the myth of our "amphibian" ancestry survives to our own day in the garb of scientific hypotheses.

Scientists in our age have postulated that some characteristics of the human body reflect our aquatic past. These include hairlessness, subcutaneous fat, the relative weakness (presumably regressed) of our olfactory sense, the rare congenital anomaly of syndactyly or "webbed fingers," the direction of body hair, and other bodily features. Sir Alister Hardy (1896–1985), eminent marine biologist, built his hypothesis upon Darwinian grounds. He proposed that a branch of the primeval ape stock from which humans descended was forced by environmental circumstances to take to the seashores for food; that there, it derived its nutriment from shellfish, sea urchins, and other marine edibles; and that adaptation to coastal life eventually replaced its former arboreal habitat.[20]

The so-called "aquatic ape hypothesis" of Hardy and his predecessors has been generally disparaged as "pseudo-science"

by academic biologists and other experts, although it has found some supporters, mainly outside of the academic community. Quite apart from its controversial scientific merit, it does not seem far-fetched to view it as a reflection of the ancient myth of hybrid, fish-man beings, and as such a component of the whirlwind of myths, fables, and hallucinating narratives that constitute the body fantastic.

6 THE BODY FANTASTIC WALKS ON FEET OF DOUBLE SIGN: PAIN AND PLEASURE

Lowest in the body by topography, the feet also stand low in the esteem we accord them; amid the bustle and scuffle of daily life, they scarcely merit our attention. Yet it is enough to look at the place the feet occupy in the symbolic realm to realize the absurdity of our neglect. Common language reveals the richness of foot symbolism. We "get off on the right foot" if we begin auspiciously, as opposed to those unfortunates who "start off on the wrong foot." He "gains a foothold" who conquers territory, but once installed would do well to "put his foot down," that is, to stand fast and hold his ground. We say of someone that he or she "has two feet on the ground" to signify that such a person does not live on illusions, but has a solid sense of the practical. A blunderer at every occasion is apt to "put his foot in his mouth." To implore a man's mercy, or to manifest our utter reverence and humility, we "throw ourselves at his feet." A wanderer is, by definition, "foot-loose." And who better expresses fixity of purpose, and love of place, than those who say they will never abandon their home ground until they come out "feet first," that is, dead?

Especially intriguing is the symbolic association between feet and death. Perhaps the feet constantly joining us to the earth recalls our ineluctable return to the earth whence we came. To go out "feet first" is a well-nigh universal image of exiting this world; and coming into the world feet first is the correlative, negative announcement of inauspiciousness and a "bad death." We have it from the authority of Pliny the Elder that those who left the maternal womb with difficulty, feet foremost, were named "Agrippa" (possibly from *aegre partus*, retained or "entrapped" childbirth). Marcus Agrippa (64/62–12 BC), Roman consul and famous architect, was the only example of a man born feet first who reached prominence in antiquity. Still, according to Pliny, he suffered the fate foretold by his irregular birth when he was made lame and, worse yet, when his progeny produced "two firebrands of mankind": his daughter Agrippina the Elder gave birth to Emperor Caligula, and his daughter Agrippina the Younger to Emperor Nero.[1]

High in symbolic stature, yet lowly in our intellectual recognition, the feet have a way to remind us of their concrete, practical importance: it is called disease. Pathology, pain, and dysfunction shake our complacency; brutally they make us realize our dependence on perishable corporeality. This point is strongly carried home by what may be deemed an emblematic foot affliction, described next.

The typical patient is a man whose most vigorous years are past (almost never a young woman), and now has adopted a lifestyle attended by little or no physical exercise. He enjoys his comfort, never says no to good wine, and is distinctly sensitive to the pleasures of the table. Of strong constitution

and great vitality, he is the type formerly called "sanguine." One day—it often happens in the depths of winter—having enjoyed a copious dinner, our man goes to bed feeling a little indigestion. Perhaps this has been preceded by a few days feeling torpor and tiredness of the legs, but not much else. There are really no premonitory sensations of any importance, so the man goes to bed without any complaint and expecting a good, restorative sleep. But, lo and behold! About two o'clock in the morning he is awakened by a pain in his big toe. Less commonly, the pain strikes other parts of the foot: the heel, the instep, or the ankle. At first it is of moderate intensity, although severe enough to have disturbed his sleep. Then, it increases gradually, feeling as if the tendons and ligaments of the foot were being stretched, or compressed, or the foot progressively crushed in a torture vise. So excruciating is this pain that the man cannot bear the weight of the bedsheets on the foot, or the minimal trembling of the bed produced by someone walking jauntily into the bedroom. Not uncommonly, a low-grade fever may accompany the painful bout. The whole night he passes in torture, tossing from one side to the other in the hope of finding a posture that would bring some relief. But relief does not come until well into the morning, when the pain abates. This favorable turn is wrongly attributed by the patient to the last position he adopted. In fact, it is part of the natural course of the disease, as it is also natural for it to come back later with equal or greater violence.

As the reader probably has anticipated, the disease described is gout. The quoted description is owed to Sir Thomas Sydenham (1624–1689),[2] a medical eminence who was lauded (posthumously, of course, as is usual for true

merit) as "the English Hippocrates," or "the father of English medicine." His description of the disease can be reproduced word by word in any of today's textbooks of clinical medicine, and no one would find it in the least objectionable. Sydenham was a man who valued direct observation of patients over the study of theoretical treatises. A story has it that a medical student once asked him what medical textbooks he considered essential for aspiring physicians. To which Sydenham answered: "Read Cervantes' *Don Quixote of La Mancha*. It is an excellent book, I sometimes still read it." The intellectual movement that he inspired proclaimed that no more instructive and richly informative books existed than the patients themselves.

Gout is a most peculiarly named malady. The word is traced to Latin *gutta*, meaning a drop. The same name passed into other Western languages: French *goutte*, Spanish *gota*, Italian *gotta*, German *Gicht*. Ancient medicine explained that the disease was produced by a noxious fluid or "humor" (probably phlegm) that originated in the head and somehow fell drop by drop to reach the feet. This head-to-toe "dribbling hypothesis," of Hippocratic parentage, blamed a single "humor" for the painful devastation taking place in the feet. This idea was disliked by Galen and his votaries, who suggested that the harmful substance—the "peccant humor," as they called it—resulted not from a single cause, but from an incorrect mixture of the four "humors" believed to exist in the body, whose perfect balance ensured good health.

In fact, the ancients had a more graphically descriptive name, not prejudging the etiology. They called it "podagra," from Greek *pous*, foot + *agra*, hunt, entrapment, capture.

Truly, the patient feels like a hunted animal that has fallen into a trap that clamps, crushes, and grinds its foot. But pain is a universal and sobering experience that eludes language: words can never adequately depict the true character of bodily pain. Pain is lived and endured, not described or intellectually apprehended. In a moving literary work authored by a clinician, we are informed of the vivid terms that patients with foot diseases apply to their suffering: "a hot line of agony focused on the underside of the first joint of the big toe"; "a ticker tape of pinpricks"; "an electrical storm under the skin"; "walking on knots"; "having socks made of rope"; "a sliver of bamboo slid under the nail"; "bayonet prodding"; "rats gnawing at the diseased site"; or "a sharp-beaked bird hopping all over your joints."[3]

It is intriguing that the metaphors used by pain sufferers in all epochs, including our own self-admiring technological era, hark back to the dark and superstitious times of an ignorant past: the victim of pain commonly speaks as if someone, an invisible agent (and who can this be, if not a malevolent spirit or demonic being?), were doing the burning, cutting, gnawing, tearing, stabbing, gouging, stretching, pricking, and rending. The English language has an expression pregnant with significance: "to be *in* pain," that is, to exist within the domain of this maleficent power; to be *in the possession of* pain. It is, indeed, a form of possession; patients often speak of the pain that has "invaded" them. The gestures of the man tortured by, say, abdominal pain, are symbolically expressive: mechanically he directs his hands to the affected site, as if he wants to pull the painful organ out manually; to draw it out and toss it away with his own hands.

The ancients personified the afflictions of mankind, usually employing a solemn or tragic tone. But the great Greek satirist Lucian of Samosata (c. AD 125–after 180) applied his inimitable humor when he portrayed gout in a work known as *Tragopodagra*, that is, "the Tragedy of Podagra."[4] In this piece, the author cleverly combines the majestic style of Greek tragedy, plus the lavishness of lyric expressions uttered by the choir, with the grotesque, and sometimes laughable, petty miseries of a gouty sufferer. The latter avows that if men had to pay in hell for the sins committed on earth, there was no point in contriving the torture of Tantalus, who thirsts in vain after a fleeing wave of water; or of Sisyphus, who must forever push a boulder up a hill; nor of Ixion, who suffers for all eternity bound to a fiery wheel ceaselessly spinning. Why bother with inventing such refined tortures? To inflict the utmost suffering, it would suffice to deliver the sinners into the power of the goddess Gout—for Lucian makes Gout a goddess, and gouty patients her votaries—whose function is to destroy men's feet and joints amid excruciating suffering.

The cruel goddess proudly declares that no mortal man could oppose her. The emanations of incense, or the blood of sacrificial victims poured upon her altars, cannot appease her. In a gibe to the fecklessness of the medicine of her time, the goddess lists the resources and medicaments to which men have turned in their vain attempts to exorcize her might. Thus, we get an idea of the popular anti-gout therapy of classical antiquity. One patient tried ground leaves of plantain, or of lettuce; another one, horehound (an aromatic mint) or pondweed. Others used nettles, comfrey (perennial herb of the genus *Symphytum*), boiled carrots, henbane,

pomegranates, root of hellebore, cypress sap, barley meal, boiled cabbage. Two home remedies make us glad to live in the modern world: human excrement and "turds of mountain goat." Dietary recommendations included meat (today formally contraindicated in gout) or other animal products, such as milk, urine, bone marrow, or dung from frog, hyena, antelope, and fox—all to no avail.

Some patients sought the advice of physicians; others were swindled by pure charlatans. As to the tutelary goddess of this misery, she says: "And I, who make everyone cry, become more irritated against those who resort to such means in an attempt to chase me away. On the contrary, those who do not resist me incite my benevolence, and I treat them more civilly." Lucian seems to be saying that in his time, no therapy was any better than the remedies recommended by charlatans.

A messenger appears on the scene, to report that two men, inflated with pride, went around telling people, and actually swearing, that Gout does not deserve to be honored and revered, and that they, these two men, shall succeed in banishing her to exile. The goddess is furious upon hearing this; she brings those men before her, and lets them know, in no uncertain terms, that she has already subjugated many a great hero: Achilles, who died from a foot injury that she occasioned; Priam, formerly known as "swift of foot," became, through her doings, "Priam the gouty"; and even Ulysses, sovereign of Ithaca, says the proud goddess, died on account of a foot ailment that she caused, "and not a fishbone, as some pretend."

The two men brought before her are Syrian physicians who wander about trying to make a living. They say they

have a powerful ointment which can relieve podagral pain; its composition is a secret. The goddess forces them to accept a challenge. They will find out who is the stronger, whether the Syrians' secret medicine or the fires that Gout can invoke. If the ointment proves victorious, she solemnly promises to abandon the earth, and to hurl herself into the deepest chasm of Tartarus. Gout then proceeds to summon her servants, "the bleak Pains of somber gaze," whom she directs to invade the joints of the medicos: one servant goes to the toes, another to the heels, and still others to the knees and fingers of the proud physicians. The Pains execute her orders, and the result is immediate: the Syrian doctors writhe on the ground with pain. The ointment is perfectly useless.

Only when the two physicians beg for the goddess's mercy does she order the cessation of the torture. She closes the matter with this admonition: "Let everyone know that I alone, among all the divinities, cannot be treated and am superior to every remedy."

Indeed, for a long time, gout was believed to be incurable. Still more: some thought it was a benefit in disguise, since the presence of gout presumably protected against more severe diseases affecting the joints, thereby avoiding the most burdensome forms of invalidism. This idea probably developed as a means of resignation before the inevitable. But man's analytical mind summoned a powerful auxiliary: science. This mighty ally changed all the prospects: the goddess was definitively dethroned. From feet-torturing deity, Gout was demoted to a contemptible idol, itself supported on feet of clay. As historians Roy Porter and G. S. Rousseau put it, "[gout] was now reduced to such chemical simplicity that

a drug test reveals its presence and drugs rectify the chemical imbalance it brings."[5] Victory over this malady was the work of a number of investigators who discovered the central role of uric acid in propitiating gout attacks, and devised the appropriate therapy. It would be overly burdensome to give an account of their names and the nature of their toils here. But there is another aspect of this disease that is worth examining.

Ever since classical antiquity, a link between sexual life and gout was suspected. Physicians originally described gout as a disease of the "sanguine" man who is a good eater and a sensuous bon vivant. Moralists, for their part, warned that gluttony and lust go hand in hand. Hippocrates wrote, in his work *Aphorisms*, that eunuchs do not suffer from gout; that this disease spares women until the time when menstruation ceases; and that young males are also spared until they begin to have sexual intercourse.[6] Arthritic pain, from gout or other diseases, was often conflated with the idea of indulgence in sexual pleasure. Thus, Shakespeare's Falstaff appears to think that gout and venereal disease converge into the same pathology. He says: "A pox on this gout! or, a gout on this pox!, for the one or the other plays the rogue with my great toe." (The "Great Pox," of course, was a common euphemism for syphilis in contradistinction to smallpox, i.e., *variola* or *variola major*.) Shortly before, in the same play, Falstaff had joined the two diseases in one sentence: "A man can no more separate age and covetousness than he can part young limbs and lechery; but the gout galls the one, and the pox pinches the other" (*Henry IV, Part 2*, I, ii).

In this context, it may be remarked that in the eighteenth century a distinguished Swiss professor of clinical medicine,

S. A.-D. Tissot, published a medical textbook in which masturbation was held to be an important cause of gout.[7] This suggested pathogenesis, says a sharp medical historian with a sense of humor,[8] must not have pleased Gibbon, the great English historian, author of *The Decline and Fall of the Roman Empire*, who was being treated for gout by Tissot at that time.

But, among the ancients, apparently no one in the Western world said that the foot, source of inexpressible physical pain in gout and other maladies, could also become the source of sensual, specifically erotic, delights. By what strange, irrational process does the human mind manage to transform a bodily part seemingly devoid of erotic significance, a part often denigrated as malodorous and lacking in charm, into an object of lust and sensuality? No one can tell, although psychiatrists have spilt torrents of ink in concocting hypotheses. All that refers to human sexuality is steeped in contradiction and ambivalence. Genital anatomy is referred to as "shameful parts" by some, "noble parts" by others, and ranked as "private" by still others. The feet, equally, have been both made objects of disdain and elevated to the status of centers of erotic pleasure.

The libido-podalic association has been part of the popular cultures of various nations. In the West, it had seeped into mainstream medicine at least since the sixteenth century. Felix Plater (1536–1614)—or "Platerus," to use his Latinized name—was a renowned Swiss physician who first described the intracranial tumor known as "meningioma"[9] and other pathological conditions. He wrote a treatise on clinical medicine, the *Golden Practice of Physick*,[10] in which he discusses the erotic value of the feet. Chapter XVII of the first volume

of this work, titled "Of Defect or Want of Copulation," is divided into subsections that discuss "the kinds," "the causes," and "the cure." The last deals extensively, as expected in a treatise of those times, with the herbal and dietary remedies commonly believed to have aphrodisiac properties. Having finished this profuse exposition, Plater turns his attention to less common therapeutic measures. For instance, he recommends the anointing of the male genital organs with sweet-scented oils. These are best for "the Yard" (a term that shows the age-old male preoccupation with measurement) and "the Stones, Loins and Privities." Significantly, though, he adds: "and sometimes the soles of the feet, these [oils, he probably meant] are made of hot attractives." Plater has more to say about the role of the feet in this therapy: "They say that if the right toe be anointed with oil of Spanish flies, it will provoke Venery, which we cannot deny to be possible. . . . These ointments in the loins and privities of women stir them up when dull. . . . But privately before copulation let the man anoint his Yard with Civet or Gall of a Hen." Perhaps Doctor Plater did not place much reliance on the efficacy of topically applied preparations, for he goes on to describe other therapeutic measures, such as "baths and fomentations for the feet and other parts," which ought to produce the desired results by virtue of being naturally hot. In addition, "it is good to wrap the feet in soft furs (which by their gentle tickling stir up women and effeminate persons) to preserve the heat and prevent cold."[11]

It may be that, in the future, scientists will discover a special neuro-circuitry which connects the feet with brain centers that regulate the physiology of erotic-sexual responsiveness. Until that time, it is fair to say that no one knows

how the erotic pulsation is made to proceed in one direction or another. But this, no doubt, is only a part of the much larger question of the choice of love object. Few scientists have had the candor to avow that the fundamental question in the psychology of love—namely, why does one love one specific person and not another?—is as yet unanswered. Among those with a healthy dose of forthrightness was Alfred Binet (1857–1911), who wrote: "love is not a banal feeling that presents itself in all with uniform characteristics. Each one has his own manner of loving, as of walking or breathing; only most often what gets displayed into the full light are the specific features of the passion, but its individual nuances remain hidden in the deepest recess of the heart."[12]

Binet described the many partialities that lovers evince. In his experience as a psychologist and researcher, he encountered lovers with a weakness for hands, others who worshipped hair, and many who made another part of the beloved, or even a simple, intangible emanation, an object of their passion. Next, he traces a line between the normal and the pathological. A lover may be captured by some detail in the physical person of the beloved, but the morbid character of this love is manifested if an exaggerated importance is attached to such detail. A tradition says that Descartes's first love was cross-eyed, and that ever afterward the celebrated philosopher developed a liking for cross-eyed women. There would be nothing abnormal in this preference, which may be seen as one of the infinite *sui generis* turns that individuals stamp upon the amorous passion. But it would be pathological if Descartes fell for *any* cross-eyed female, intelligent or stupid, neat or slovenly, young or old, shrewish or even-tempered. For then he would

love cross-eyedness, not the woman. His love would imply "a kind of hypertrophy of one element which brings about the atrophy of all the rest."

This tendency to "utterly detach the object of the lover's cult from everything that surrounds it, and to make of it an independent whole"[13] is the core of Binet's concept of amorous or sexual *fetishism*.[14] Overwhelmingly a male condition, sexual fetishism has this peculiarity: that it abstracts one element and sacrifices the totality of the person. In contrast, healthy love is addressed to the whole person.

More than a hundred years have passed since Binet published his study, and little has been added to his original formulations. The markedly private aspect of sexual behavior and the absence of a good theoretical model are said to hinder the growth of knowledge in this area. But we have learned a remarkable fact: that the foot is the body part where the fetishist sexual preference concentrates. Among close to 5,000 individuals surveyed, the foot represented 47 percent of fetishes, vastly exceeding the relative frequency of other anatomical substrates, like hair (7 percent), the navel (3 percent), or the breasts (3 percent).[15]

The preeminence of the foot as object of sexual fetishism is nothing new. Historical records contain many examples of this singular preference. Among the most colorful are those narrated by Madame d'Aulnoy (also known as Countess d'Aulnoy:1650/1651–1705), a French woman celebrated as a wit and a scandalous figure in the second half of the seventeenth century. A writer of fairy tales (she is credited with having invented the name of this genre), she gained notoriety for a political scandal in which her husband, some twenty years

her senior, was accused of treason, probably with her intervention. Forced to emigrate under incredibly adventurous circumstances, she stayed for some time in Spain. There, she jotted down pointed descriptions of the customs and manners of the common people and the aristocracy. The following anecdote reflects the attitude regarding female feet that prevailed in Madrid's royal court.

One morning, the countess was visiting a woman of the high Spanish nobility, Doña Teresa de Figueroa, who was only seventeen, but was married to an old man, Don Agustin Pacheco. "Spanish women," notes the writer, "are naturally lazy, they love to get up late." This particular woman received her while still in bed. The countess had come accompanied by several men, who stayed in the hall outside the lady's bedroom,

> because it is not the custom in Spain for men to enter into a woman's bedroom when she is still in bed. A brother never has this privilege, unless his sister is sick. Doña Teresa received me with such warmth as if we had been old friends. But I will say this in praise of Spanish women, that in their politeness there is never that air of familiarity that comes from lack of education . . . they know well what they owe to others and what they owe to themselves. . . .
>
> She courteously asked permission to get up from bed. But, as she was about to put on her shoes, she had the door of the bedroom securely locked, and removed the key. I was intrigued by this precaution and wanted to know why she decided to barricade herself that way. She told me that she was aware that I had come with some Spanish gentlemen in attendance, and that "she would rather lose her life than permit that they should see her feet."[16]

With her usual mordant style, Madame d'Aulnoy says she burst out laughing and asked to let her see them, since her gaze was "of no consequence." And she adds: "to be truthful, they were quite small. I have seen six-year-old children who had them just as large."

Elsewhere, Madame d'Aulnoy describes a luxurious mule-drawn carriage at Madrid: "It had doors like our old carriages, which can be detached and the leather opened in the lower part, so that when the ladies wish to come down—*they don't want to show their feet*—they lower this door all the way to the ground, so as to conceal the shoe."[17]

Later, in commenting about feminine sumptuary customs, she remarks that Spanish women wear very long skirts, so long that they drag on the ground, but always in front, never in the back. They wear them at ground level, but they want to be able to actually tread on them, "in order to hide their feet, which are the part of the body that they conceal most carefully."

Here the lady chronicler is referring to an antique piece of clothing called *tantillo*, a women's garment that earned a place in European history. All the court ladies, and the queen herself, used to wear it. Maria Luisa of Savoy (1688–1714), the popular and well-liked first wife of pusillanimous King Philip V of Spain, took it upon herself to abolish the *tantillo*. She argued, quite correctly, that it was part of a most impractical apparel, and raised a lot of dust upon walking.

The question of the suppression of the garment became an "affair of State." Since the result would have been to shorten skirts—both front and back—the matter acquired an unsuspected importance. A chronicler says that some husbands

"pushed their extravagance to the point of saying that they would rather see their wives dead than to suffer the indignity that others saw their feet." Blécourt, the French ambassador, in his grave dispatches to Louis XIV, affirmed that a raid by the English on the entire coastline of Spain would cause less trouble. Nevertheless, the queen got what she wanted, and the Spanish ladies found themselves so comfortable in the new fashion that, according to a foreign observer, eventually they shortened their skirts "outrageously."

In her account, in the form of letters to her daughter, Madame d'Aulnoy writes: "I have heard it said that after a lady has had every possible complacence for a gentleman, it is by showing him her foot that she confirms to him her tenderness, and that is what they call here the ultimate favor."[18]

There are other foot-related incidents that Madame d'Aulnoy recounts. It was no secret that King Philip V (reigned 1683–1746) tenderly loved his first wife, Maria Luisa (Marie Louise by her French name) of Savoy. Breaking with a long tradition of the monarchy in his land, Philip not only slept in the same bedroom, but made it a point to sleep with her, in the same bed, and, like his French grandfather, Louis XIV, assiduously insisted on exerting his marital rights well past his mature years. To his immense chagrin, Marie Louise died at the age of twenty-six. While she lived, of all the ladies' feet in the land, the queen's feet were the greatest taboo. The very sight of this part of her anatomy was forbidden to all except her royal husband.

One day, the queen decided to accompany her spouse to the hunt. (She was the first among the Spanish queens to whom this liberty was granted.) At the starting point, merely

to mount on a horse was for her a very difficult operation. She had to propel herself from the carriage door onto the horse's back, in such a way as not to expose her feet. But she had a skittish horse that withdrew precisely at the moment when she leaped on top of it. The result was that her august frame landed most roughly on the ground. When this happened to the queen, the king ran to her assistance, but when he was not present, no one else dared to approach her, for it would have been a grievous fault and an irresponsible audacity to touch her and help her to rise and remount her horse.

Philip, aware that his wife loved horse-riding, had acquired three beautiful Andalusian steeds for her. She chose one that was not exactly an easy-gaited palfrey. No sooner did she try to mount it than it reared abruptly, and Louise went down. Unfortunately, one of her feet became trapped in the stirrup; the horse, feeling this encumbrance, lashed out furiously, dragging the queen at risk to her life. This happened in the palace's central court. The king watched the scene from a balcony, and was desperate. The court was full of people, including servants, guards, ladies, and noblemen, but they all stood paralyzed. No one dared to run to help the queen, "because it is forbidden to a man to touch her, and mainly on her feet." The only exceptions were the little boys whom she used to call her *meninos*, who helped her to put on her shoes, and this function earned them general estimation. The queen could lean on them during her strolls. But they were all children, too little to be of help in her present predicament. At last, two Spanish gentlemen, Don Luis de las Torres and Don Jaime de Soto Mayor, resolved to risk everything and came to their queen's aid at that critical juncture. One of them was able

to hold the reins, while the other took the queen's foot and released it from the stirrup, suffering the dislocation of one of his fingers in the process. Madame d'Aulnoy's report reads:

> But, without stopping a single moment, they got out, ran to their respective homes and had their horses saddled to escape the king's wrath. Count Peñaranda, who was their friend, approached the queen and respectfully told her that those two, who had just had the happiness of saving her life, now had reason to fear the worst, unless she had the kindness to intercede in their favor with the king, *because it is not allowed to touch her, and very particularly on the feet*. The king manifested his extreme joy upon realizing that she was not wounded, and received very well the plea that she made in favor of those generous delinquents. He sent a carriage for them; they were at home ready to flee. The queen honored them with a gift, and since then had a particular regard for them.[19]

This kind of feet-based eroticism may seem ridiculous or absurd to us. It was no joking matter for Spanish monarchs, as demonstrated by the following story.

Queen Elisabeth of France (1602–1644) became queen consort of Spain from 1621 to 1644 by her marriage to King Philip IV (1605–1665). This monarch superintended the ruinous period that saw the decline of Spain from a huge empire that spanned the entire known world, and covered about 12.2 million square kilometers, to a weak European nation beset by severe internal and external problems. Not the least of this monarch's difficulties was an unsettled and tempestuous private life, in which his first wife, Elisabeth, played a role.

Elisabeth (known in Spain as Isabel de Bourbon) was an attractive young woman. Although she did not share with Iberian beauties what an admiring Englishman once described as "the soft blood-tinged olive of the glowing complexion," because she was very fair, she certainly possessed the appeal of "the large black eye and the dark expressive glance," which according to the aforementioned Englishman outdid the "soft blue eye and delicate loveliness" of his own countrywomen.[20] Alas, these very charms were also the cause of woe for Elisabeth. To her consternation, she attracted the unsolicited attentions of a brilliant but fiery, aggressive, and dissolute aristocrat, Juan de Tarsis[21] y Peralta (1582–1622), second Count of Villamediana. This man's father, the first Count of Villamediana, had been in the service of the unfortunate Prince Don Carlos (romantically idealized in Verdi's well-known opera), and was made a count by King Philip II. Thus, there was no question that the family belonged to the highest aristocracy in the land. This secured for the second Count an excellent humanistic education, which unfortunately did nothing to thwart his proclivity for gambling, womanizing, and reckless, dangerous exploits. Among the latter must be counted his writing acid satires about contemporary grandees of Spain, whose foibles he knew very well, since he moved in the same circles. His satirical pieces circulated from hand to hand, and it is said that their cold, concentrated scorn has never been surpassed. This activity earned him, as may well be supposed, plenty of rancorous enemies.

His disordered life and the acerbic animosities that he incited led to his being banished from the court. He went to

live in Spain's Italian possessions for six years, at the service of Count Lemos (1576–1622), Viceroy of Naples, President of the Council of the Indies and of the Supreme Council of Italy. Villamediana returned to Spain after the death of King Philip III. Banishment had been far from edifying for the Count; his irresponsible, troublesome behavior led to a second exile, but he was eventually reinstated by King Philip IV, who made him gentleman-in-waiting of his entourage. This is where he conceived a passion for the young queen.

There were many incidents in his amorous pursuit. The king was notoriously unfaithful; his many escapades became only too blatant in the form of the children he fathered in profusion out of wedlock. But the queen was zealously guarded; her opportunities to cultivate a liaison were exceedingly rare; and attempts to create occasions for intimacy were not only difficult, but dangerous in the extreme. Passion, however, will make the timid bold; what it would do to those who are by nature rash and reckless, there is no telling. It is recounted that during a festivity in the Plaza Mayor of Madrid, Villamediana appeared wearing a cape adorned with silver coins called "reales" (*real* in Spanish means both real and royal) and carried a motto: *son mis amores reales* ("my loves are 'real/royal'") Thus, he played with the various possible meanings of the word "real": it could allude to the silver coin, to the notion of reality, or to royalty, i.e., he may have been expressing his love for the queen. Besides daring acts of this kind, he tried, by the many subterfuges proper to lovers, to make Elisabeth aware of the fire that consumed him. But indirectness and dissimulation could never permit a full avowal. Spurred by desire, Villamediana thought of a plan that astonishes by its sheer folly. The

queen could not be touched, under pain of death; but our man thought of creating a state of emergency that would justify his taking the queen into his arms and telling her, this time openly and unhesitatingly, how he felt and what he wanted of her.

A story from mythology says that Love is a blind child because Madness, his nurse, playing with him one day, caused an accident that led to his losing his eyesight. Zeus was angered, and in punishment for her negligence condemned her to be forever the blind child's guide. This is why love is ever since conducted by madness. Villamediana's plan had to be conceived in madness. He had written a theater play entitled *The Glory of Niquea*,[22] in which the queen had graciously agreed to play a role. The performance was scheduled for April 8, 1622, in the royal gardens of Aranjuez. The final scene represented Elisabeth ascending to heaven as the goddess of Beauty in all her glory. Villamediana had brought from Italy a famous architect to prepare the special effects for this scene. At this point, a fire started on the stage. Some claim that the lover had instructed one of his men to start the fire, so that he could take the queen into his arms. Madame d'Aulnoy is quite direct. She says that during the fire, Villamediana took the queen to safety "through certain back-stairs, where he stole some favors from her, and what in this country is considered the uttermost daring, he went as far as touching her foot. A little page who saw him, informed the Count-Duke [the prime minister, Olivares], who never doubted, upon seeing the fire, that it had been the work of the Count."

Historians cast some doubt on the veracity of this story; they claim that it is a romanticized fabrication of people overly fond of mystery novels.[23] The truth is that shortly after the

fire, on August 21, 1622, as the Count of Villamediana was getting out of his coach, where he was traveling with a friend, he was attacked by masked assassins who fatally stabbed him. The killers were never found. This remains one of the famous unsolved murders in history. Suspicion naturally fell upon the king, but also on the many rivals and enemies that the Count of Villamediana made during his agitated life. A large, gripping oil painting of the death scene was executed in the nineteenth century by the folklorist artist Manuel Castellano (1826–1889); it is in the Prado Museum. It shows the lifeless body of the Count lying on the street, surrounded by a crowd of onlookers; in the background is the church of San Jacinto, next to which the murder took place.

The beautiful and intelligent Elisabeth of France died at the age of forty-one. A few years later, Philip IV married his second wife, Mariana of Austria (1634–1696), who was his niece (daughter of Philip's sister). It is enough to see the masterful portraits of these two queens, owed to the incomparable genius of Velázquez, to realize that physical agreeableness was not the chief determinant of the king's choice for his second marriage. Indeed, the marriage was above all an act of political expediency. He was forty-four; she was only seventeen. This did not bode well for their union. But against whatever anguish and frustration Mariana of Austria may have experienced, she found refuge in religion. Her zeal and devotion she carried to a degree that was considered excessive even for the time and place in which she lived. The atmosphere of zealotry and prudishness that surrounded her is instanced in the following anecdote.

Mariana was traveling in Spain. When she arrived in a small village, a commission came to present her with several gifts, among them silk stockings. The *Mayordomo mayor* (head steward of the palace) no sooner saw these presents than he irately threw them back to those who had brought them, saying: *Habéis de saber, que las Reinas de España no tienen piernas!* ("You ought to know that the Queens of Spain have no legs!") The Austrian-born queen, then psychologically still a child, took this utterance literally, and began to cry, saying that she wanted to return immediately to Vienna, for she had discovered a villainous plot to have her legs amputated. Her accompanying ladies knew how to comfort her, and the trip continued.

From our vantage point in the second millennium, this type of story may seem absurd and probably fake. But it is sobering to remember that prudery, starchy pretense, and puritanical hypocrisy may easily slip into pathological extremes. Only two or three generations ago, there were ladies of Mrs. Grundy's temperament who, at a public concert sponsored by a women's college, decided to cover the legs of the piano with a cloth. Why? Because legs are legs; and who knows if the piano legs, by an association of ideas, might bring into men's minds the image of women's legs; and from female legs, who knows into what abyss of concupiscence they could be dragged? Men are such brutes! . . .

This kind of reasoning, which we may call "the slippery slope of lewdness," implies that one first stimulus leads, by easy transition, to progressively more dangerous representations of lasciviousness. This is how some would explain the

sexual charge of female feet. Their hypothesis appears summarized in a few lines by the French poet Alfred de Musset (1810–1857):

> Que, lorsqu'on voit le pied, la jambe se devine,
> Et tout le monde sait qu'elle a le pied charmant[24]
>
> ("Who sees the foot, the leg must surely guess / How charming is that foot to roving eye")[25]

Possibly the erotic charge assigned to female feet has to do with their inaccessibility. Under ordinary circumstances of social life, the foot is a part of the body that remains hidden and wrapped under layers that ensure its perennial invisibility and seclusion. Madame d'Aulnoy herself seems not altogether insensible to feminine podalic charm among the Spaniards, for when she was allowed to see what women so rigorously defended from men's gaze, she declared that "one has to agree that nothing is prettier in that species. As I have said, they have feet as small as those of our dolls. . . . When they walk it seems that they fly. In a hundred years we could not learn that kind of gait."

The erotic significance of female feet, as is generally known, reached extraordinary prominence in the Far East, and especially in China. Equally well-known is the ancient Chinese practice of foot-binding, foisted on female feet and clearly implemented under erotic determinants. A caveat is appropriate at this point. Whereas it is true that severely tight foot-binding caused a painful distortion of the feet, and kept women in a state of subjection, seclusion, and domesticity, it is also true that the practice was neither uniform nor universal

(there were forms of foot-binding that did not interfere with walking), and that a number of historical and social factors, all too often unknown to Western authors, contributed to promote this custom. These facts have to be taken into consideration in any discussion of foot-binding. For instance, in the social realm, foot-binding could be a way for a family of restricted means to marry a daughter into a higher social class, since foot-binding was associated with a better economic situation. Elite women were not required to engage in physical labor, in contrast to rural women, for whom bound feet would have been an unbearable encumbrance. In the political domain, foot-binding could express loyalty to the Han ethnic group, against the Manchus, who invaded Ming China in the seventeenth century and established the Qing dynasty (1644–1911). The invaders prohibited the Han Chinese from following their traditional customs, including foot-binding. The perpetuation of this practice, therefore, could be regarded as having nationalistic undertones, among other meanings.

The distinguished Western Sinologist Robert Hans van Gulik (1910–1967) wrote that sharp-pointed and excessively small feet had figured as indispensable attributes of feminine beauty ever since the Song dynasty (960–1279), and that attempts to trace the origin of this custom to more remote times must be rejected as false and groundless.[26] This coincides with Chinese sources: the Song scholar Zhang Bangji (flourished in the twelfth century) stated in a book published in the 1140s: "Women's foot-binding began in recent times; it was not mentioned in any books from previous eras."[27]

Van Gulik claimed that the history of the practice itself is not difficult to trace. The real problem is to ascertain why it is

that the feet have played so particular a role in the sexual life of the Chinese. For the truth is that they created an ever more involved folklore on feet and shoes, and came to consider the feet as "the most intimate part of the feminine body, something like the very symbol of femininity," the most powerful focus of women's sexual attractiveness.

Van Gulik informs us that erotic illustrations from the Song dynasty and those that followed not uncommonly show women's naked bodies. In some, genital anatomy is far from hidden: the vulva may be displayed quite openly. But there is not one of these figurative representations—and as far as he knows, none exists—in which the artist represented the bound feet of a woman after they were uncovered. The biggest artistic license that painters or illustrators allowed themselves was to show a woman in the act of doing or undoing the bandages that bind her feet, yet those feet are shown still covered by the bandage. "The naked feminine feet are strictly a taboo," writes the Sinologist, and it seems to us that we are reading Madame d'Aulnoy's Spanish chronicle. From women with bound feet, concludes van Gulik, the taboo was extended to women who did not follow this practice. Feet became a prohibited sight—disallowed in all women. The only exceptions were the feet of goddesses, such as Gwan-yin, the goddess of mercy, and the feet of lowly personages, such as servants.[28]

A vivid example of the erotic significance of the female foot in Chinese culture is found in a novel deemed one of the four great classical novels of Chinese literature. Its title is most commonly translated as "By the Water's Edge" or "Water Margin" (Chinese 水滸傳; Romanization in pinyin: *Shui hu zhuàn*).[29] Its authorship has been a matter of contention, but

it is usually attributed to Shi Nan-ai (c. 1296–1372), a native of Suzhou. Although this book is considered one of the peaks of Chinese literary fiction written in the vernacular, there were critics in the Ming period (1368–1644) who denounced it as obscene or indecent. In one section of the novel, a young man is instructed by a go-between on how to seduce a married woman. Elsewhere I have summarized the step-by-step strategy detailed by the go-between in this novel in order to achieve the young man's desire.[30] What is striking is that, as familiarity increases between the prospective seducer and the woman during a *tête-à-tête* meal, physical contact seems to have relatively little erotic charge.

Van Gulik says that, should the man happen to intentionally (but, of course, trying to make it seem involuntary) touch the woman's breast or her gluteal region, this probably would have been interpreted as an accident, the result of an awkward motion. But the young man in the novel, on the advice of the go-between, lets the chopsticks with which he was eating fall on the ground, and as he lowers himself, presumably to pick them up, he goes for the woman's feet instead, which he tenderly squeezes. There can be no question, then: this is the ultimate erotic caress, just as it was in the seventeenth-century Spanish court. It is the most direct and exciting erotic move: tantamount to sexual foreplay preceding intercourse. "Different strokes for different folks," says the American popular wisdom. How true. Strange as it seems, pedal "stroking" has carried an explosive erotic charge in both East and West.

Such is the irrationality and unpredictability of human erotic life that Western men are not exempt from undue attachment to female feet. It seems that Napoleon Bonaparte

"shared the Mongol taste" in this respect, as a French author put it. In a woman, he tells us, Napoleon prized above all the hands and the feet. The breast, in the view of the ephemerous Emperor of the French, was secondary. So it was that Josephine and Marie-Louise were endowed with charming lower extremities, but ill-provided in the pectoral region. The bosom of the former, "lowly placed and flat," swung up and down in the absence of corset or brassiere, which she did not wear; that of the latter, on the contrary, was "rather strong, quite that of a suckling nurse."[31] This mattered little to the great Corsican.

7 TO THE BODY FANTASTIC, ORALITY EQUALS INDIVIDUALITY

ON SOME PERVERSIONS OF THE APPETITE

Philosophers who have discoursed on the shaping of our individuality see this problematic process rooted in the "inside/outside" opposition sensed by all human beings. In everyday life, we experience an "inside," namely that which exists within our body—whose workings we may not quite understand, yet somehow perceive as a coherent structure—and an "outside," which is all that lies external to it. This opposition we do not find disturbing. But to the elementary imagination the outside is threatening, because it is alien, unknown, and unreliable. Therefore, in the deepest strata of our mind, the "outside" is bad: it represents a principle of destruction to our individual or our group identity. In contrast, the "inside" is part of us, hence it is dependable, certain, familiar, and therefore good.

In the course of developing his psychoanalytic theories, Sigmund Freud came up with the startling conclusion that there is an "oral stage" of development during which the pleasure-seeking ego yearns to introject into itself everything

that is good and to reject everything that is bad. But it is a fact of life that the most basic form of incorporating external matter into our substance is eating, thus turning the "outside" into the "inside." For it is through the open mouth that we "taste the world," and make it a part of ourselves. Bakhtin, using his well-known trope of the "grotesque body," noted that it is through the "open, chewing, rending mouth" that the world is introduced into our own body, and made a part of ourselves. Presumably, as we grow older our autonomy is progressively consolidated. The opposition "inside/outside" becomes stronger, better delineated, more and more clearly defined as we mature. The elementary system of values, however, remains the same as it was at the beginning: generally, the "outside" is bad, and the "inside" is good. Hence that singular feeling we call "disgust," which arises when that which is outside is perceived as a danger. In this interpretation, disgust is essentially a defense reaction. It is expressed as nausea and vomiting, i.e., a rejection, which is the opposite of ingestion, and therefore a metaphorical way of defending our personal identity from external threats.

The body fantastic, always unhappy with the limitations proper to the human condition, longs to strike down the barrier of individuality. The limits of the individual become blurred when an overwhelming oral instinctual drive erases all distinction between "inside" and "outside." Indeed, an irrational, centripetal movement impels some people to try to assimilate and possess all that is alien, i.e., all that lies "outside" of the self. From the outside, this strange impetus looks like a perversion of the appetite. But there are degrees of severity in which this dark tendency manifests. At the lower end of the scale, we find

the disorder called "pica," defined as the desire to eat materials without any nutritional value. We may say that it lies on the borderline between normality and pathology, since it is seen, albeit uncommonly, in women during pregnancy. The term "pica" comes from the Latin word for magpie, a bird known for its propensity to hoard, and often to ingest, all kinds of brilliant and brightly colored objects. A number of synonyms were formerly used, including the Latin *picaceus appetitus*, or "picatio," and the Greek *allotriophagia* (ἀλλοτριοφαγία from *allotrion*, αλλοτριον, alien, strange, and *phago*, φάγω, I eat).

People with pica have been known to eat plaster, charcoal, earth, and other strange things. An old medical encyclopedia enumerates the following: sand, lime (especially slaked lime taken from walls), chalk, clay, mud, bricks, dust of all kinds, lead, paper, lint, linen, raw meat, human flesh, living frogs, spiders, hair (their own or that of others), and many other materials. The compiler of this list tells us, speaking of the propensity to eat ants: "The famous singer Catalani, strolling together with me in 1819 at Vilnius [Lithuania] in the garden that she enjoyed in the Antokol suburb, avidly ate ants, after pulling out their heads."[1]

In ancient Rome, there were "lithophages," i.e., stone-eaters, who, to amaze their audience, filled their stomach with stones, and then caused them to resonate by percussing their own abdomen. Apparently, this strange practice has always existed and exerted a morbid fascination. In the sixteenth century, Montaigne deplored that young women wishing to appear pale—a feature deemed attractive in women at the time—wolfed down sand, ashes, and would have gobbled up anything, even if by doing so they "ruined their stomach, just

so they would acquire the pale colors. . . . Yes, even to the point of causing their own death."[2] Nor is this an idle admonition even in our day, since about 1,500 people die annually in the United States after swallowing injurious foreign objects.

In seventeenth-century London, there appeared a curious personage, Francis (or Francesco) Battaglia, an Italian who astonished audiences by consuming large portions of stone and gravel. After finishing this odd entrée, he would vigorously shake his body to and fro, so as to elicit a rattling sound inside his stomach, the better to impress his audience. Legend had it that he came into the world with one stone in one hand and two stones in the other. The narrative further states that he refused to suck the maternal breast, or to take any other aliment, and when physicians were consulted on what to do, they decided that "since the child brought its meat with it into the world, that it was to be nourished with stones." Accordingly, says the strange legend, he was raised with this kind of nourishment right up to his manhood.

The seventeenth-century physician and writer John Bulwer (1606–1656) mentioned Battaglia in his book *Anthropometamorphosis*, once a popular work despite its intimidating title. Bulwer commented that some men choose to "come out of that order wherein Nature prudently placed them." Man, he wrote, is perpetually precipitated by his passions into all forms of dangers and disgraces. And "the blandishment of his appetite, which [since his first infancy] he finds neither wit nor will to withstand, hurry [sic] him to that intemperance that has no precedents among the beasts."[3]

I have had occasion to observe a couple of cases of aberrant ingestion of a different nature. Surgeons today are

familiar with this uncommon occurrence, but in the nineteenth century, when operations on the abdomen with opening of the stomach were not practiced, the diagnosis of this condition was a matter of unalloyed wonder, as illustrated by the following case, culled from the medical literature of the nineteenth century.

A thirty-year-old woman had complained since her late teens of severe abdominal pain, vomiting, diarrhea, and great prostration. She was tall, thin, pale, and looked anxious. A globular tumor could be easily palpated on her upper abdomen; it was smooth and hard but not painful, and was easily movable. However, she had been able to carry out her activities as a domestic servant for ten years, until she was forced to spend some time in the London Hospital for Diseases of Women. The tumor, felt by several physicians who attended her, slowly grew after she was discharged, while her other symptoms remained unchanged.

Medical technology was then rudimentary. In the absence of X-rays, the physicians relied on the tactile sensation of their fingers and hands. Of course, they were unsure of the diagnosis: some thought the tumor was a "scirrhous" (hard, indurated) cancer of the stomach; others believed the palpable mass was due to fecal impaction in her colon, but strong purgation had long been ineffective. One day, the patient was seized with a violent abdominal pain, fainted, and, after much suffering, died. At autopsy, a black mass was discovered inside her stomach and esophagus which consisted almost entirely of hair, except for some entrapped food and mucus. The stomach was otherwise empty; on its posterior wall there was a perforation, which had caused fatal peritonitis (fig. 7.1).

Figure 7.1
Mass of hair that was found obstructing the stomach of a patient with the longstanding habit of pulling her hair and swallowing it. Note that the mass, or "trichobezoar," adopted the shape of the stomach and, on its upper portion, the esophagus. From Palemon Best, "Death from Accumulation of Hair in the Stomach of a Woman," *British Medical Journal* 2, no. 467 (December 11, 1869): 630–631.

Commented her attending physician: "The inability of any of the medical men who saw this patient to arrive at a correct diagnosis was probably due to the extreme rarity of cases resembling it. . . . I had never heard of a similar one." But

he added, by way of clarification, that the patient's relations and friends "all bore testimony to the extraordinary habit of eating her hair in which she had, for the last fifteen years, indulged."[4]

Today, this condition—a big hairball in the stomach—is quite well known in medicine and is only rarely a cause of death. Present advances permit surgical removal of the hair mass, usually without complications. In general, this disease manifests itself in children or adults as an irresistible impulse to pull out hair, a strange habit for which medical terminology reserves, as is customary, a cryptic name: "trichotillomania."[5]

The victims of this disorder have the compulsion to eat the hair they pull out, an act which goes by the technical term of "trichotillophagia." This is a most intriguing disorder; its precise nature is still a matter of dispute among experts in neuropsychiatry. Some talk loosely about the compulsive habit of eating hair, calling it a "tic." But tics are defined as usually purposeless, abrupt, spasmodic muscular contractions in reaction to a sensory stimulus. Habitual hair-pulling is not like that at all. Instead, the patients display complex motions directed toward a specific end. They may comb their hair, at the same time or just before pulling it out. The whole act may look like a strange ritual: the person who has just extracted a hair may examine it, slide it against the tongue, bite off the tip that has the hair follicle, roll it, or twist it, then gulp it down or otherwise dispose of it. They seem to be doing this unconsciously, mechanically, while engaged in reading, watching television, or during other activities. But is there such a thing as an automatic, senseless, repetitive act? Psychiatric theory would seem to negate the existence of

utterly purposeless, meaningless human acts. What mysterious impetus can possibly drive this manner of self-ingestion? No one knows.

In any case, repetitive hair-pulling over time ends up forming unsightly bald patches that are distressing to the patient and suggest the diagnosis of trichotillomania to the physician. Of those patients with the compulsion to pull their own hair out, some 5 to 18 percent will proceed to eat it. Most patients are pubescent girls or young women.[6] Some of them say they perceive the act of deglutition as pleasurable; others declare that they do it out of fear of being scolded by their parents, or for other reasons. In any case, the hairs, swallowed one by one, slowly accumulate in the stomach, where they are detained by the mucus that lines the inner surface of this organ, and, by gradual accumulation, may form a compact mass able to cause gastric outlet obstruction or perforation. In some instances, the mass of hairs may form a long tail: hairs intertwine with each other end to end, in such a way that the "tail" may extend into the small intestine, and even the colon. In that case, physicians of a romantic bent replace the imposing names of "trichotillomania-trichotillophagia" with the more poetical term, "Rapunzel syndrome," currently in use in the medical literature,

Solid masses composed of conglomerates of foreign objects in the stomach are called "bezoars," from the Arabic *gadzehr* (or the Persian *padzahar*), meaning counterpoison or antidote, since at one time it was believed that some bezoars protected against toxins and certain diseases; Queen Elizabeth I of England owned a bezoar richly enchased in gold. Thus, a bezoar made of hair is termed "trichobezoar"; one

made of vegetable matter, "phytobezoar"; of curdled or somehow congealed milk, "lactobezoar"; and so on.

LIFE AND VICISSITUDES OF SOME CELEBRATED HISTORICAL GOBBLERS

Among the wildness and bewildering strangeness of aberrant ingestions, some examples have achieved exceptional notoriety. Historically, an egregious case of extravagant ingurgitation was seen in nineteenth-century Paris. A mature man named Jacques de la Falaise (1754–1825), a worker in the quarries of Montmartre, amused his co-workers by swallowing the corks of wine bottles and whole eggs, shell and all. An acquaintance persuaded him to show his amazing ability to the public for financial gain. His "performance" at a theater included swallowing, apparently without any pain, several whole walnuts, a rose with its leaves and thorny stem, three pieces of cardboard rolled together into a cylinder, a live mouse, and, to finish this disgusting meal, a live eel. After each solid object was gulped down, he drank half a glass of wine, which people said contained a secret preparation to ease the digestion of such preposterous meals. He seemed to carry out his horrible devouring without any trouble. No one ever saw him doing any special movement to try to kill the live animals he swallowed. Nor did his face express pain caused by a difficult digestion. Wrote a physician who attended the bizarre spectacle: "They say that he expels from down under the solid residues, like the debris of the bird and the mouse, within twenty-four hours, but the undigested parts of the eel come out until the third day. His dejections are extremely fetid" (fig. 7.2).[7]

Figure 7.2

Jacques de la Falaise, famous "polyphage," with some items of his menu. From *Notice sur Jacques de Falaise, ses habitudes, sa nourriture, et les moyens qu'il emploie pour conserver sa santé* (Paris: Ballard, 1820). Courtesy of the National Library of France.

The mouse Monsieur de la Falaise used to swallow was a white rodent of African origin. In spite of its small size, this is an animal with sharp teeth and claws, capable of inflicting painful wounds. The parrot that was also downed by our man was furnished with a hard beak and feathers, which by themselves might have made digestion well-nigh impossible. The acute, pointed thorns of the rose are no less forbidding: to eat such an object seems a dire risk. But to engorge a live eel or a live crayfish is an act the mere sight of which is apt to give us nightmares. On occasion, minutes after gulping down these animals, the human devourer was bothered by the sensation of their movements inside his stomach; yet it sufficed for him to drink a small amount of strong liquor for the creatures to calm down and be digested, just like any other foodstuff.[8]

Eighteenth-century France seems to have been fertile ground for colorful, grotesque examples of bizarre gorgers. For history contains one of the most extraordinary instances of this kind, a Frenchman who went by the name of Tarare (also spelled Tarrare), although it is uncertain whether this was his real name or his nickname, since he came from a village of the same appellation near the city of Lyon. He was a derelict. He had been forced to leave the paternal home at a very early age, and survived by stealing, begging, or joining the itinerant troupes of mountebanks that acted farces in countryside fairs. His "act" on the stage consisted in challenging the spectators to furnish him with enough food to make him reach satiety. If he found simpletons wishing to pay for the performance, he would eat huge baskets of apples, or raw potatoes that the peasant audience gleefully tendered him. If

no one took up the challenge, he would swallow cork stoppers, pebbles, and other unusual, non-alimentary fare, to the indescribable astonishment of his public. Repeated performances earned him some notoriety, and also more than one admission to hospital to relieve self-induced, acute abdominal distress. However, as soon as he felt somewhat recuperated, he went back to his gastronomical public follies.

He arrived in Paris as a boy in 1788, during a perilous time of revolutionary fervor. His extravagant guzzling games earned him one admission to the Hôtel-Dieu hospital, where the chief surgeon, Doctor Giraud, recognized him. The following dialogue ensued:

—Are you Tarare, the famous *eater*?

Indeed, sir. The very same.

—And how are you feeling?

Quite all right, sir. As good as new. I could show you, if you would allow me.

—Really? How would you do that?

Let me see your watch, please, for just a moment.

No sooner had Tarare uttered this last sentence than he proceeded to take a pocket watch from the surgeon's vest, and would have swallowed it, together with the gold chain attached to it, but for a quick motion by the surgeon, who stopped him before he could drop the expensive timepiece down his throat.

An internist, Doctor Desault, seeing his repeated admissions to the hospital, tried psychology to change his behavior. When Tarare came in, once again complaining of colic, the

medico attempted to scare him by announcing that he could not cure him with the accustomed remedies. This time, he said, he had to cut open his abdomen, and ordered an assistant to prepare the surgical instruments. Colicky as Tarare was, the announcement scared the living daylights out of him. He escaped from the ward immediately, and treated himself at home, resting and drinking lukewarm cooking oil. However, as soon as he felt well again, he returned to his stage performances.

Those were times of great social and political turmoil. Revolutionary France was attacked by neighboring nations weary of her political ideas. Tarare was recruited into the army, to defend the fatherland against the Prussian menace. He was a destitute young lad; the soldiers used him to do various chores for them. To fill his ever-demanding stomach, he used to steal the rations of his comrades-in-arms. This was not enough for him: his appetite for the unusual continued, and he fell ill. He had to be taken to the improvised medical post that had been installed in a small Alsatian town called Sulzen, between Weissenburg and Haguenau, near the front line. An army physician who came to inspect this facility recognized the recruit as the escapee from the Hôtel-Dieu in Paris and the celebrated devourer of all things. A morbid curiosity, which I will not dignify with the name "scientific curiosity," made the physician wish to see how far Tarare's aberrant appetite would take him. From then on, the patient's daily ration increased fourfold, prepared out of the kitchen extras and the leftovers from the other patients' meals. Tarare nonetheless found a way to sneak into the hospital's pharmacy, where he

gobbled up the cataplasms, salvers, and whatever other pharmaceutical ingestible matter fell into his hands.

A legend about him began to grow. It was said that cats and dogs instinctively felt that he could eat them up, and gave him a wide berth. A story went about that one day he captured a cat that he was on the point of eating. The physician assigned to his detachment was called in. When the medical man arrived, Tarare was holding the cat securely by the neck and the legs, and had begun to rend its belly with his teeth. Allegedly, all the officers present witnessed, horrified, how he packed away the whole cat, rejecting only, at the end of his repugnant meal, the animal's fur, in the manner of birds of prey.

Trust the military to think of bellicose uses for the common, unwarlike things of daily life. Doctor Courville, the regiment's chief surgeon, had an idea to put Tarare's ingurgitating abilities to the service of the army. He summoned the man to his presence, showed him a case where the surgical lancets were kept, and bluntly asked him: "Can you swallow this?" Tarare examined the rectangular, narrow boxwood case, and declared that he could do it. Courville opened it up, placed inside some paper sheets, having rolled them into a cylinder, and handed it back to Tarare, who, after wetting its surface with saliva, rammed it down his own throat. The next day he brought the case, carefully washed, to the chief surgeon, who—not without a gesture of repugnance, considering the place through which the box had just passed—opened it up and found the papers inside, perfectly dry. Courville's idea had been to use Tarare's uncanny ingestive ability as a way to transmit secret war correspondence. The surgeon informed a

member of the army's supreme command of his plan and the result of his preliminary experiment.

Tarare made a demonstration of his unmatched ingurgitative talent in the presence of high military officers, including no less than General Alexandre de Beauharnais, close attendant of Napoleon Bonaparte during France's Revolutionary Wars. After this, Tarare received the order of carrying, in the same case he had previously swallowed, and then expelled through the lower route, a top-secret letter destined for a French colonel who had been captured by the Prussians and was being held prisoner at a place near Landau, not far from Neustadt, where the Prussian King had his headquarters.

So, here we have Tarare turned military spy. He leaves at night, under careful secrecy, disguised as a peasant, with the precious message inside a case, and this case inside his stomach. His orders were unambiguous: should he encounter unforeseen difficulties that impeded his trip and brought the message to the light of day, or if the message and its container should happen to come out prematurely, he was to swallow it again, immediately, so as not to betray the vital secret of which the fatherland and his destiny had made him custodian and transmitter. Thus provided, he crossed the enemy lines.

Our man, however, was no spy. His appearance, his bungling, his ignorance of the German language, and his whole demeanor soon gave him away. Miles from Landau the Prussians captured him. They frisked him, interrogated him, and roughed him up a bit, but could get nothing out of him. They took him, under escort, to the camp of General Zoegli, where he had a second examination and a second "harsh interrogation," as we would now term it.

After these inauspicious beginnings, Tarare was held under arrest, as a spy. Among his captors were soldiers who threw him some scraps from their own rations, and were stupefied upon seeing the avidity with which he consumed not only the food itself, but any paper, cardboard, and sundry non-comestibles that came his way.

It may be easily imagined that, after thirty hours of detention, the paper and the case that held it clamored to be let out. We can also imagine the anguish of that unfortunate courier. If his captors found out what he was carrying inside, there was no question he would be hanged from the nearest tree: such was the inflexible law of war. Fortunately for him, the message and its wooden conveyance made the complete round trip—out and back in—without eliciting any suspicions. Tarare's captors were sufficiently generous to send him back to the French camp, having persuaded themselves that he was a poor devil who could do them no harm, and, for all they knew, might even help the Prussian cause once he was back among the French. But this generosity was not entirely gratuitous: it cost Tarare a third "harsh interrogation."

As it turned out, the so-called secret message he was carrying was only an innocuous invitation to a reception which the French colonel's wife had received. It was a way to let him know that his family was well. General Beauharnais of the French High Command (and, who knows? I like to fancy that Napoleon himself may have been present at Tarare's demonstration) did not think much of the man's intelligence, and did not consider him sufficiently trustworthy to make him the depository of highly sensitive military secrets.

Forever disenchanted with the life of a secret agent, Tarare wished to be cured of his pathological appetite. He went back to the hospital, where the doctors employed on his behalf all the resources of the medical science of that time. The therapies used included the administration of acid beverages, opium-based preparations, and even pills made of tobacco, plus the *coque de Levant*,[9] used in India to calm hunger. None of these therapies was successful. To satisfy his enormous voracity, Tarare roamed about the countryside, where he was seen in sheepfolds, disputing with the wolves their prey, or in poultry yards, stealing eggs and chickens, or in farm kitchens, plundering whatever he could. All this contributed to darken further his ill fame. The peasants now thought of him with horror. In the hospitals, the nurses claimed that they had seen him drink blood taken from a patient's veins, for, as is well known, bleeding by phlebotomy was then a procedure held in high regard and almost universally practiced. There were reports of having sighted him in the morgue, satisfying his abominable hunger with human remains.

At length, the sudden, inexplicable disappearance of a fourteen-month-old infant gave rise to the suspicion that Tarare had something to do with it. A furious mob let it be understood that he would be lynched on sight. The poor wretch speedily escaped from the city, and went into hiding. His biographers tell us that between 1794 and 1798 no one knew where he was, or what he was doing. Shortly thereafter, he was seen again at Versailles, this time in a most lamentable state of emaciation. He was dying of consumption, the popular name for what was, in most instances, tuberculosis. He

was only twenty-six years old. His disease, reflects one of his biographers, explains the obscurity of his life during that long interval. For this was a man who, despite the great cataclysms of the French Revolution, would still have been the talk of the town, however much the people may have been perturbed by the daily events of that calamitous era.

Several times Tarare had complained to physicians that years before, during one of his public "performances," he had swallowed a silver spoon, which he never could expel. He pretended to blame this old ingestion for his terminal disease. This became an obsession for him: if only he could get rid of that accursed spoon! When he died, after a severe diarrheic episode, several physicians were interested in seeing the state of his digestive organs. The scientific interest of those who performed the autopsy was radically different from that expected of pathologists today. They were strongly condemnatory of the poor devil: their disapproval of his morals and their own disgust at their appointed task dominated a report that should have been a no-nonsense description of objective findings. They spoke of the cadaver of a "monster." His body was so "corrupted" just hours after his death that the physicians "hesitated to open it," yet went ahead prompted by such momentous scientific queries as to ascertain whether there was, or was not, a silver spoon in the stomach. There was no such thing. From the hurried, cursory examination conducted it is possible to conclude that a massive, generalized peritonitis, possibly of tuberculous origin, was the cause of death. All that was said of the stomach was that it extended to the lower abdomen and had ulcers. The bad odor of the cadaver

impeded the examiners' motivation to "carry the inspection as far as they had intended."

Nonetheless, special attention was paid to the upper alimentary tract. We learn that Tarare's cheeks, coursed by deep wrinkles, could be extended to such a size that they could enfold, like those of certain monkeys, a great number of foodstuffs—a dozen eggs, for example, or so many large apples; that his mouth was very wide and slit-like, with almost no lips; and that his dentition was complete, with not a single tooth missing. For all the neglect with which the internal organs were examined, the mouth and throat were carefully looked at, and some verification maneuvers were carried out. Thus, the jaws were opened as far as possible, and the opening's diameter was estimated as about ten centimeters. Then it was determined that, with the head extended backward, the space of the oral cavity and the esophagus formed a broad, straight canal, such that a cylinder twenty or more centimeters long could be introduced without bumping against the palate.

The following physiological phenomena captured the attention of physicians while Tarare was alive. The man sweated continuously, especially during his eating binges; and from his body, which was always very warm, emanated a visible vapor. When he spoke, this vapor came out of his mouth, even in the summer, like the mist that flows out of the oral cavity in a cold wintry climate. This visible haze also emerged from his nose as he breathed. And the haze was just as perceptible to the eye as it was to the nose, for the man stank to such a degree that his bad odor could be detected at twenty paces. He suffered from frequent diarrheas, and his

stools were extremely malodorous. When he had just had his fill, the vapor that came out of his body seemed to increase, his cheeks were reddened, his eyes brilliant and congested, and a brutish somnolence, which a physician qualified as "a kind of hebetude," seized him. At such times he needed to go carry out his digestion in some remote, tranquil corner.

Strikingly, this man, who ate like ten, was no more corpulent than the average male of his nation. The physicians attributed this fact to his frequent diarrheal bouts—had he lived today, there might have been talk of "intestinal malabsorption"—and to the metabolic losses reflected in the constant sweat that drenched his body, and the "fumes" that emerged in "torrents" with his respiratory movements.

There you have a summary of the life of "the greatest polyphage and *omophage* (eater of raw food, especially meat) of modern times," as Tarare was once called.[10] Numerous other amazing guzzlers and prodigious devourers have surfaced in our own lifetime. Some of these could certainly vie with Tarare in point of immoderate, spectacular swallowing: to wit, another Frenchman, Michel Lotito (1950–2007), who ingested a whole airplane, a Cessna-150, in a preposterous feat that took him over two years to complete.[11] But there is no point in listing these champions of the absurd. My purpose is not to compile a collection of medical curiosities or events worthy of a roadside freak show. I wished to demonstrate the body's inherent rebelliousness and unpredictability. The body is constantly torn by inner tensions of its constituent parts. On the one hand, our thinking brain tells us that we must preserve and respect out corporeal limits, which are the bulwark against the intrusions of "the outside." Without

this defense, our individuality is rendered vulnerable. On the other hand, however, a pulsation of the body fantastic impels us to transgress these limits, to go beyond them, into the territory of alterity, of that which is "outside."

In our societies, writes Le Breton, "the skin's limits are the limits of the subject, and everything that transgresses these has consequences for the individuals themselves. The boundaries of the ego in Western societies are organic boundaries."[12] But there are areas of the body that normally exist at the very limit of our corporeality, at the interface between the inside and the outside. Of these, the most important for the "body fantastic" is the mouth, because it is "the tangible site of exchange with the world and the interiorization of the universe within the self, where an individual taste for life can be lost or restored, his or her identity shaken and corrupted."[13] I intend to illustrate only one minor aspect of the complex play of orality upon a man's individuality. To do this, I will use an episode from my own life. I have narrated this autobiographical anecdote elsewhere.[14] A recapitulation of the main features is as follows.

ON THE VIRTUES OF FIRE-EATING

As a child growing up in Mexico City more than seventy years ago, I used to marvel at street performers who, in those innocent, now irrevocably bygone times, entertained the people by introducing fire into their mouths. They extinguished live torches, and ejected huge, impressive, flaming plumes right out of their oral cavity. I could not avoid linking these wondrous feats with a general custom of the country: the use of

unbearably acrid hot peppers as a condiment. Why do people eat foods that burn? Aberrant ingestions are an enigma. The medical literature hypothesizes about nutrient deficiencies (of iron, zinc, calcium), emotional stress, cultural beliefs, protection against toxins of pathogens, and so on. But the truth is that no one has fully explained the craving and consumption of substances which no one (not even the craver and consumer) would think of introducing into his or her mouth under ordinary circumstances. I therefore feel free to propose that the fierce instincts of Aztec human sacrificers and the obsessive self-mortification of gaunt Castilian anchorites were two ancestral influences whose conjunction in Mexicans directed them to transform the pleasurable experience of eating into a painful sacrifice.

Painful, of course, mainly to those not inured to the daily assaults of capsaicin-rich seeds. As for the natives, they start being trained early in their lives to withstand this gustatory aggression. Only I showed myself unfit for such training, and this ineptitude annoyed my father. I recall an incident at table. My father tendered me a fair portion of one of his favorite, incendiary sauces. My timid approach to it, the expressions of whimpering qualm with which I received it, and the minuteness of the sample I tasted, were too much for him. His vexation burst forth in the form of a question: "What's the matter with him? Is he not a Mexican?"

The question was rhetorical: it was a denunciation of my timorousness, which in his view was depreciatory of the national honor code of manly courage and virile stoicism. But at the same time it was an appeal to a higher authority, that of my mother, to whom the question was addressed, and

who always had the last word in everything that concerned my upbringing. Of course, she shielded me on that occasion, as she always did, from any potential injury from the devilish concoction. She argued that I was too young; that hot sauces were not necessarily salubrious for such a young lad; and that a balanced diet with or without them is equally conducive to good nutritional results. To this day, I feel that my oral mucosa escaped scatheless thanks to her providential protection. For those caustic seasonings were such as could melt cast iron, and I doubt if they would have shown any mercy to a boy's tongue.

It must be said that my father's partiality for harsh, pungent, aggressive flavors was but a reflection of the grittiness of his philosophy of life. This came from his having spent his best, formative years amid the collective savagery euphemistically termed "the Mexican Revolution." In this armed conflict he had fiercely combated . . . on the losing side. It was in those years of constant uncertainty that he learned that audacity, reckless gambling, and unwariness in the face of danger often profit a man many times more than assiduous industry, frugality, and prudence. He saw that enormous fortunes were made one day and dissipated the next, depending on the prevailing direction of the political winds. He learned that most men are covetous and self-serving; that they think nothing of falsely professing the highest ideals as a means to ascend to power, but are ready to commit the same larcenies and villainies they condemned as soon as their usurpation is complete. Those were times in which the most precious, most cherished values were annulled, repealed, or invalidated, and the only certainty one could count on was the imminence of death.

From all this experience my father derived his personal philosophy. Its full extent or its central tenets I never did discover. As far as I could make out, in my childish view, it was a rude version of male stoicism that valued maleness, toughness, prepotency, and endurance, and depreciated effeminacy, feebleness, and cowardice. Its central motto was *Los hombres no lloran*: "Men don't cry."

The problem was: those agitated times came to an end. And when the troubles were over, he found out that the lessons he had learned no longer applied. Peace found him unprovided with the tools for survival in the new environment. He was out of phase with the world; confronted by men whom he inwardly despised, but who mocked his pride and derided his intrepidity, which was of no longer of any use, and even ridiculous in the new era. He probably agreed with Vauvenargues that "peace makes the people happy, but the men weak."[15] Or his plight might have been better described in Shakespeare's words:

> The painful warrior famoused for fight
> After a thousand victories once foiled
> Is from the book of honor razed quite,
> And all the rest forgot for which he toiled.[16]

Be this as it may, he sought to dilute his rancor and frustration in alcohol. What bullets could not do, the spirituous fumes easily accomplished: his liver was irreparably destroyed. When he saw his death approaching, he asked, in pitiful, plaintive tones, to be taken to his mother's home, deep in the province. Uncharitable critics said that he faltered at the last hour: where had all his bluster gone? Whatever happened to

the revolutionist's derring-do? Such is the invidiousness and malice of the world toward those who, at the last minute, recant the opinions or principles they formerly professed. As if finding oneself in an inexpressible predicament—the most vulnerable situation possible for any human being—was not sufficient cause for seeing things differently!

I attended my father's funeral wake when I was not quite ten years old. It took place deep in the Mexican province, and was conducted in accordance with longstanding traditions. Women wrapped in black *rebozos* (shawls) prayed constantly while they sat around the open coffin, which rested on a high support. My small stature did not allow me to look inside. As was customary, there was a table with coffee and victuals—the indispensable hot sauce conspicuously present—to sustain the women in their incessant recitation of rosaries and litanies. "The duty of women is to cry for the dead. That of men is to remember them," wrote Tacitus,[17] and this millenarian expression was singularly fitting to the scene I contemplated.

A man, an overly officious attendee at the ceremony, who had been a drinking companion of the deceased (and for that reason detested by my mother), grabbed me by the waist, and lifted me so that I could "see my father for the last time." The sight was neither necessary nor consoling nor edifying: a broken man, jaundiced and devastated by the combined assaults of utter despair and liver cirrhosis. I would rather not have seen him thus. The man who had lifted me without asking my permission deposited me back on the floor. Then, I began experiencing something indescribable, something like an inner vacuum, a never-to-be-filled hole in my existence. At the same time, a sort of inchoate sob was taking shape deep inside me.

There are times at which the body seems actuated by other than normal physiological impulses. We then say that "we don't know what came over us" and made us act in a certain way; or else we eschew the mystery by referring to "the unconscious." This was one of those occasions. It was as if my whole being wished to eliminate the boundaries of individuality, and dissolve into the surroundings; it was an obscure yearning to merge with the universe into one great Whole where there is no cognizance, no anxiety, no anguish, and no suffering. Without being conscious of what I was doing, I approached the table with the food on it, took the wooden spoon dipped in hot sauce, and immersed it, full to the top with the infernal mixture, deep into my mouth.

I felt as if I had put a live coal into my mouth. My face turned intensely red, swollen, and contorted in the gestures of pain, while abundant tears flowed from my eyes. The women interrupted their praying to come to my aid, bringing me sugary beverages, towels, ice, and gushing consoling expressions of commiseration. "The poor little darling! He didn't realize that the bowl contained the hot sauce!" But in the midst of this commotion, I felt proud for having fooled everyone. They never suspected that I was actuated by impulses stemming from the immaterial body, which they could not see. They attributed my tearful grimacing to a physiological reaction triggered by capsaicin, not to forlornness, despondency, and a son's sorrow. For I had been taught that such maudlin effusions are a sign of weakness, which a real man must never show.

Had my father seen my behavior, he certainly would have approved of it. Men don't cry.

Notes

INTRODUCTION

1. Paul Valéry, "Réflexions simples sur le corps," in *Œuvres*, vol. 1 (Paris: Gallimard, 1957), 925–931.
2. Ibid., 930.
3. Plato's *Phaedo* (sections 64d–66d), translated with an introduction and commentary by R. Hackforth (1955; Cambridge: Cambridge University Press, 1994), 44–47. See also Plato's *Gorgias* (sections 524a–527a) for a discussion of the philosopher's soul stripped from the body.

CHAPTER 1

1. For a discussion of the possible origin of the name of the uterus, and of the Platonic idea of the mobility of this organ, see Mark J. Adair, "Plato's View of the 'Wandering Uterus'," *Classical Journal* 91, no. 2 (December 1995–January 1996): 153–163.
2. This saying, often attributed to Plato, is said to be owed to Aretaeus of Cappadocia in his *Treatise of the Signs, Causes, and Cure of Acute and Chronic Diseases*. I used the French version of this work, translated from the Greek by M. L. Renaud: *Traité des signes, des causes et de la cure des maladies aiguës et chroniques* (Paris: Chez Lagny, 1834). The famous saying is in chapter X, "De la suffocation de la Matrice," page 66.
3. Ibid., 350.

4. Castoreum is said to come from the beaver's anal sacs, which are not true glands, but repositories of the secretion. Its use in perfumery requires prolonged aging of the anal sacs, otherwise the odor would be too raw and offensive. The ancient Romans believed that its fumes could cause abortion.

5. Richard Folkard, *Plant Lore, Legends and Lyrics: Embracing the Myths, Traditions, Superstitions and Folk-Lore of the Plant Kingdom* (London: Folkard & Son, 1884).

6. Christopher A. Faraone, "Magical and Medical Approaches to the Wandering Womb in the Ancient Greek World," *Classical Antiquity* 30, no. 1 (April 2011): 1–32.

7. Ibid., 24.

8. W. O. Baldwin, cited in J. M. Sims, *The Story of My Life* (New York: Appleton & Co., 1884).

9. Adair, "Plato's View of the 'Wandering Uterus'," note 2.

10. From *Timée*, French translation of Plato's *Timaeus* by Luc Brisson (Paris: Flammarion, 1992).

11. Jean-Baptiste Bonnard et al., "Male and Female Bodies According to Ancient Greek Physicians," *Clio* (English edition), no. 37, "When Medicine Meets Gender" (2013): 18–37.

12. Camille Paglia, "Sex and Violence, or Nature and Art," chapter 1 in *Sexual Personae. Art and Decadence from Nefertiti to Emily Dickinson* (New York: Vintage Books, 1990).

13. Véronique Dasen, "Métamorphoses de l'utérus d'Hippocrate à Ambroise Paré, " *Gesnerus* 59, no. 3–4 (2002): 167–186.

14. In *Generation of Animals*, book II, chapter 7, Aristotle says that "nature sends the blood into this part of the uterus (cotyledons) as it were into breasts."

15. A. A. Barb, "Diva Matrix: A Faked Gnostic Intaglio in the Possession of P. P. Rubens and the Iconology of a Symbol," *Journal of the Warburg and Courtauld Institutes* 16, no. 3/4 (1953): 193–238.

16. Alfred Plaut, "Historical and Cultural Aspects of the Uterus," *Annals of the New York Academy of Sciences* 75, no. 2 (January 1958): 389–411.

17. Quoted by Hermann Heinrich Ploss et al. in *Woman: An Historical, Gynaecological and Anthropological Compendium*, vol. 1 (London: William Heinemann Medical Books, 1935), 388.

18. The *Golden Legend* story of Nero's gastric batrachian is told as a digression in the Life of Saint Peter Apostle. I used Jacques de Voragine's *La Légende Dorée*, French translation from Latin by J. B. M. Roze (Paris: Garnier-Flammarion, 1967), 414–427.

19. For a concise mention of Sobremonte's ideas on the biological problem of intersex, see Richard Cleminzon and Francisco Vázquez García, *Sex, Identity and Hermaphrodites in Iberia 1500–1800* (2013; New York: Routledge, 2016), 22–25.

20. The *Oxford English Dictionary* says the meaning of the word "colluvies" is: "Chiefly Med. A collection or gathering of filth or foul matter; spec. foul discharge from an ulcer."

21. Quoted in Felice La Torre: *L'utero attraverso i secoli. da Erofilo ai giorni nostri* (Città di Castello, 1918), 58.

22. My chief source for the medical debate on "the thinking uterus" was Giacomo Casanova, *Lana Caprina: Une controverse médicale sur l'Utérus Pensant à l'Université de Bologne en 1771–1772*, texts annotated by Paul Mengal, translations by Roberto Poma (Paris: H. Champion, 1999).

23. The Italian word *podice* derives from Latin *podicem*, which is a corruption of *pordicem*, from the Greek *pordé*, meaning "fart" (*Dizionario etimologico della lingua italiana di Ottorino Piangiani*, published online at http://www.etimo.it/). Italian dictionaries (Garzanti, Zingarelli) define the word *podice* as: 1. (Anat.) lower extremity of the trunk of the fetus; and 2. Seat. Anus. Anal region.

24. This third book appeared with the rather cryptic title of *Lana Caprina: Lettre d'un lycanthrope addressée à S.A. La Princesse J.L. n. P.C. Bologna 1772.* (See note 22 for its most recent reprinting.) *Lana Caprina* ("goat's wool") is an expression taken from Horace (*Epistles* book I, XVIII, 15) alluding to those who argue whether the goat's hair should be called wool or hair. It became a proverbial expression meaning "to argue over trifles." Casanova, the book's author, maintained the cryptic tone to the end, signing "E. P.," initials thought to stand for Eupolemus Pantoxenos, one of his many synonyms, and one with which he liked to sign his poems.

25. Charles-Clapiès d'Alais (1724–1801) translated Acidalius' book into French as *Paradoxe sur les femmes, où l'on tâche de prouver qu'elles ne sont pas de l'espèce humaine* (Krakow, 1766).

26. Casanova, *Lana Caprina*, 175. The names of Peter and Jack were an allusion to Jonathan Swift's *Tale of a Tub*, although the exact phrase quoted does not exist in Swift's tale.

27. The statement was in keeping with the then accepted concepts about the relation between the uterus and the spectacular symptoms of so-called "hysteria."

28. Gunning S. Bedford, *Lecture Introductory to a Course in Obstetrics & Diseases of Women and Children* (New York: Press of New York University, 1846).

29. Quoted in M. L. Holbrook, M.D., *Parturition without Pain: Code of Directions for Escaping from the Primal Curse* (New York: M. L. Holbrook Publisher, 1872), 14–15.

30. M. Brannström et al., "Livebirth after Uterus Transplantation," *Lancet* 385, no. 9968 (February 14, 2014): 607–616.

31. M. Brannström, "Uterus Transplantation Trial: 2-year Outcome (Abstract)," *European Gynaecological Oncology Congress* (ESGO), 2015.

32. K. S. Arora et al., "Uterus Transplantation: Ethical and Regulatory Challenges," *Journal of Medical Ethics* 40, no. 6 (2014): 396–400.

33. Evie Kendal, "The Perfect Womb: Promoting Equality of (Fetal) Opportunity," *Journal of Bioethical Inquiry* 14, no. 2 (2017): 185–194.

34. Jean-Jacques Aubert, "Threatened Wombs: Aspects of Ancient Uterine Magic," *Greek, Roman and Byzantine Studies* 30, no. 3 (1989): 421–449.

CHAPTER 2

1. Quoted by Fraser Lewry, "The Man Who Ate Everything," *The Guardian*, published online February 25, 2008, https://www.theguardian.com/lifeandstyle/wordofmouth/2008/feb/25/foodherowilliambuckland.

2. For a recent biography of Frank Buckland, see Richard Girling, *The Man Who Ate the Zoo: Frank Buckland, Forgotten Hero of Natural History* (London: Chatto & Windus, 2016).

3. For a brief summary of Broussais's medical system, see H. Gouraud, "Illustrations scientifiques: Broussais," *Revue des Deux Mondes* 18 (1839): 1–27.

4. Broussais's ideas are incorporated in a lecture by an American physician: William Stokes, "Pathology and Treatment of Chronic Gastritis," *Boston Medical and Surgical Journal* 10, no. 16 (May 28, 1834): 245–252.

5. Edward Miller, "Some Remarks on the Importance of the Stomach as a Center of Association, a Seat of Morbid Derangement, and a Medium of the Operation of Remedies in Malignant Diseases," in *Medical Repository of Original Essays and Intelligence Relative to Physic, Surgery, Chemistry, and Natural History*, vol. 5 (New York: E. Bliss & White, 1802), 300–310.

6. Roger Lewin, "Is Your Brain Really Necessary?," *Science* 210 (December 12, 1980): 1232–1234.

7. Lionel Feuillet et al., "Brain of a White-Collar Worker," *Lancet* 370, no. 9583 (July 2007): 262.

8. Donald R. Forsdyke, "Wittgenstein's Certainty Is Uncertain: Brain Scans of Cured Hydrocephalics Challenge Cherished Assumptions," *Biological Theory* 10, no. 4 (December 2015): 336–342.

9. J. Just, R. M. Kristensen, and J. Olesen, "Dendrogramma, New Genus, with Two New Non-Bilaterian Species from the Marine Bathyal of Southeastern Australia (Animalia, Metazoa incertae sedis)—with Similarities to Some Medusoids from the Precambrian Ediacara," *PLoS One* 9, no. 9 (September 2014): e 102976, http://journals.plos.org/plosone/article?id=10.1371/journal.pone.0102976.

10. "Apophoreta" entry in Anthony Rich, *A Dictionary of Roman and Greek Antiquities*, 5th ed. (London: Longmans, Green & Co., 1890), 44.

11. Deborah Ruscillo, "When Gluttony Ruled!," *Archeology* 54, no. 6 (November/December 2001): 20–25.

12. Quoted by Athenaeus in his *Deipnosophists or the Banquet of the Learned*, 3 vols. (London: Henry G. Bohn, 1854), vol. 3, 821–822.

13. Most likely Mithridates VI (reigned 120–63 BC), who engaged the Romans in repeated wars. It is famously recounted that he became immune to many poisons by early exposure to the same over a long time period.

14. Athenaeus, *The Deipnosophists*, vol. 2, 655.

15. Richard M. Dorson, "Big Eaters," *Journal of American Folklore* 92, no. 363 (March 1979): 77–79.

16. David Kamp, "Whether True or False, a Real Stretch," *New York Times*, December 30, 2008, Food section.

17. H. Paul Jeffers, *Diamond Jim Brady: Prince of the Gilded Age* (New York: John Wiley & Sons, 2002).

18. Ross Arbes, "The Aspiring Writer Who Became an Eating-Contest M.C.," *New Yorker*, July 1, 2016.

19. See its website: http://www.majorleagueeating.com/. The MLE was established in 1997.

20. "L'ingestion de hot-dogs comme sport, l'autre fête nationale américaine," *Le Monde*, May 7, 2016.

21. Samantha Schmidt, "At Nathan's Hot Dog Contest, 15 Women Challenge the Gluttony Ceiling," *New York Times*, July 4, 2016.

22. Marc S. Levine et al., "Competitive Speed Eating: Truth and Consequences," *American Journal of Radiology* 189 (2007): 681–686.

23. Krystal D'Costa, "How Does Competitive Eating Represent Us as Americans?," *Scientific American*, published online July 4, 2013, https://blogs.scientificamerican.com/anthropology-in-practice/how-does-competitive-eating-represent-us-as-americans/.

24. Brian Wansink and Kevin M. Kniffin, "Exhibitionist Eating: Who Wins Eating Competitions?," *Frontiers in Nutrition* 3 (November 24, 2018), article 51, https://doi.org/10.3389/fnut.2016.00051.

25. Figure from the United Nations Food and Agriculture Organization for 2016. See https://www.worldhunger.org/2015-world-hunger-and-poverty-facts-and-statistics/.

26. Thomas H. J. Jukes, "How to Survive the Perils of Eating," *FASEB Journal* 9 (August 1995): 991–992.

CHAPTER 3

1. Cornelius Tacitus, *The Histories of Cornelius Tacitus*, book IV, 81. This work may be consulted online at: http://www.ourcivilisation.com/smartboard/shop/tacitusc/histries/chap17.htm. The quoted story is also told in

1. Suetonius (Gaius Suetonius Tranquillus), *The Twelve Caesars*, VII, 2. I used the 1984 Penguin Classics illustrated edition, translated by Robert Graves, p. 264.
2. Pliny the Elder (Gaius Plinius Secundus), *Natural History*, translated by W. H. S. Jones, book XXVIII, chapter vii (Cambridge, MA: Harvard University Press, 1979), 27–29.
3. Albert le Grand, *Les Secrets Admirables du Grand Albert, comprenant les influences des astres, les vertus magiques des végétaux, minéraux et animaux* (Paris: Chez Tous les Libraires, 1895).
4. [Nicholas Robinson?], *A Treatise on the Virtues and Efficacy of the Saliva, or Fasting Spittle, being conveyed into the intestines by eating a crust of bread, early in a morning fasting, in relieving the gout, scurvey, gravel, stone, etc.*, first American from the 10th London edition (Salem: Henry Whipple, 1844).
5. Ibid., section VIII, p. 21.
6. H. S. Brand et al., "Saliva and Wound Healing," *Monographs in Oral Science* 24 (2014): 52–60.
7. S. Dagogo-Jack, "Epidermal Growth Factor EGF in Human Saliva: Effect of Age, Sex, Pregnancy and Sialogogue," *Scandinavian Journal of Gastroenterology*, supplement 124 (1986): 47–54.
8. Meno J. Oudoff et al., "Histatins Are the Major Wound-Closure Stimulating Factors in Human Saliva as Identified in a Cell Culture Assay," *FASEB* 22, no. 11 (2008): 3805–3812. This article, first report on the identity of a healing factor in saliva, may be consulted online: http://www.fasebj.org/content/22/11/3805.abstract. See also Hirochika Umeki et al., "Leptin Promotes Wound Healing in the Oral Mucosa," *PLoS One* 9 (7) e101984, published online July 17, 2014, https://doi.org/10.1371/journal.pone.0101984.eCollection.
9. P. Overgaauw and F. van Knapen, "Is Being Licked by Dogs Not Dirty?" [in Dutch], *Tijdschr Diergeneeskd* 137, no. 9 (September 2012): 594–596.
10. Sebastien J. C. Farnaud, et al., "Saliva: Physiology and Diagnostic Potential in Health and Disease," *Scientific World Journal* 10 (2010): 434–456.
11. Maria Greabu et al., "Saliva—a Diagnostic Window to the Body, Both in Health and Disease," *Journal of Medicine and Life* 2, no. 2 (April–June 2009): 124–133.

12. Manjul Tiwan, "Science behind Human Saliva," *Journal of Natural Science, Biology and Medicine* 2, no. 1 (January–June 2011): 53–58.

13. R. F. Vining and R. A. McGinley, "Hormones in Saliva," *Critical Review of Clinical Laboratory Science* 23 (1986): 95–146.

14. Anup Kaphie, "Chinese Tourists' Bad Manners Harming Country's Reputation, Says Senior Official," *Washington Post*, May 17, 2013.

15. Edward O. Otis, *The Great White Plague* (New York: Crowell & Co., 1909), 247.

16. French Senate, Proposition de Loi adoptée par la Chambre de Députés tendant à l'interdiction de cracher à terre dans tous les établissements et locaux ouverts au public, Minutes of the Senate session of October 19, 1922, Bibliothèque Nationale de France, Sénat (1875–1942).

17. Song entitled "Défense de Cracher," published in *Les Chansons Illustrées* (Paris), no. 320 (1894), n.p.

18. *Le Rire*, n.s., no. 88 (October 8, 1904).

19. Charles-Camille Pelletan (1846–1915), referenced in the caption to figure 3.2, was a leftist politician, Minister of Marine of the French government and member of a radical socialist party founded in 1902, two years before the appearance of the reproduced caricature.

20. Vincenzo Savica et al., "Urine Therapy through the Centuries," *Journal of Nephrology* 24, S 17 (2011): S 123–125.

21. Bruno Halioua and Bernard Ziskind, *Medicine in the Days of the Pharaohs*, translated by M. B. DeBevoise (Cambridge, MA: Belknap Press of Harvard University Press, 2005), 71–72.

22. Ibid.

23. Sara Rasmussen et al., "On the 'Spitting' Behavior in Cobras (Serpentes: Elapidae)," *Journal of Zoology* 237, no. 1 (September 1995): 27–35.

24. Diodorus Siculus, *The Library of History*, book V, chapter 33, translated by C. H. Oldfather (Cambridge, MA: Harvard University Press, 1993), 187.

25. Strabo's *Geography*, translated by H. C. Hamilton, Esq. and W. Falconer M.A.; published online at http://www.perseus.tufts.edu/hopper/text?doc=Perseus%3Atext%3A1999.01.0239%3Abook%3D3#note-link278.

26. Catullus, poem XXXVII, in *Catullus, Tibullus, per Vigilium Veneris*, translated by Frances Warre Cornish, 2nd ed. (Cambridge, MA: Harvard University Press, 1988), 45.

27. http://twitter.com/healthmeup. See buff.ly/2QQpGyH (site visited March 7, 2020).

28. Reported in a BBC article by Ashita Nagesh: "Please Can Everyone Stop Drinking Their Own Urine?," published online September 26, 2018, https://www.bbc.co.uk/bbcthree/article/fe46907b-d860-4a72-ae32-809a1da4c1eb.

29. Arthur Christian, *Études sur le Paris d'autrefois* (Paris: Roustan & Champion, 1904), 33.

30. Katy Winter, "'Drinking a Pint of Urine Every Day Keeps Me Young. And It's Delicious': Glamorous Health Fanatic, 63, Reveals Revolting Beauty Secret," *Daily Mail*, October 3, 2013.

31. Christine R. Totri et al., "Kids These Days: Urine as a Home Remedy for Acne Vulgaris?," *Journal of Clinical Anesthesiology and Dermatology* 8, no. 10 (October 2015): 47–48.

32. Mary Beith, *Healing Threads: Traditional Medicines of the Highlands and the Islands* (Edinburgh: Polygon, 1995), 188.

33. Jane Flanagan, "Cameroon Threatens to Jail Urine Drinkers," *Daily Telegraph*, March 23, 2003.

34. M. Geoffriau et al., "The Physiology and Pharmacology of Melatonin in Humans," *Hormone Research* 49, no. 3–4 (1998): 136–141.

35. T. Pääkkönen et al., "Urinary Melatonin: A Noninvasive Method to Follow Human Pineal Function as Studied in Three Experimental Conditions," *Journal of Pineal Research* 40, no. 2 (March 2006): 110–115.

36. B. Claustrat et al., "The Basic Physiology and Pathophysiology of Melatonin," *Sleep Medicine Review* 9, no. 1 (February 2005): 11–24.

37. Anonymous, "Melatonin for Sleep Problems in Children with Neurodevelopmental Disorders," *Drug Therapy Bulletin* 53, no. 10 (October 2015): 117–120.

38. K. Harinath et al., "Effects of Hatha Yoga and Omkar Meditation on Cardiorespiratory Performance, Psychologic Profile, and Melatonin

Secretion," *Journal of Alternative and Complementary Medicine* 10, no. 2 (April 2004): 261–268. See also E. E. Solberg et al., "The Effects of Long Meditation on Plasma Melatonin and Blood Serotonin," *Medical Science Monitor* 10, no. 3 (March 2004): CR 96–101.

39. Acharya V. Vasudeva, "Does Urine Therapy Work?," *Times of India*, February 20, 2012, http://timesofindia.indiatimes.com/city/bengaluru/Does-urine-therapy-work/articleshow/11958030.cms.

40. Bernard Picart, *Cérémonies et coutumes religieuses des peuples idolâtres, représentées par des figures dessinées de la main de Bernard Picard, &c.*, vol. 2, 1st part (Amsterdam: J. F. Bernard, 1728), 28.

41. N. K. Jain et al., "Efficacy of Cow Urine Therapy on Various Cancer Patients in Mandsaur District, India—a Survey," *International Journal of Green Pharmacy* (January–March 2010): 29–35.

42. Ashok D. B. Vaidya, "Urine in Ayurveda: Ancient Insights to Modern Discoveries for Cancer Regression," *Journal of Ayurveda and Integrative Medicine* 9 (2018): 221–224.

43. American Cancer Society statement on Urotherapy in "Complementary and Alternative Medicine," https://www.cancer.org/treatment/treatments-and-side-effects/complementary-and-alternative-medicine.html.

44. Quoted in John Mann, *Murder, Magic, and Medicine*, rev. ed. (New York: Oxford University Press, 2000), 78.

45. A long explanation of the drug "mumia" or mummy and its confusion with embalmed bodies may be found in chapter 12 of R. J. Forbes, *Studies in Early Petroleum History* (Leiden: E. J. Brill, 1958).

46. Abraham Herbert, *Asphalts and Allied Substances: Their Occurrence, Modes of Production, Uses in the Arts and Methods of Testing*, 4th ed. (New York: D. Van Nostrand, 1938); Heather Anne Pringle, *The Mummy Congress: Science, Obsession and the Everlasting Dead* (New York: Barnes and Noble Books, 2001), 196–197.

47. Engelbert Kaempfer, *Exotic Pleasures. Fascicle III: Curious Scientific and Medical Observations*, translated with an introduction and commentary by Robert W. Carruba (Carbondale: Southern Illinois University Press, 1996), 18–29.

48. Ibid.

49. François-Laurent-Marie Dorvault, *L'officine, ou Répertoire général de pharmacie* (Paris: Asselin, 1867), 298.

50. The interested reader may find an erudite discussion of the origin and evolution of the word "mummy" in the history of "corpse medicine" in the excellent article by Karl H. Dannenfeldt, "Egyptian Mumia: The Sixteenth Century Experience and Debate," *Sixteenth Century Journal* 16, no. 2 (Summer 1985): 163–180.

51. Warren R. Dawson, "Mummy as a Drug," *Proceedings of the Royal Society of Medicine* 21 (November 2, 1927): 34–39.

52. Jean de Renou, *Pharmacopoea or Apothecaries Shop, composed by the Illustrious Renodaeus, Chief Physician to the Monarch of France; and now Englished and Revised by Richard Tomlinson of London, Apothecary* (London: Contrel, 1657). This work may be consulted online, under the title "A Medicinal Dispensatory, Containing the Whole Body of Physick"; see https://books.google.com/books/about/A_Medicinal_Dispensatory_Containing_the.html?id=1P-vnQAACAAJ.

53. Quoted in Christian, *Études sur le Paris d'autrefois*, 32.

54. Karen Gordon Grube, "Anthropophagy in Post-Renaissance Europe: The Tradition of Medicinal Cannibalism," *American Anthropologist*, n.s. 90, no. 2 (1988): 405–409.

55. Nicolas Leméry, *Dictionnaire ou traité universel des drogues simples* (Amsterdam, published at the expense of the Company, 1716), 363.

56. Quoted by Dannenfeldt, "Egyptian Mumia."

57. The incident is recounted in Georges Touchard-Lafosse, *Chroniques de l'Oeil de Boeuf, des petits appartements de la Cour et des salons de Paris, sous Louis XIV, la Régence, Louis XV et Louis XVI* (Paris: Barba, 1860), 228–229.

58. Ambroise Paré, *Discours d'Ambroise Paré, Conseiller et Premier Chirurgien du Roi. De la Mumie, de la Licorne, des Vénins, et de la Peste* (Paris: Gabriel Buon, 1582); see chapter VIII, "Discours de la Mumie," 8.

59. Samuel Johnson, *A Dictionary of the English Language, in which the words are deduced from their originals, and illustrated in their different significations by examples from the best writers, to which are prefixed a History of the*

 Language and an English Grammar, 8th ed., vol. II (London: [by a large number of printers], 1799), p. 159, col. 1036.

60. Quoted in Gordon-Grube, "Anthropophagy in Post-Renaissance Europe."

61. John Z. Bowers and Robert W. Carrubba, "The Doctoral Thesis of Engelbert Kaempfer on Tropical Diseases, Oriental Medicine, and Exotic Natural Phenomena," *Journal of the History of Medicine and Allied Sciences* 25, no. 3 (July 1970): 270–310. See note 1 of page 281.

62. For an excellent discussion of the historical controversies regarding cannibalism, see Cătălin Avramescu, "The Conquest of the Savages," chapter 4 in *An Intellectual History of Cannibalism* (Princeton: Princeton University Press, 2009).

63. Mabel Peacock, "Executed Criminals and Folk Medicine," *Folklore* 7, no. 3 (1896): 268–283.

64. J. H. Hulton, "Presidential Address: The Cannibal Complex," *Folklore* 54, no. 2 (1943): 274–286.

65. Anonymous, "Folklore of South Northamptonshire," *Notes and Queries* 2, no. 33 (June 15, 1850): 36–37.

66. Quoted in Richard Sugg, "'Good Physic but Bad Food': Early Modern Attitudes to Medicinal Cannibalism and Its Suppliers," *Social History of Medicine* 19, no. 2 (2006): 225–240.

67. Gordon-Grube, "Anthropophagy in Post-Renaissance Europe."

68. P. Kenneth Himmelman, "The Medicinal Body: An Analysis of Medicinal Cannibalism in Europe, 1300–1700," *Dialectical Anthropology* 22 (1997): 183–203.

69. Renee C. Fox and Judith P. Swazey, *Spare Parts: Organ Replacement in American Society* (Oxford: Oxford University Press, 1992).

70. Margaret Lock, "Human Body Parts as Therapeutic Tools: Contradictory Discourses and Transformed Subjectivities," in Margaret Lock and Judith Farquhar, eds., *Beyond the Body Proper: Reading the Anthropology of Material Life* (Durham: Duke University Press, 2007), 224–231.

71. William James, "The Consciousness of Self," chapter 10 in *The Principles of Psychology*, vol. 1 (New York: Henry Holt, 1890).

CHAPTER 4

1. Pliny, *Natural History*, translated by H. Rackham, 2nd ed., vol. 3, book XI, lxx 185–lxxi 187 (Cambridge, MA: Harvard University Press, 1983), 547–549.

2. Philostratus, *Life of the Sophists*, translated by William C. Wright (Cambridge, MA: Harvard University Press, 1989), 205–207.

3. Quoted in D. H. Spodick, "Medical History of the Pericardium: The Hairy Hearts of Hoary Heroes," *American Journal of Cardiology* 26, no. 5 (November 1970): 447–454.

4. Pedro Mansueto Melo de Souza et al., "'Bread and Butter' Fibrinous Pericarditis," *Autopsy Case Reports* 6, no. 4 (October–December 2016): 5–7, https://www.ncbi.nlm.nih.gov/pmc/articles/PMC5304555/.

5. E. A. Swanson Jr., "Hair Follicles in the Canine Tongue," *Oral Surgery, Oral Medicine, Oral Pathology* 51, no. 3 (1981): 277–280.

6. Louis Legrand, *Une esquisse du conflit entre la cellule et le milieu: aliment et poison; la multiplication cellulaire et l'adaptation au milieu, etc.* (Paris: A. Maloine, 1902), 150.

7. Marcel Baudoin, "Les tératomes ne sont que le vestige de l'un des sujets composants d'un monstre double," *Bulletins et Mémoires de la Société d'Anthropologie de Paris* (December 6, 1906), note 2, p. 73.

8. R. Hamilton Bell, "The Colour of the Hair in Ovarian Dermoids," *British Medical Journal* 2, no. 2384 (September 8, 1906): 599.

9. Reviewed in Charles Répin, *Origine parthénogénétique des kystes dermoïdes de l'ovaire* (Paris: G. Steinheil, 1891), 6.

10. Anup Mohta and Nita Khurana, "Fetus in Fetu or Well-Differentiated Teratoma—A Continued Controversy," *Indian Journal of Surgery* 73, no. 5 (October 2011): 372–374.

11. De Lagausie et al., "Highly Differentiated Teratoma and Fetus-in-Fetu: A Single Pathology?," *Journal of Pediatric Surgery* 32 (1997): 115–116.

12. C. C. Hoeffel et al., "Fetus in Fetu: A Case Report and Literature Review," *Pediatrics* 105 (2000): 1335–1344.

13. Laura Marynczak et al., "Fetus in Fetu: A Medical Curiosity—Considerations Based upon an Intracranially Located Case," *Child's Nervous System* 30, no. 2 (2014): 357–360.

14. The authors of the report, mindful of Latin terminology, do not use the now universal designation "*fetus in fetu.*" Since the mass was not found inside a fetus, but in a boy, they refer to it as "*fetus in puero.*" See P. Lombard et al., "Un fetus de 3 mois dans l'abdomen d'un garçon de 20 mois. Monstre endocymien parasite," *Bulletin de l'Académie Nationale de Médecine* (November 24, 1953): 574–580.

15. See the *Encyclopédie* of Diderot, published online by the University of Chicago's ARTFL project, under the head-word "Cheveux," pages 3–317. May be consulted at https//encyclopedie.uchicago.edu/.

16. A. J. Sigaud de la Fond (the author's name appears in the book's front page simply as A.J.S.D.), *Dictionnaire des Merveilles de la Nature*, vol. 1 (Paris: Rue et Hôtel Serpente, 1781), 100.

17. I. Platt, *Cyclopedia of Wonders and Curiosities of Nature and Art, Science and Literature*, vol. 1 (New York: Hurst and Company, 1878–1882), 30.

18. Anonymous, "Essay on Hair," in *Literary Conglomerate or a Combination of Various Thoughts and Facts* (Oxford: Thomas Combe, 1839), 184.

19. Auguste Debay, *Les vivants enterrés et les morts ressuscités: considérations physiologiques sur les morts apparentes et les inhumations précipitées* (Paris: Moquet, 1848), 21–23.

20. See "Hair," in *London Encyclopedia; or, Universal Dictionary of Science, Art and Miscellaneous Literature, etc.*, 22 vols., vol. 10 (1798; London: Thomas Tegg, 1837), 757.

21. Arnold Chaplin, MD, *The Illness and Death of Napoleon* (London: Hirschfeld Brothers, 1913). See Appendix Three, "The Exhumation of Napoleon." This work may be consulted online, through the Internet Archive; see https://archive.org/stream/cu31924011586751/cu31924011586751_djvu.txt.

22. L.-A. Obert: *Traité des maladies des cheveux, de la barbe et du systèmes pileux en général, présenté à l'Académie royale de médecine et à l'Académie des sciences* (Paris: Lacour, 1847), 22.

23. Nathaniel Wanley, *The Wonders of the Little World; or, a General History of Man: Displaying the Various Faculties, Capacities, Powers and Defects of the*

Human Body . . . etc., vol. 1 (London: W. J. Richardson and others, 1805), 33.

24. All these feats are described in St. Augustine, *City of God*, book XIV, chapter 25. I used the Penguin Books edition translated by Henry Bettenson (Baltimore, 1972), 588–589.

25. Valerius Maximus, *Memorable Doings and Sayings*, translated by D. R. Shackleton Bailey, book I, 6, "Of Prodigies" (Cambridge, MA: Harvard University Press, 2000), 65.

26. Deborah Pergament, "It's Not Just Hair: Historical and Cultural Considerations for an Emerging Technology," *Chicago-Kent Law Review* 75, no. 1, Article 4, "Symposium on Legal Disputes Over Body Tissue."

27. Ovid (Publius Ovidius Naso), *Ars amatoria or The Art of Love*, book III, part 3, lines 1047–1048.

28. Andrea Tratner, "Mit Radikal-Look: Ioanna Palamarcuk will Miss Germany werden," *Neue Presse*, February 2, 2018, http://www.neuepresse.de/Menschen/Mensch-Hannover/Mit-Radikal-Look-Ioanna-Palamarcuk-will-Miss-Germany-werden (accessed March 16, 2018).

29. The *Xiaojing* has been translated into English by James Legge: *The Hsiao King*, vol. III of *Sacred Books of the East* (Oxford: Oxford University Press). A French translation is Léon de Rosny, *Le Hiao-king* (Paris: Maisonneuve & Ch. Leclerc, 1893). The quoted lines come from a conference dictated at the Guimet Museum: Henri Cordier: *La piété filiale et le culte des ancêtres en Chine*, Conférences au Musée Guimet, vol. 35 (Paris, n.d.).

30. Timothy W. Ryback, "Evidence of Evil," *New Yorker*, November 15, 1993.

31. Ibid.

32. Rachel Donadio, "Preserving the Ghastly Inventory of Auschwitz," *New York Times*, April 15, 2015.

CHAPTER 5

1. Benito Jerónimo Feijóo y Montenegro, "Examen filosófico de un peregrino suceso de estos tiempos. (El anfibio de Liérganes)." This work is part of Feijóo's *magnum opus Teatro Crítico Universal*, and is reproduced in *Obras escogidas del Padre Fray Benito J. Feijóo y Montenegro* (Madrid: Rivadeneyra Impresor, 1863), 326–340.

2. Ibid.
3. For a short review of the history of ideas on how the fetus breathes *in utero*, see Michael Obladen, "Pulmo Uterinus: A History of Ideas on Fetal Respiration," *Journal of Perinatal Medicine* 46, no. 5 (July 2018): 457–464.
4. Yonette Joseph and Tiffany May, "Einstein the Anti-Racist? Not in His Travel Diaries," *New York Times*, June 14, 2018, World section.
5. Although "directed panspermia" was originally presented at a scientific meeting in the guise of a serious scientific hypothesis, it must be stated in fairness that Crick and his collaborator L. E. Orgel later acknowledged in writing that the scientific evidence available was inadequate to support this idea. See F. H. C. Crick and L. E. Orgel, "Directed Panspermia," *Icarus* 19 (1973): 341–346.
6. Gregorio Marañón, "Historia maravillosa del hombre pez y su revisión actual," chapter 29 in *Las ideas biológicas del P. Feijóo* (Madrid: Espasa-Calpe, 1934), 236–257.
7. Fortunately, endemic cretinism is largely eradicated today. A classic treatise on this disease, *Der endemische Kretinismusm*, is available in English translation on the internet: *Endemic Cretinism*, edited by John Denison, Charles Oxnard and Peter Obenford (Springer, 1936); see https://epdf.tips/endemic-cretinism.html.
8. The work quoted by Marañón is that of L. Asher et al., "Physiologie der Schilddrüse," in M. Hirsch, *Handbuch der inneren Sekretion*. vol. 2. II, 2nd half (Leipzig, 1929).
9. See the entry "List of Piscine and Amphibian Humanoids" in Wikipedia, for a list of fabulous hybrid men-fish personages in myth, legend, hoaxes, and fiction: https://en.wikipedia.org/wiki/List_of_piscine_and_amphibian_humanoids (accessed May 7, 2020).
10. Quoted by Sarah Murden, "Legends of the Sea," in *All Things Georgian*, a blog dedicated to the Georgian era, posted July 14, 2016, available at https://georgianera.wordpress.com/2016/07/14/legends-of-the-sea/ (accessed June 14, 2018).
11. Ibid.

12. James Cameron made a 3D film of his exploit, titled *Deepsea Challenge*, a 2014 National Geographic documentary; see https://www.imdb.com/title/tt2332883/ (accessed July 15, 2018).

13. See the entry "Static Apnea" in Wikipedia. The male record was established in October 2014 in Dubai; the female record in Belgrade, Serbia, in June 2013.

14. Benedetto Croce, *Storie e leggende napoletane*, 7th ed. (Milan: Adelphi, 2009), 300.

15. Maria d'Agostino, ed., *La leggenda di Cola Pesce* (Rome: Salerno Editrice, 2008).

16. Cervantes makes Don Quixote refer to "the great swimmer named Nicolas" in chapter XVIII of the 2nd part of *Don Quijote de la Mancha*, where he lists swimming ability as one of the qualities of an outstanding knight errant.

17. It has been suggested that Croce identified himself with the legendary figure of Colapesce, and that the nature of this identification varied as he aged. See Luisella Mesiano, "Identificazione infantile, adulta e senile di Benedetto Croce nella figura di Cola Pesce." *Cuadernos de Filología Italiana* 17 (2010): 127–137.

18. Raffaele La Capria, in the preface to "Colapesce," in *Opere* (Milan: Mondadori, 2003), 401.

19. Censorinus, *Liber de die natali*, French translation as *Livre de Censorinus sur le jour natal*, translated by M. J. Mangeart (Paris: Panckouke, 1843), 19.

20. Alister Hardy, "Was Man Aquatic in the Past?," *New Scientist* 7, no. 174 (March 17, 1960): 642–645.

CHAPTER 6

1. Pliny's *Natural History*, book VII, chapter viii, 45–46 (rpt., Cambridge, MA: Harvard University Press, 1989), vol. 2, 535–537.

2. Thomas Sydenham, "Treatise on Gout," in *The Works of Thomas Sydenham, M.D. Translated from the Latin edition of Dr. Greenhill, with a Life of the*

Author by R. G. Latham, M.D., in 2 Volumes (London: Sydenham Society, 1848), vol. 2, 123–162.

3. These affecting depictions of pain by patients were collected and movingly narrated in Michael Stein, M.D., *The Lonely Patient: How We Experience Illness* (New York: William Morrow, 2007).

4. One of the most authoritative English translations is that of M. D. Macleod: *Gout and Swift of Foot*, vol. VIII of *The Works of Lucian* (Cambridge, MA: Harvard University Press, 1993). A number of Lucian's works in English translation may be consulted online; see http://onlinebooks.library.upenn.edu/webbin/book/lookupname?key=Lucian%2C%20of%20Samosata. See also the Lucian of Samosata Project at: https://lucianofsamosata.info/resources.html.

5. Roy Porter and G. S. Rousseau, *Gout, the Patrician Malady* (New Haven: Yale University Press, 1998), 211.

6. These are three famous Hippocratic aphorisms: numbers 28, 29, and 30, in the sixth section of the book *Aphorisms*. An extremely rare disease, the "Lesch-Nyhan syndrome," may produce uric-acid-induced "gouty" attacks in children. But this is an inheritable error of metabolism due to a defective enzyme, accompanied by serious neuro-psychiatric alterations, and should not be equated to gout.

7. Quoted by W. S. C. Copeman in *A Short History of the Gout and the Rheumatic Diseases* (Berkeley: University of California Press, 1964), 236.

8. The commentator was Dr. Ange-Pierre Leca, in his scholarly work *Histoire illustrée de la rhumatologie. Goutte, rhumatismes et rhumatisants* (Paris: Roger Dacosta, 1984), 49.

9. S. C. Bir et al., "Felix Platter and a Historical Perspective of the Meningioma," *Clinical Neurology and Neurosurgery* 134 (July 2015): 75–78.

10. Felix Plater, Abdiah Cole, and Nicholas Culpeper, *Platerus Golden Practice of Physick* (London: Peter Cole, 1664).

11. Ibid., 175.

12. Alfred Binet, *Le fétichisme dans l'amour* (1888; Paris: Claude Tchou, Bibliothèque des Introuvables, 2000), 29.

13. Ibid., 68.

14. Before Binet, the term "fetishism" was used by anthropologists in connection with religions, to name the practice (thought to represent primitive stages of the religious conception) of venerating or worshiping animals, plants, or inanimate objects, such as bright stones, in the belief that such objects possessed a soul. In his 1888 essay, Binet reviewed the psychiatric literature for mention of intense genital excitation produced by objects that would leave any normal person unaffected, and commented that, in this case, "religious adoration is replaced by sexual appetite."

15. C. Scorolli et al., "Relative Prevalence of Different Fetishes," *International Journal of Impotence Research* 19 (2007): 432–437. May be consulted online: http://www.nature.com/ijir/journal/v19/n4/full/3901547a.html

16. Madame d'Aulnoy, *La cour et la ville de Madrid vers la fin du XVII siècle; relation du voyage d'Espagne* (Paris: E. Plon et Cie., 1874), 248–249.

17. Ibid., 258.

18. Ibid., 272.

19. Ibid., vol. II, 210–211.

20. Frederic Shoberl, ed., *The World in Miniature: Spain and Portugal, containing a Description of the Character, Manners, Customs, Dress, Diversions, and other peculiarities of the inhabitants of those countries*, 2 vols. (London: R. Ackerman), vol. 1, 12. 1825

21. Also written Tassis and Tasis.

22. *Florisel de Niquea* is the name of a fictional princess in a book of knight errantry called *Amadis de Grecia* (Amadis of Greece), part of a series of nine volumes on Amadis, a legendary knight errant. These books were immensely popular during the sixteenth century, when they were translated into several languages. In Cervantes' famous work, Don Quixote goes crazy reading this type of novel and, in his delirium, frequently quotes the heroic deeds of Amadis de Gaula, whom he tries to emulate. The authorship of the various Amadís texts is a subject of dispute, since their origin goes back at least to the early fourteenth century. Not without controversy, Feliciano de Silva (1491–1554) is often mentioned as author of the volume on *Amadis de Grecia*, published in 1530 in Spain.

23. For a scholarly examination of Villamediana's theater play, and the clues it may contain regarding his assassination, see Frederick A. de Armas,

"'The Play's the Thing': Clues to a Murder in Villamediana's La gloria de Niquea," *Bulletin of Hispanic Studies* 78, no. 4 (2001): 439–454.

24. Alfred de Musset in *Premières Poésies, Namouna*, published in 1831.

25. More literally: "On seeing the foot, the leg is guessed / and everyone knows her foot is charming." I quoted the English translation that appears in Alfred de Musset, *Namouna, Oriental Tale*, First Canto, stanza IV, in *The Complete Writings of Alfred de Musset*, 10 vols. (New York: Edwin C. Hill Co., n.d.), privately printed for subscribers; English translation by Andrew Lang, Charles Conner Hayden, and Marie Agathe Clarke, vol. 1, 68. May be consulted online at https://archive.org/details/completewritings 01mussiala.

26. Robert Hans van Gulik, *Sexual Life in Ancient China: A Preliminary Survey of Chinese Sex and Society from ca. 1500 B.C. till 1644 A.D.* (Leiden: Brill Academic Publishers, 2003). This book was first published in 1961, by Brill Publishers. I used the French edition, *La vie sexuelle dans la Chine ancienne* (Paris: Gallimard, 1971). All references are to this edition.

27. Quoted in Dorothy Ko, *Cinderella's Sisters: A Revisionist History of Footbinding* (Los Angeles: University of California Press, 2007), 111.

28. Ibid., 275.

29. Other titles in English translation include *Outlaws of the Marsh, Tale of the Marshes, All Men are Brothers, Men of the Marshes*, and *The Marshes of Mount Liang*.

30. F. Gonzalez-Crussi, *On the Nature of Things Erotic*, copyright 1988, 1989, latest edition: New York: Kaplan Publishing, 2009), 121 ff.

31. G.-J. Witkowski, *Les seins dans l'histoire* (Paris: A. Maloine, 1903), 7, note 1. The author is quoting from a book by F. Masson: *Napoléon et les femmes* (Paris: Ollendorff, 1894).

CHAPTER 7

1. Friedrich August Benjamin Puchelt, "Pathologie médicale," in Joseph Frank and F. A. B. Puchelt, *Encyclopédie des sciences médicales*, vol. 5 (Paris: P. Mellier, 1840), 376–377.

2. Michel de Montaigne, *Essais*, book 1, chapter XIV, "Que le goût des biens et des maux dépend en bonne partie de l'opinion que nous en avons," in *Œuvres Complètes* (Paris: Seuil, 1967), 40.

3. John Bulwer, *Anthropometamorphosis. Man Transform'd, or the Artificial Changeling. Historically presented, in the mad and cruel Gallantry, foolish Bravery, ridiculous Beauty, filthy Fineness, and loathesome Loveliness, etc.* (London: J. Hardesty, 1650), initial pages unnumbered.

4. Palemon Best, "Death from Accumulation of Hair in the Stomach of a Woman," *British Medical Journal* 2, no. 467 (December 11, 1869): 630–631.

5. N. Sehgal and G. Srivastava, "Trichotillomania + / − Trichobezoar: Revisited," *European Academy of Dermatology and Venereology* 20 (2006): 911–915.

6. J. L. Soriano, R. L. O'Sullivan, L. Baer, et al., "Trichotillomania and Self-Esteem: A Survey of 62 Female Hair-Pullers," *Journal of Clinical Psychiatry* 57 (1996): 77–82.

7. Anonymous, "Homophage," in *Dictionnaire des sciences médicales par une société de médecins et de chirurgiens* ed. Adelon, Alard, Albert, et al. (Paris: C. L. F. Panckoucke, 1812–1822), vol. 21, 347.

8. Anonymous, *Notice sur Jacques de Falaise, ses habitudes, sa nourriture, et les moyens qu'il emploie pour conserver sa santé* (Paris: Ballard, 1820).

9. In the dictionary of the French Academy, 6th edition, 1835, the "coque de Levant" is "the fruit of a tree from the Indies, brown-blackish, of the size of a chickpea, which has the property of inebriating the fish, so that they can be fished out by hand" (see http://artflsrv02.uchicago.edu/cgi-bin/dicos/pub dico1look.pl?strippedhw=coque). The 18th edition of this dictionary adds that the tree is from Malabar and the Molucca Islands.

10. Most of the biographical information on Tarare was obtained from the entry "Homophage" in the *Dictionnaire des sciences médicales*, vol. 21, 344–357.

11. Tom Lorenzo, "Michel Lotito: The Man Who Ate an Airplane and Everything Else," Tailgate Fan CBS Local, October 1, 2012, http://tailgatefan.cbs local.com/2012/10/01/michel-lotito-the-man-who-ate-an-airplane-and-everything-else/.

12. David Le Breton, *Sensing the World: An Anthropology of the Senses*, translated by Carmen Ruschensky (New York: Bloomsbury Books, 2017), 252.

13. Ibid., 248.

14. F. Gonzalez-Crussi, "Fire Eaters," *Hektoen International* 11, no. 1, https://hekint.org/2018/08/17/fire-eaters/.

15. Luc de Clapiers, Marquis de Vauvenargues, *Réflexions sur divers sujets*, in *Œuvres completes*, vol. 1 (Paris: Brière, 1827).

16. William Shakespeare, sonnet XXV, http://www.shakespeares-sonnets.com/sonnet/25.

17. Quoted by Henry de Montherlant in *Mors et vita. Essais de Montherlant* (Paris: Gallimard, 1963), 510.

Index

Achilles, 123, 193
Acidalius, Valens, 31
Adephagia, goddess of gluttony, 62
Ælius Verrus, 57
Agrippa, Marcus, 188
Agrippa, etymology of, 188
Agrippina the Elder, mother of Emperor Caligula, 188
Agrippina the Younger, mother of Emperor Nero, 18–19, 188
Albert the Great (Albertus Magnus), 75, 78
Allotriophagia, 217
Amanita muscaria, hallucinogenic fungus, 95
Amatus Lusitanus. *See* Castelo Branco
Anaximander, 185
Aphrodite, 144
Apnea, static, 167–169
Apophoretae, 57
Aretaeus of Cappadocia, 6–8
Aristomenes, 122–123

Aristotle, 5, 8, 15, 23, 131
Athenaeus of Naucratis, 61, 62, 64
Augustine of Hippo, Saint, 139
Aulnoy, Madame d', 199–204, 207, 210, 212
Auschwitz-Birkenau Museum, 148–151
Ayurveda, 92, 94
Aztecs, 112, 236

Baccharis plant, 7
Bacon, Francis, 103
Bakhtin, Mikhail, 216
Banquets, in ancient Rome, 56–59
Battaglia, Francesco, 218
Beauharnais, Alexandre de, 229, 230
Beith, Mary, Scottish activist and historian, 90
Benivieni, Antonio, 125
Bezoar, 222
Bilbao, 153, 155
Binet, Alfred, 198–199

Bitumen, 97–102
 its collection process in Persia, 99
 used to treat traumatic lesions, 99–101
Blécourt, French ambassador under Louis XIV, 202
Boar in the Trojan style, 58–60
Boyd, William, Scottish novelist, 90
Brady, James Buchanan, notorious glutton, 63–64
Brännström, Mats, performed the first uterus transplant, 38
Bravo de Sobremonte, Gaspar, 23–25
Broussais, François-Joseph-Victor, 50–51, 55
Browne, Sir Thomas, 160
Buckland, Francis Trevelyan (Frank), 48–49
Buckland, William, 45–48
Bulwer, John, 218

Cadaver, curative powers, 114
Calvino, Italo, 173
Cambles, King of Lydia, ate his wife, 62
Cameroon, 90
Cannibalism, 103, 111–112
 hypothetical origin and symbolism, 113
Capsaicin, 236, 240
Cardano, Girolamo, 126, 139
Casanova, Giacomo, 30–34
Castellano, Manuel, Spanish artist, 208
Castelo Branco, João Rodrigues de, 126
Catalani, singer, 217
Catullus, Gaius Valerius, 87
Celtiberians, 88
Cervantes, Miguel de, 172, 190
Charcot, Jean-Marie, 36–38
Charras, Moyse, advocate of urino-therapy to treat "vapors," 88
Chlorine, as war gas, 89
Cinnamomum plant, 8
Colapesce, 170, 177–184
Confucius, 147
Cotyledons, 14
Crespo Agüero, Tomás, archbishop of Zaragoza, 158
Cretinism, 161
 endemic form, 163
Crick, Francis, 161
Croce, Benedetto, 173

Dasen, Véronique, 13, 14
Deipnosophists or the Banquet of the Learned, 61. *See also* Athenaeus of Naucratis
Dendrogramma, 54–55
Deng Xiaoping, 80
Desai, Morarji, 91
Descartes, René, 198
Diemerbroeck, Isbrand van, 24–25
Diocles of Carystus, 15
Diodorus Siculus, 87–88

Eating competitions
 in the United States, 64–67
 in foreign countries, 69–70
Eccentrics, 45–46
Ectogenesis, 39–40
Einstein, Albert, 161

Elisabeth, Queen of France and queen consort of Spain, 204–205, 206
Elizabeth I, Queen of England, 103, 222
Eucharist, 116
Excrement, definition, 121

Falaise, Jacques de la, 223–225
Falstaff, 195
Feet, symbolism, 187–188
 erotic value, 196–197, 210, 213
Feijóo y Montenegro, Benito Jerónimo, 153, 155, 158–162
Fetus-in-fetu, 133–134
Fludd, Robert, 103
Fontaine, Guy de la, physician to King Antoine de Navarre, 108–110
Foot-binding, 210–212
Francis I, King of France, 103
Freud, Sigmund, 38, 215

Gastritis, 20, 51
Gediccus or Gedick, Simon, 31
Gibbon, Edward, 196
Golden Legend, 18, 21–22
Gomutra, cow's urine in India, 93
Gout, 189–194
Goya, Francisco de, 114, 115
Gulik, Robert Hans van, 211–213
Gwan-yin, Chinese goddess of mercy, 212

Hair
 assumed postmortem growth, 136–138
 biology according to the *Encyclopedia* of Diderot and D'Alembert, 134–135
 bursts into flames, 140
 as excrement, 121–122
 feature of female attractiveness, 144
 grows in the heart of courageous men, 123, 125
 hair style imposed in China by Manchu rulers, 147
 in the ovary, 128
 preservation in the Holocaust Museum, 150–152
 symbolic significance, 149
 in the tongue, 127
Haller, Albrecht, 126
Hardy, Alister, 185
Harvey, William, 160
Hawker, Robert Stephen, 45
Helmont, Jan Baptist van, 35, 50
Heraclides of Pontus, 58
Hermogenes of Tarsus, 124, 125
Herophilus of Chalcedon, 13, 14
Hess, Rudolf, 149
Hesychius of Alexandria, 5
Himmelman, Kenneth, 116–117
Hippocrates, 5, 8, 87, 190
 Aphorisms, 15, 195
 attributes the cause of women's maladies to the uterus, 23
Holocaust Memorial Museum, 148–150
Hysteria, 6, 34, 36
Hysterogenic zones, 36, 37

Icthyosis, 163
Inula coryza, 7

James I, King of England, 104
James, William, 119
Josephine, first wife to Napoleon, 214

Kaempfer, Engelbert, German naturalist and traveler, 97–101
Kobayashi, Takeru, champion in eating competitions, 66
Koryak people of Kamchatka, 95

La Capria, Raffaele, 173
Lamb, Charles, 48
Lambe, William, opponent of meat eating, 67
Lana Caprina, 32, 243n24
Lateran, 22
Lavoisier, Antoine, 159
Le Breton, David, 235
Lémery, Nicolas, French chemist, 104
Lemos, Pedro Fernández de Castro, Count of, 206
Lewin, Roger, 51–52
Liérganes, 153–160, 162, 165
Lorber, John, 52
Lotito, Michel, 234
Lucian of Samosata, 192–193
Lucius Marcius, 141–142

Manchu dynasty, 147–148, 211
Marañón, Gregorio, 160, 161, 163, 164, 166
Marchand, Louis-Joseph, valet to Napoleon, 138
Marcus Aurelius, Emperor, 124
Maria Luisa of Savoy, first wife to Philip V of Spain, 201–204
Mariana of Austria, second wife to King Philip IV of Spain, 208–209
Marie-Louise, second wife to Napoleon, 214
Melatonin, 91
Messina, 176, 181
Mexía, Pedro, 172
Miki Sudo, female champion in eating contests, 67
Miller, Edward, physician, 51
Milo of Croton, 60, 63
Montaigne, Michel Eyquem de, 217
Mummy, 98, 101–103
 anecdote of mummy importation, 105–108
 commercialization of embalmed bodies, 105
 definition in Johnson's dictionary, 110
 eating, 103
 importation from Middle East to Europe, 104
 still sold in the early twentieth century, 111
Musset, Alfred de, 210
Mytton, John, 45

Napoleon Bonaparte, 138, 213–214, 229, 230
Nematodes, lack a heart, 52
Nero, Emperor, 18–22
Newton, Frank, opposed meat eating, 67
Newton, Isaac, 160
Ningyo, aquatic being in Japanese mythology, 165

Nowakowski, Jacek, administrator of the Washington, D.C. Holocaust Museum, 149

Olesen, Jørgen, 53, 54
Olivares, Gaspar de Guzmán, Count-Duke of, 207
Orion, 170–172
Ovarian dermoid cyst, 128
 hypothetical origin, 129–131
Ovid (Publius Ovidius Naso), 144

Palamarcuk, Ioanna, German beauty queen, 145, 146
Panspermia, 161
Paracelsus, 49–50
Paré, Ambroise, 102, 109–110
Parkinson, John, English botanist, 103
Pausanias, 122–123
Peñaranda, Count, 204
Pericarditis, fibrinous, 125–126
Philip IV, King of Spain, 204, 206, 208
Philip V, King of Spain, 201–204
Pica, 217
Picart, Bernard, French engraver and author, 92, 93
Plater, Felix (Platerus), 196–197
Plato, 4, 6, 10–11, 35
Pliny the Elder (Gaius Plinius Secundus)
 on causes of abortion, 43
 on origin of the name Agrippa, 188
 on the story of Aristomenes, 123
 on therapeutic uses of saliva, 74
 on therapeutic uses of urine, 86

Podagra, 190, 192. *See also* Gout
Porter, Roy, 194
Priam, 193
Pujol, Joseph, 140

Qing dynasty, 147–148, 211

Radcliffe, John, court physician, 34
Rapunzel syndrome, 222
Rebolledo, Efrén, Mexican poet, 149
Recrement, 75–76
Rhazes, Persian physician, 97
Riba, Gaspar de la, 158
Ritson, Joseph, opposed eating meat, 67
Robinson, Nicholas, author of a book on medicinal properties of saliva, 75–77
Rousseau, G. S., 194
Rubens, Peter Paul, 15–16
Rullus, Servilius, 58
Ruscillo, Deborah, 57

Saliva
 diagnostic usefulness, 78–79
 miraculously cured blindness, 73
Sanderson, John, imported mummies to Europe, 104–104
Santander, 158
Scaliger, Julius Cesar, 139
Scheele, Carl Wilhelm, 159
Sciascia, Leonardo, 173
Scipio, Publius and Gnaeus, 141
Servius Tullius, hair ignited spontaneously, 140, 141
Sévigné, Marie de Rabutin-Chanal, Marquise de, 88

Shakespeare, William, 4, 195, 238
Shelley, Percy Bysshe, 67
Shi Nan-ai, Chinese author of *Water Margin*, 213
Sichem or Shechem, biblical city, 24
Sisyphus, 192
Sobremonte. *See* Bravo de Sobremonte, Gaspar
Song dynasty, 211, 212
Soranus of Ephesus, 5, 14
Sorcery and magic, 10, 43
Soto Mayor, Don Jaime de, 203
Spitting
 old social habit, 79–80
 prohibition of, 81–83
Stomach
 called king of bodily economy, 50
 paralysis, 68
 present in almost all animal forms, 53
 primary seat of diseases, 51
Strahlenberg, Filip Johann von, Swedish explorer, 95
Sushruta, 94
Sydenham, Thomas, 189–190

Tacitus, Publius Cornelius, 74, 239
Tallemant des Réaux, Gédéon, 11
Tantalus, 192
Tarare, celebrated "polyphage," 225–234
Tarquinius Priscus, Roman king, 141
Tarsis y Peralta. *See* Villamediana
Taylor, Edward, physician, prescribed eating mummy, 103
Teratomas, 128–132
Thales of Miletus, 185

Theagenes of Thasos, ate a whole bull at a single sitting, 60, 63
Thermopylae, 124
Tissot, S. A.-D., 196
Tom James, known as "Tom the Guts," 63
Torres, Don Luis de las, 203
Trichobezoar, 222
Trichotillomania, 221, 222
Trichotillophagia, 221, 222
Tyler Smith, W., homologized uterus and heart, 41–42

Ulysses, 193
Urine
 in ancient diagnosis of gender of the unborn, 85–86
 cows' urine used in India as medicament, 93
 credited as panacea in Cameroon, 90
 as dentifrice, 87–88
 nasal instillation, 91
 preserves toxic, mind-altering compounds, 95
 protection against war gas, 89
 unconfirmed claims of anti-cancer activity, 94
Urinotherapy, 84
Uterus
 as batrachian, 17–19
 as heart, 41–42
 imagined mobility, 10–11
 as octopus, 13–14
 as sentient animal, 5–7
 as "thinking organ," 25–29
 as winged creature, 16–17

Valbuena, Marquis of, 158
Valerius Maximus, 142
Vauvenargues, Luc de Clapier, Marquis de, 238
Vega, Lope de, 172
Vega Casar, Francisco de la, the "amphibian man," 153–157, 161
Velázquez, Diego, 208
Villamediana, Juan de Tarsis y Peralta, Count of, 205, 206, 207
 assassination, 208
Vives, Luis, 172
Vodyanov, water spirit in Slavic mythology, 165

Wallace, Alfred Russel, 160
Water Margin, Chinese classical novel, 212–213
Watson, James, 161
Wulferus, German chronicler, 136

Xerxes, King of Persia, 124
Xiaojing, Chinese classic work on filial piety, 147–148

Yacuruna, Quechua word for mythical, manlike aquatic being, 165

Zecchini, Petronio, 25–29
Zhang Bangji, 211